12/03

WITHDRAWN

Classic Japanese Design

Katachi

Takeji Iwamiya | **Kazuya Takaoka**

CHRONICLE BOOKS
SAN FRANCISCO

Katachi

First published in the United States in
1999 by Chronicle Books.

First published in Japan in 1999 by P·I·E Books,
#301, 5-37-1 Komagome
Toshima-tu, Tokyo 170-0003.

Printed in Japan

ISBN 0-8118-2547-7

Library of Congress Cataloging-in-Publication Data available.

Book and cover design: Kazuya Takaoka
Cover photograph: Takeji Iwamiya
Translation: Pamela Virgilio, Douglas Allsopp

Distributed in Canada by
Raincoast Books
8680 Cambie Street
Vancouver, B.C. V6P 6M9

10 9 8 7 6 5 4 3 2 1

Chronicle Books
85 Second Street
San Francisco, California 94105

www.chroniclebooks.com

Contents

—

Through the Mirror of Japan

Mutsuo Takahashi

What the word *"katachi"*—or sense of form—
represents in Japanese is difficult to define suc-
cinctly in other languages. Perhaps the difficulty
arises because Japan itself eludes concise definition.
Novelist, essayist, and playwright Yukio Mishima
once likened Japan to a crucible: "There is nothing
in Japan. But it is the emptiness of a crucible that
absorbs everything from the outside and transforms
it into something totally different. That force of
transformation is Japan." | Mishima's remarks
were inspired by my anecdote about a friend who
had visited a Shintō shrine to have his fortune
foretold after ten years of living abroad. He had
been asked to wait in the worship hall, the sparsity
of which he found vaguely unsettling. There
was nothing there—save a mirror and a sakaki tree
branch adorned with strips of white paper. He
later expressed his sentiments to the head priest
who nodded in agreement and stated, "That is so.
There is nothing in Shintō." | Mishima's paraphras-
ing may be somewhat controversial, but it is
particularly insightful in reference to the Japanese
sense of form. The Shintō mirror, originally intro-
duced from the mainland, performs the function

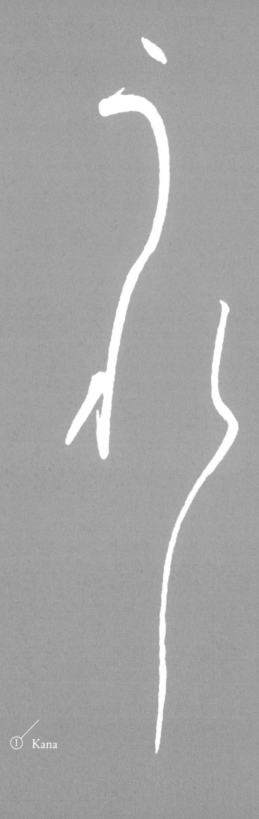

of Mishima's crucible. The Shintō worship hall, and particularly the mirror, are cases of a tangible crucible replacing an intangible one. The mirror is not the object of worship, as it is often mis-construed; it is an object that reflects something sacred. This mirror is made of polished metal, which will inevitably rust. Reflections in a metal mirror are dim and blurry, imbuing them with a greater sense of sacredness. | That mirror is Japan, a culture that absorbs the light of external objects and ideas and reflects back a changed image, an image transformed. The originals are assimilated through the looking glass of Japan, stripped to their essence, and mirrored in forms that epitomize their intrinsic nature—in material, in function, and in force—as they relate to their new context. | Take the written language, for example. Japan had no indigenous form of writing; tradi-tions were passed down orally. Kanji, or Chinese characters, were later introduced from abroad. Chinese characters are distinctive in that they are ideographs, each character representing a single idea. For this reason, it is essential that the integrity of each character's form be preserved and thus transcribed. | The Japanese relentlessly studied the forms of each ideograph, and read them in books brought back from overseas. Initially, pronunciation and reading order undoubtedly followed the Chinese model, but as time passed, new and uniquely Japanese systems of pronunciation, word order, and punctuation evolved. From there,

亨之筆當投筆以攪沫泊沉秋

④

天地元黄宇宙洪荒日月盈昃辰

③

樂日月其除無已太康職思其居

②

inflectional endings to existing Chinese characters were devised, with which kana, the Japanese syllabary, was born. Adaptable kana emerged in contrast to unequivocal kanji. The neutral nature of kana was more appropriate for expressing the subtle implications of Japanese than kanji, which are logic-based and specific. Accordingly, the use of kanji and kana in combination, and of kana alone, signaled the true development of written Japanese. | The birth, or more accurately, transformation of kana from kanji (figure 1) can be described as "becoming cursive." The standard angular calligraphic form for kanji, called *kaisho* (figure 2) became semicursive *gyōsho* (figure 3) with brush-writing, and then fluidly cursive *sōsho* (figure 4). *Sōsho* formed the intermediate stage in the evolution of totally stylized, modern kana. The transition from angular to cursive can be described as a stylistic transformation, but the shift from kanji to kana is more accurately described as a metamorphosis. | These transformed objects, like the mirror that easily rusts in the damp Japanese climate, symbolize a metamorphic force. Kanji, unyielding and intentionally invariable in form, were transformed into gentle and mutable kana through the mirror of Japan. This is just one example, but typical. Japanese forms are gentle and susceptible to change, and have a fragility that evaporates into the atmosphere. This holds true for all materials, not only paper, fiber, wood, or earth, which are frail in appearance. Materials

② Kaisho ③ Gyōsho ④ Sōsho

such as stone and metal, perceived to be permanent, are also soft; they change, disintegrate and disappear with the passage of time. | The lyrics of the de facto Japanese national anthem—used to uphold the nation's eternal strength—was adapted from a 10th-century *waka* poem:

> Thousands of years of happy reign be thine;
> Rule on my lord, till what are pebbles now
> By age united to mighty rocks shall grow
> Whose venerable sides the moss doth line.
>
> (as translated by Basil H. Chamberlain)

Ironically, the symbolic "mighty rocks" are lined, hence altered, with the growth of moss. The gentle, transitive nature inherent in all forms—including that of the nation itself—contains the force that is Japan. | Takeji Iwamiya has captured in photographs the transformative power underlying the Japanese sense of form. Both his choice of objects —the comb, the streetsign, the sword, the tea whisk —and their rendition display the same understanding of intrinsic nature as is revealed in the objects themselves. Iwamiya's camera has become the mirror, recording objects but reflecting intangible qualities. These photographs have the power to transform the viewer's perception of design and to inspire a quest for forms that achieve a true balance between function, the potentials of materials, the context within which an object is used, and beauty. *Katachi* is a testament to the art of design; it is also a tribute to the ever-changing nature of Japan itself.

Paper

紙

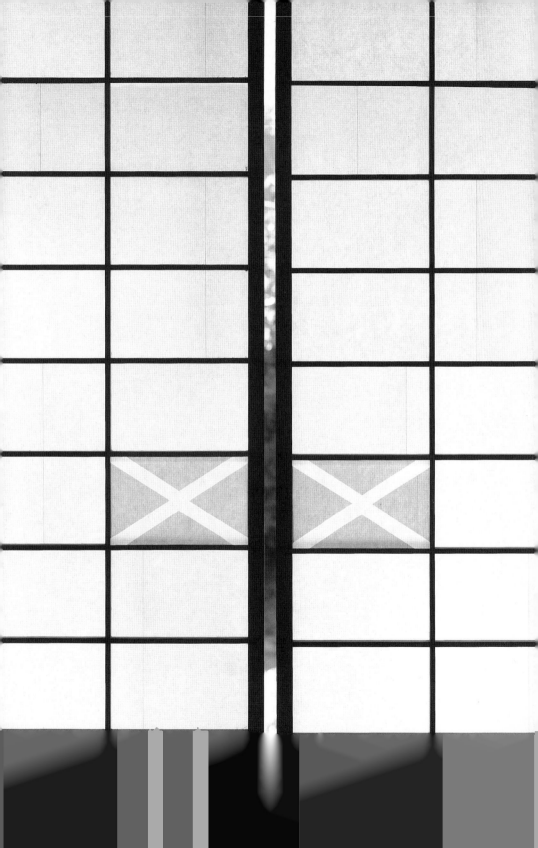

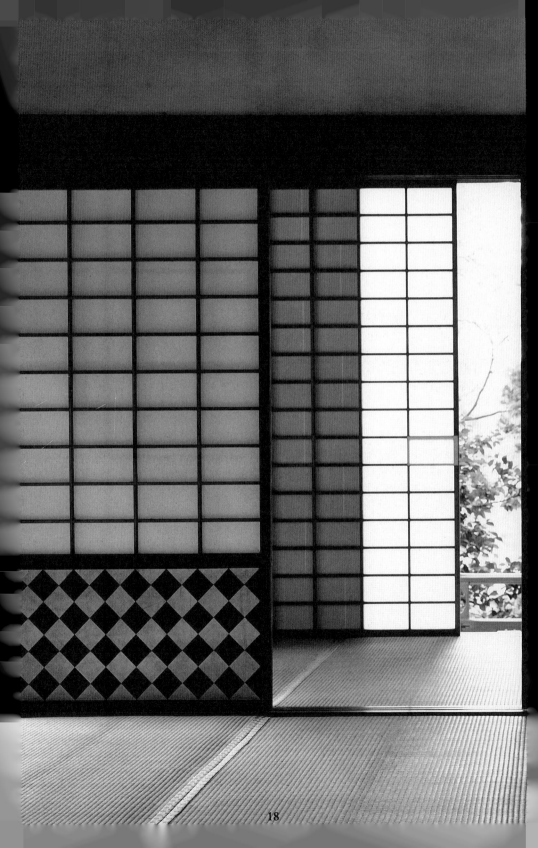

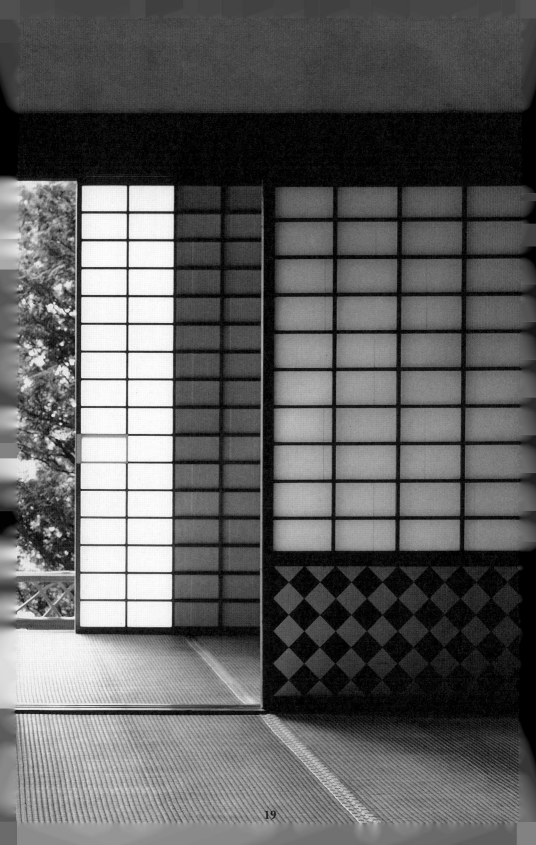

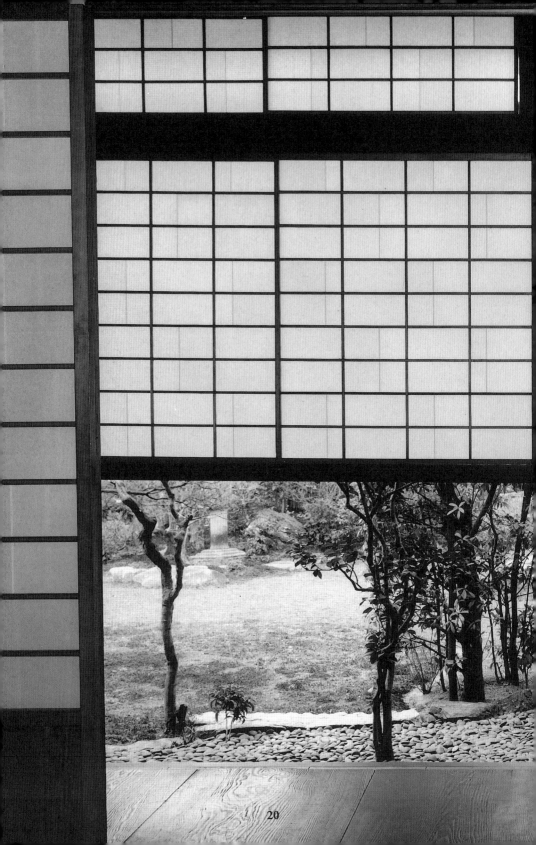

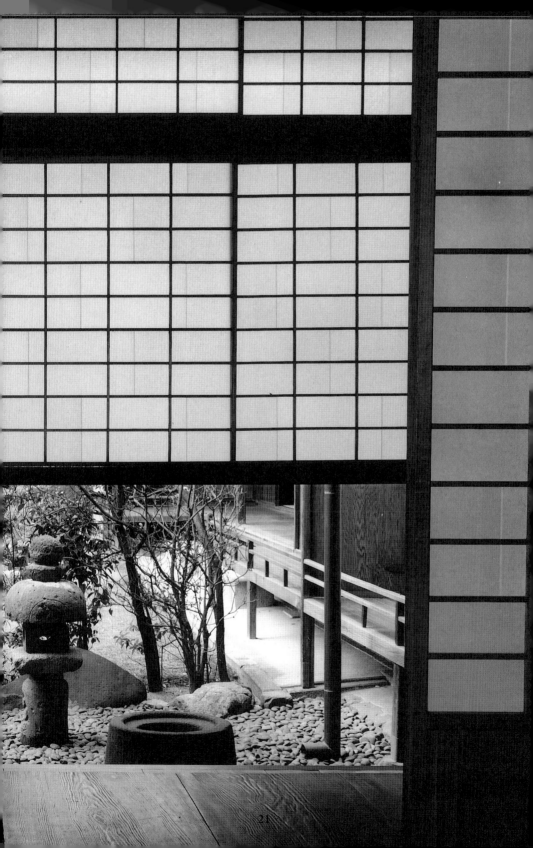

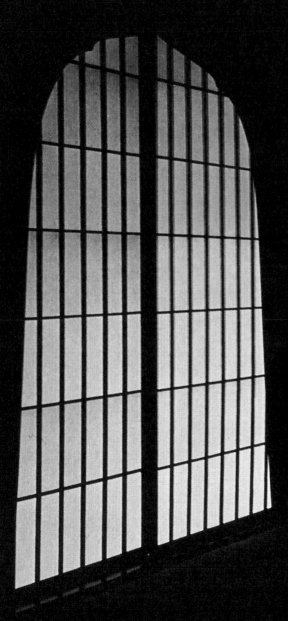
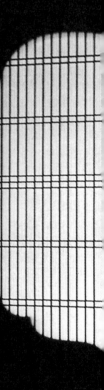

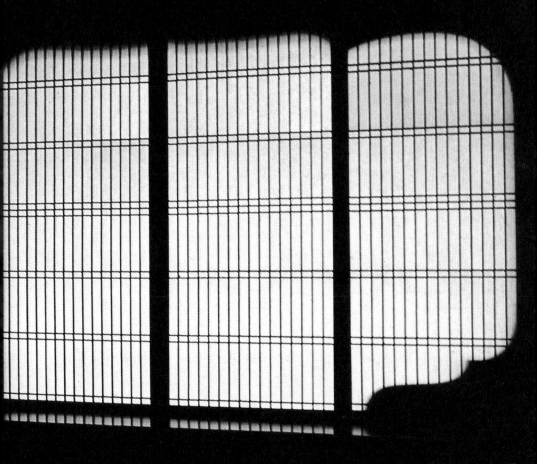

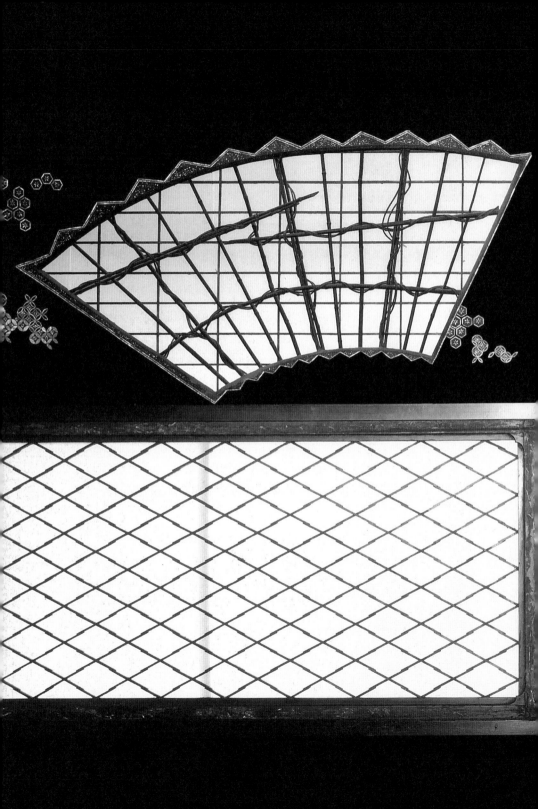

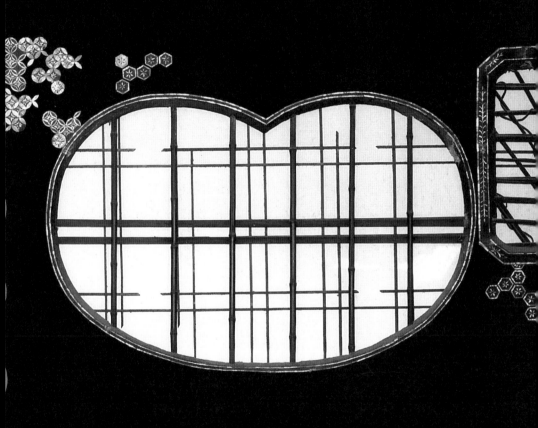

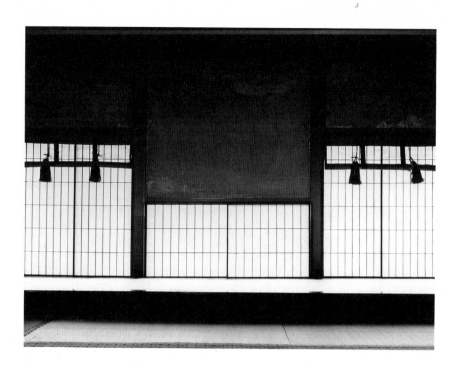

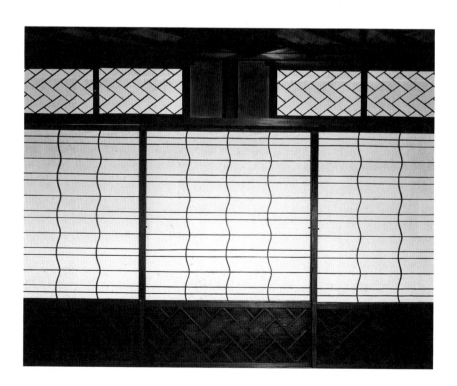

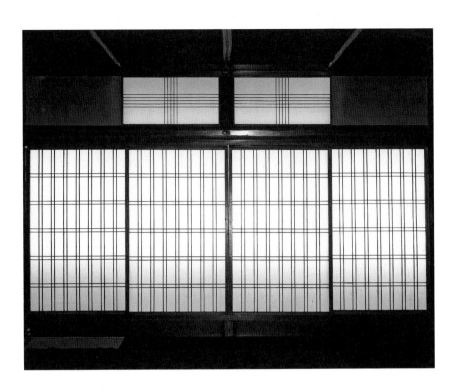

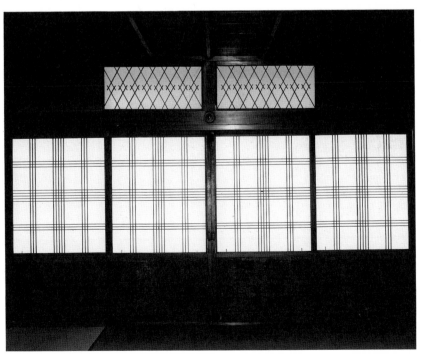

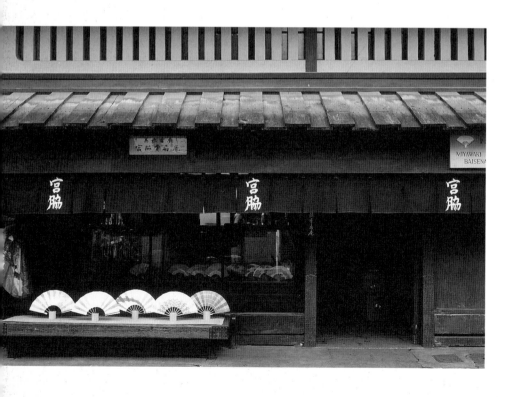

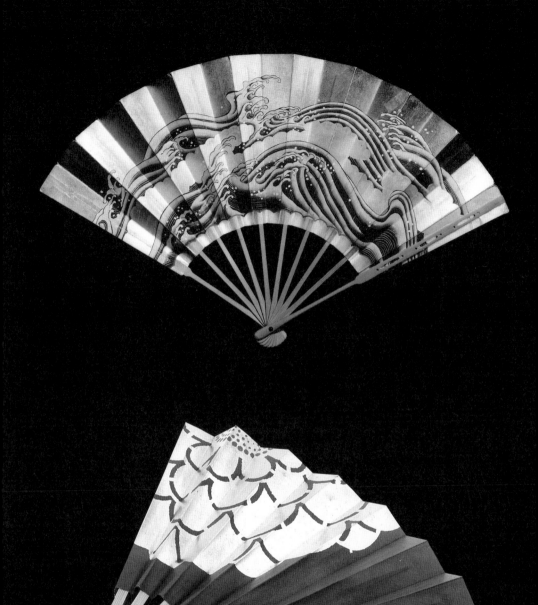

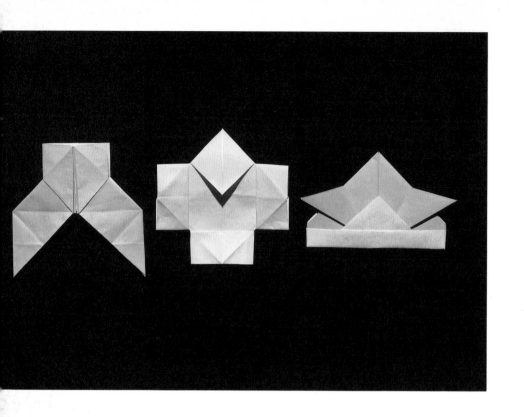

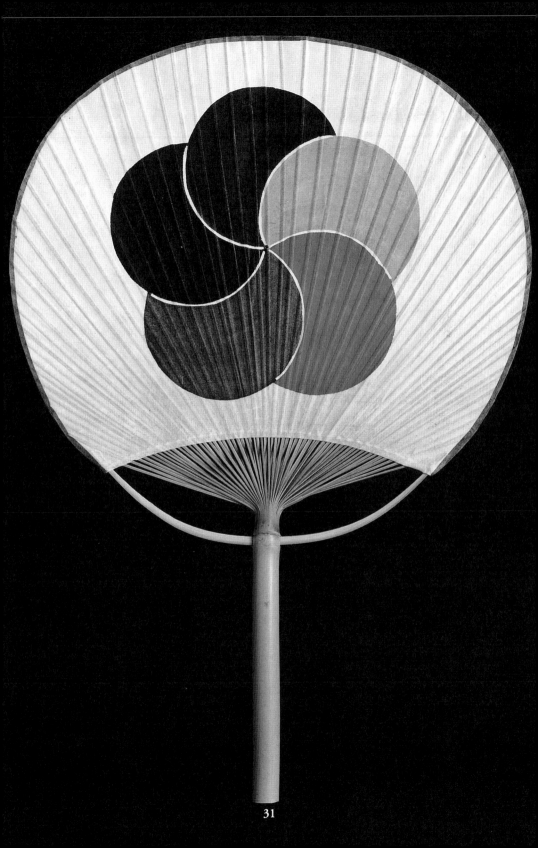

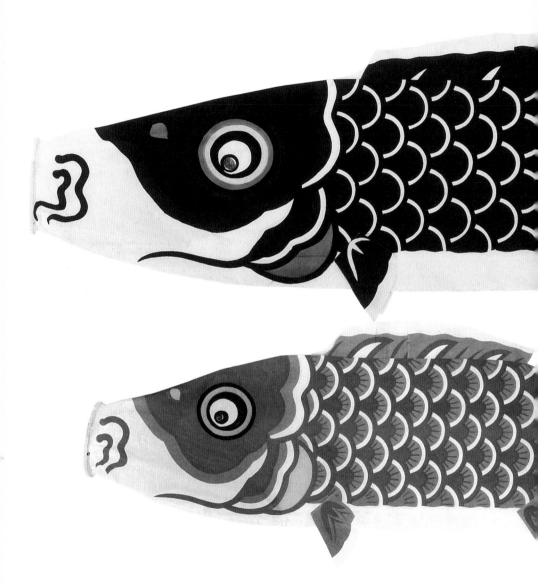

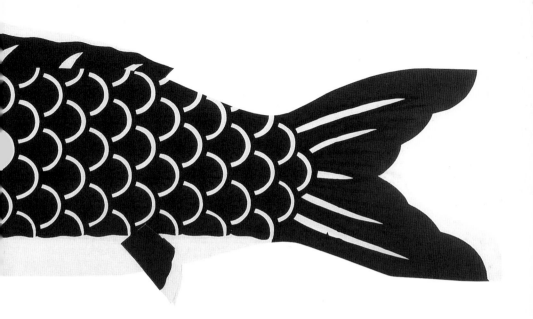

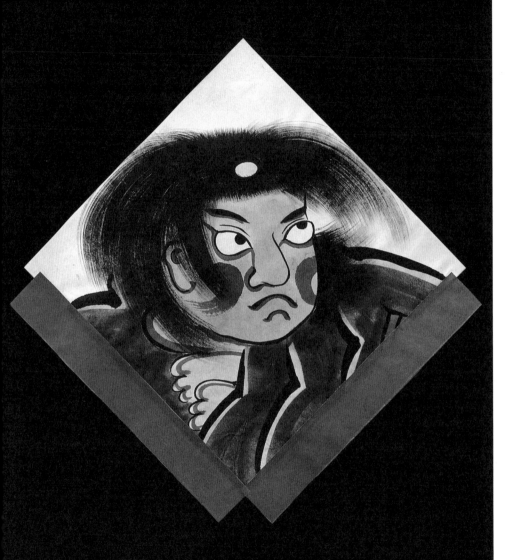

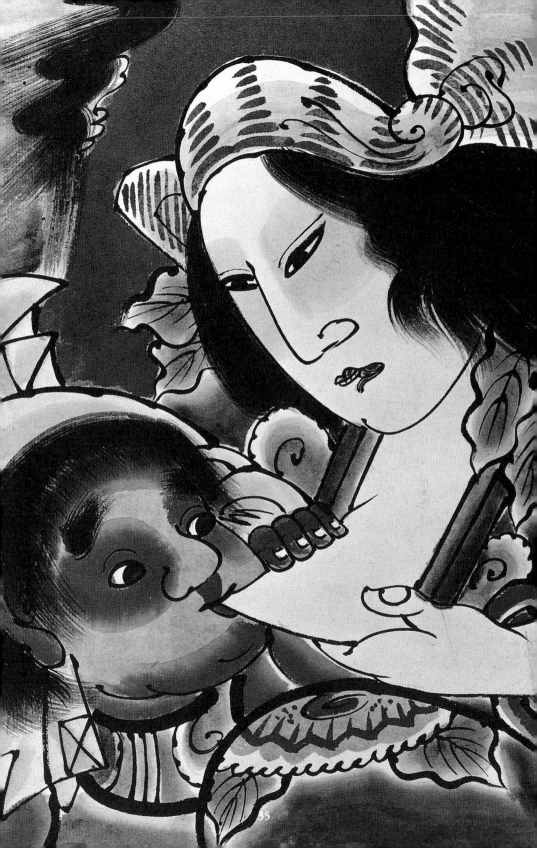

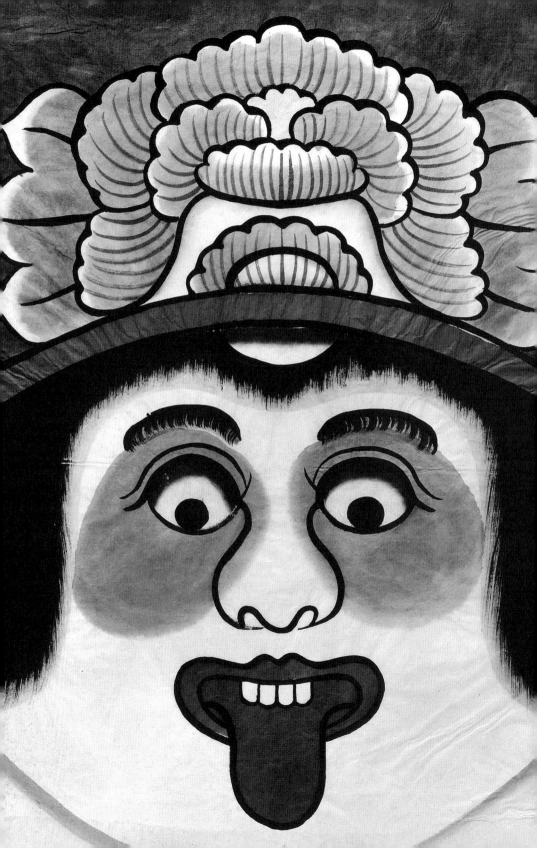

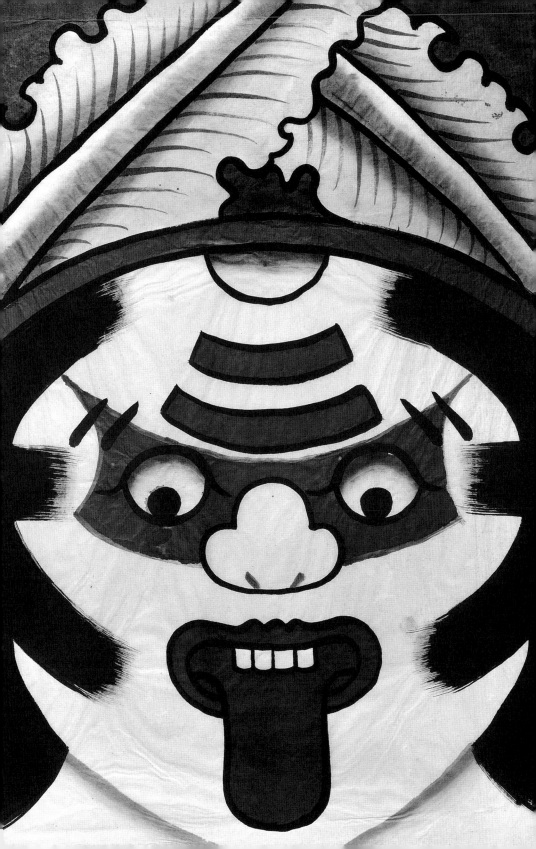

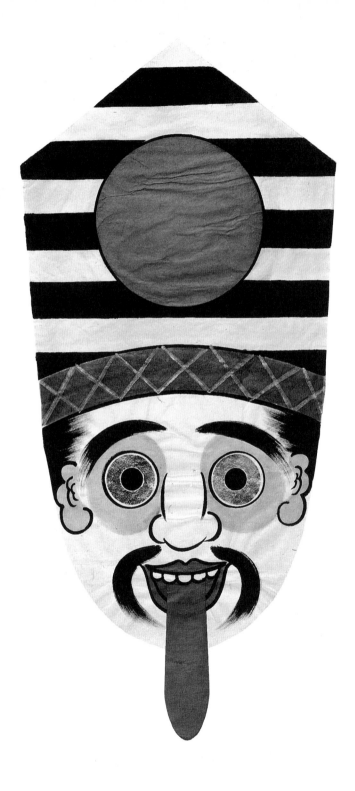

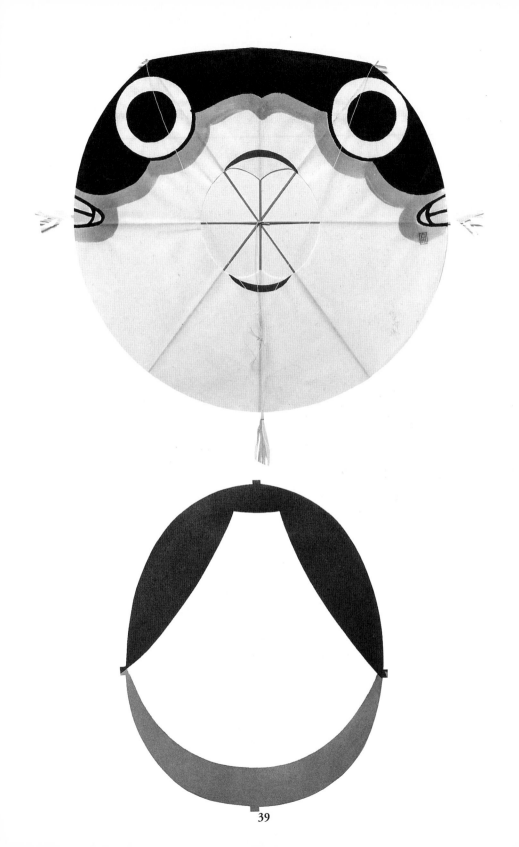

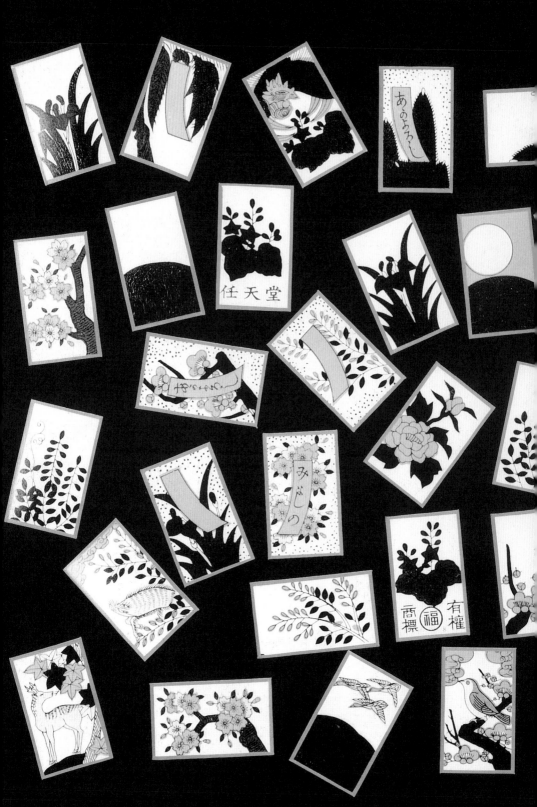

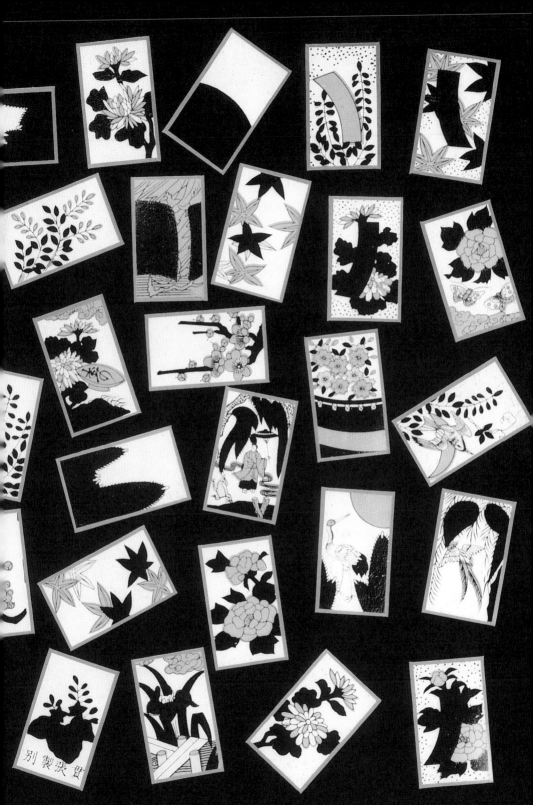

別製張貫

45

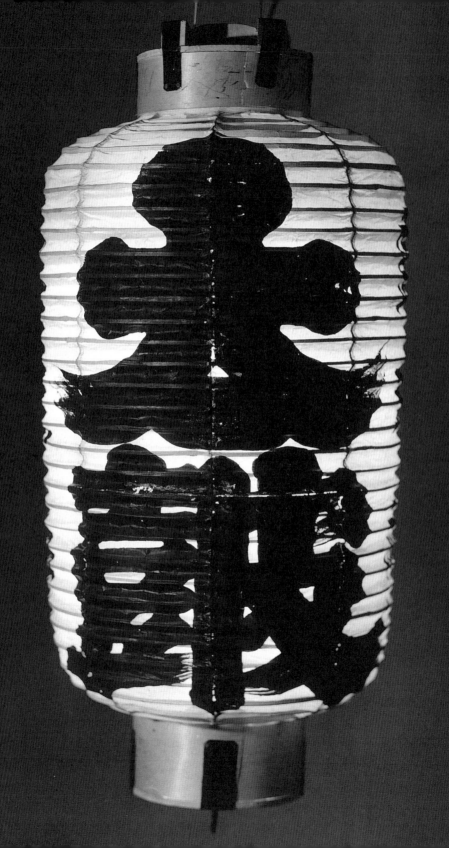

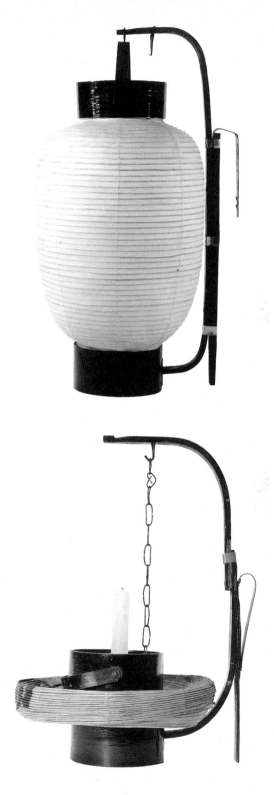

火も舟の路もねつ津

と奥勇みてひ共

御遠かゆりあ共ど

ありも盤のうろ

清元流正本 第貳編

三保松富士曙明

十二代目　常磐津小文字太夫

版元　坂川平四郎

歌舞伎座

鳥居清満画

右常磐津一流太夫直傳之正本者私方ヨリ外ニ決而無御座
仍而太夫自筆ヲ取而節章句ヲ正シ
令開版者也御求御覧被遊可被下候以上

常磐津正本版元

常磐津小文字太夫

常磐津太夫太夫
常磐津組太夫

岸澤式佐
岸澤三藏
岸澤三八

東京都豊島区谷中清水町壱番地
印刷兼發行者　坂川平四郎

昭和廿二年一月再版

天保九戌霜月

（坂川藏版）

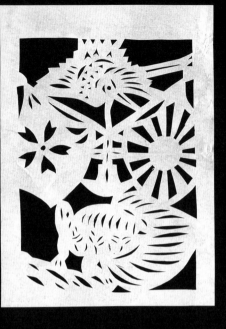

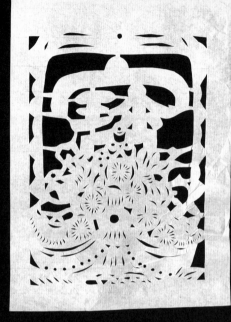

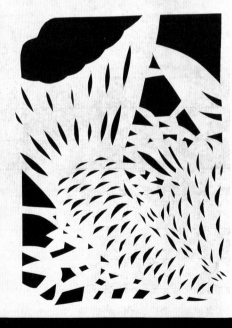

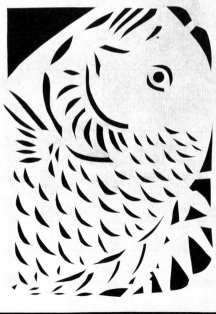

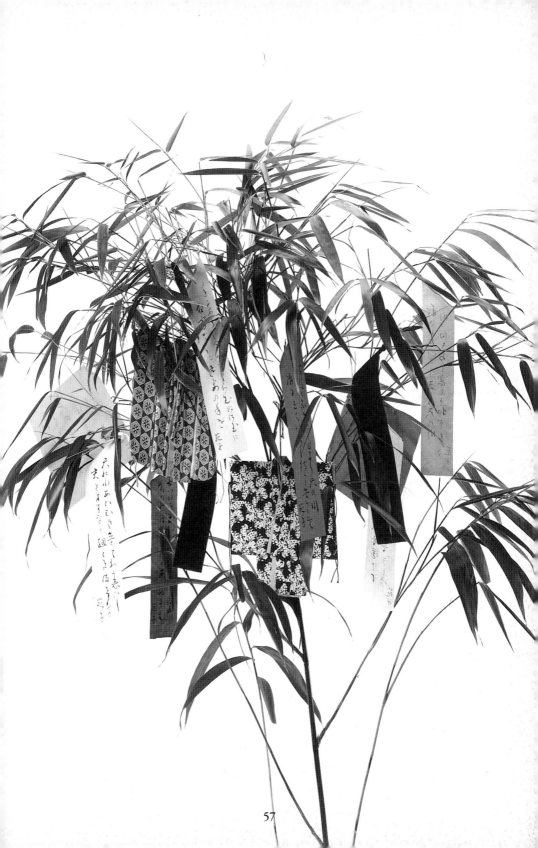

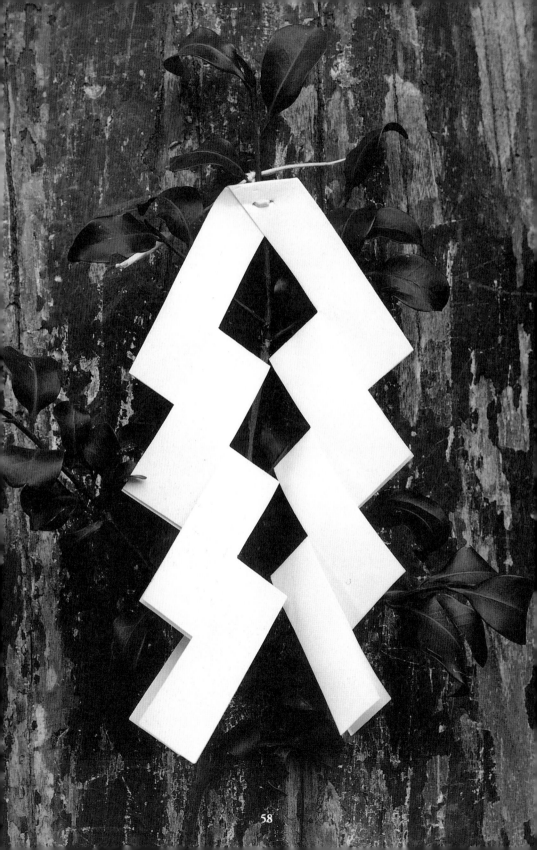

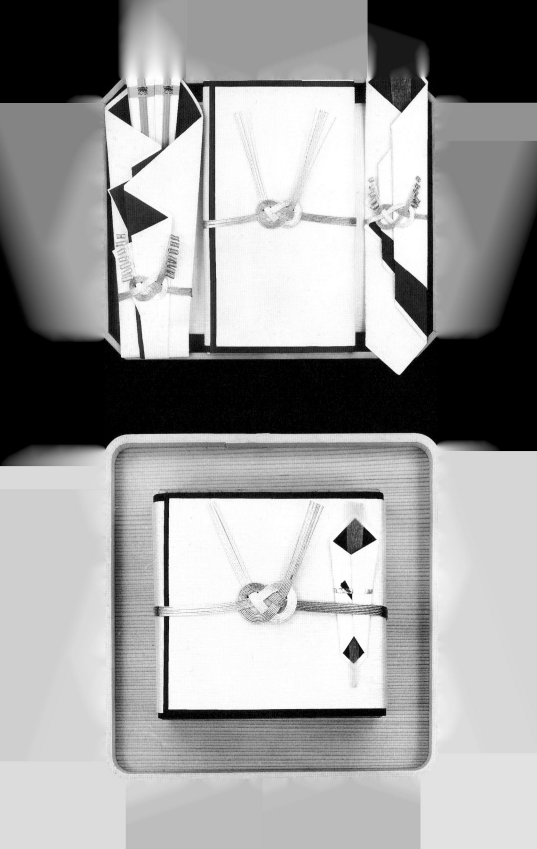

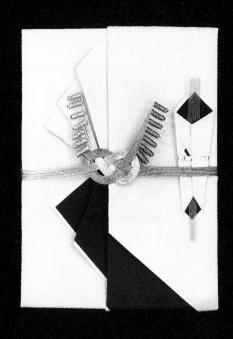

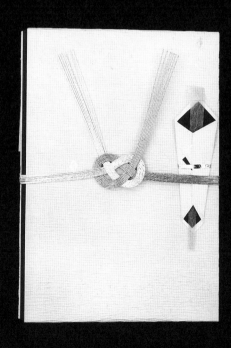

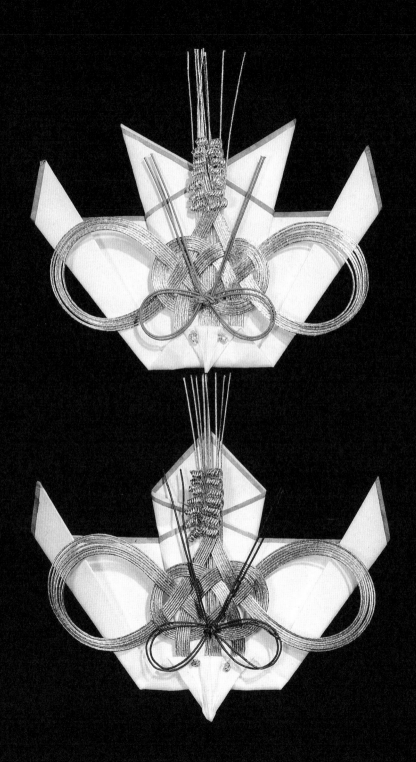

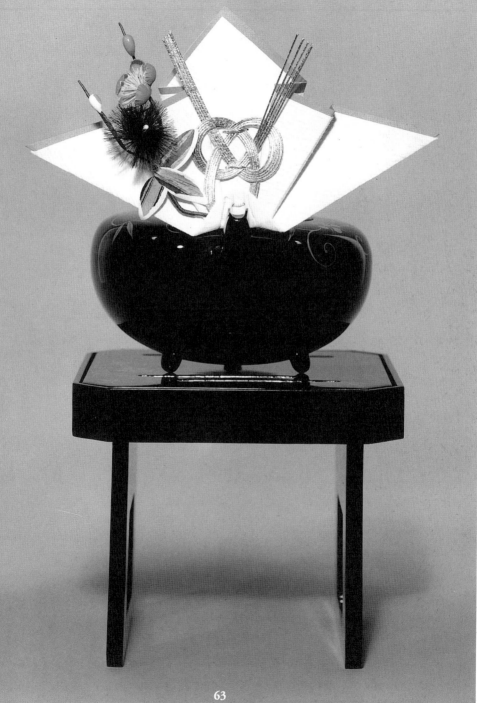

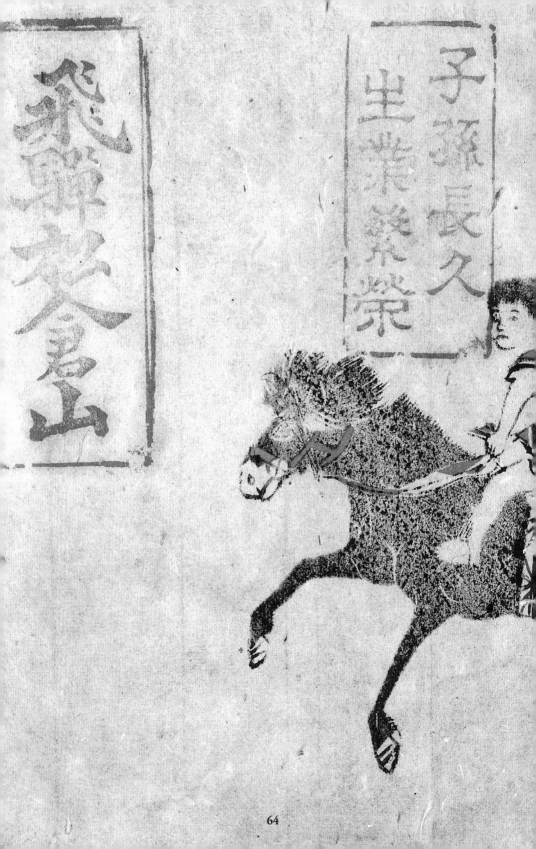

飛騨松本君山

子孫長久

生涯繁榮

卍 除厄御祈禱秘法寳牘　あびこ　觀音寺

卍 厄除之御守　吾彦山　観音寺

卍 開運除厄觀世音寳牘　吾彦山　觀音寺

卍 立春除厄大吉祥

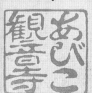

卍 爲修除厄聖觀世　秘法如意吉祥至心祈攸

稲荷大神守護所

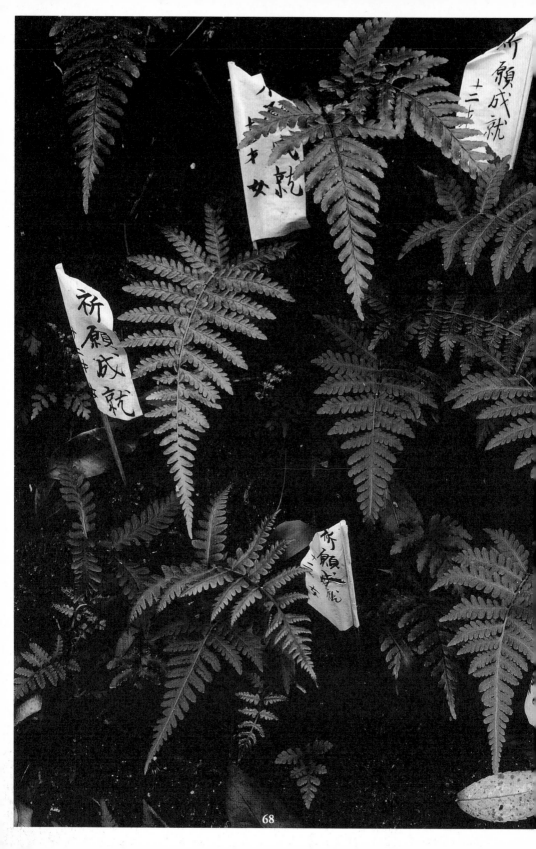

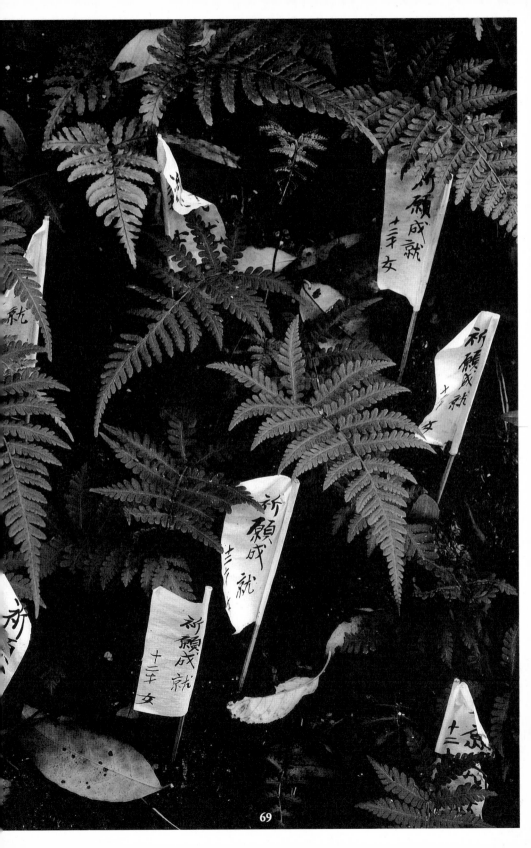

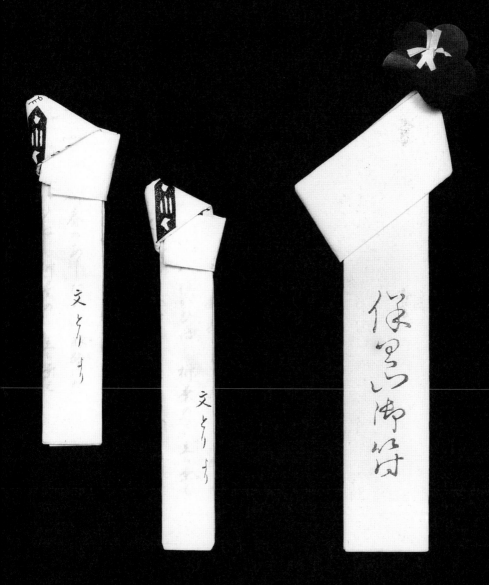

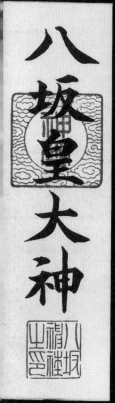

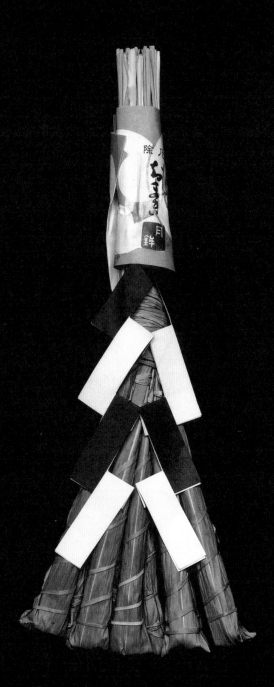

Wood

木

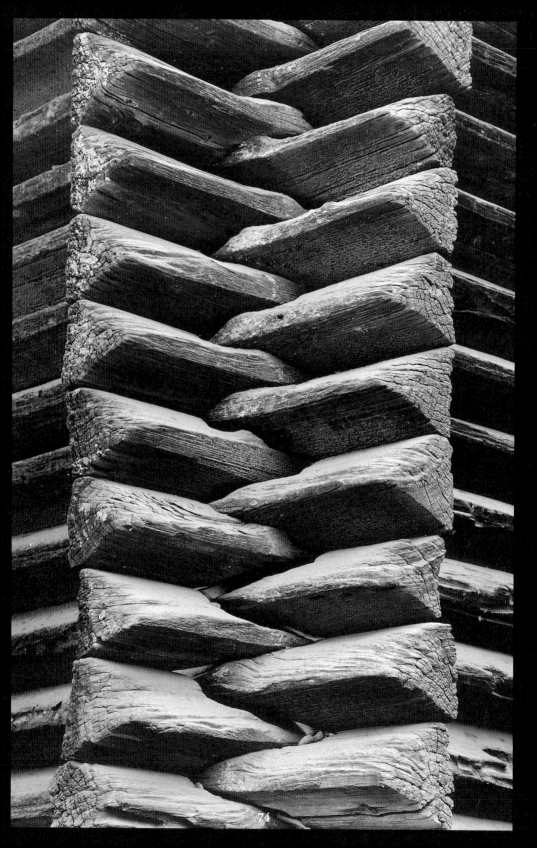

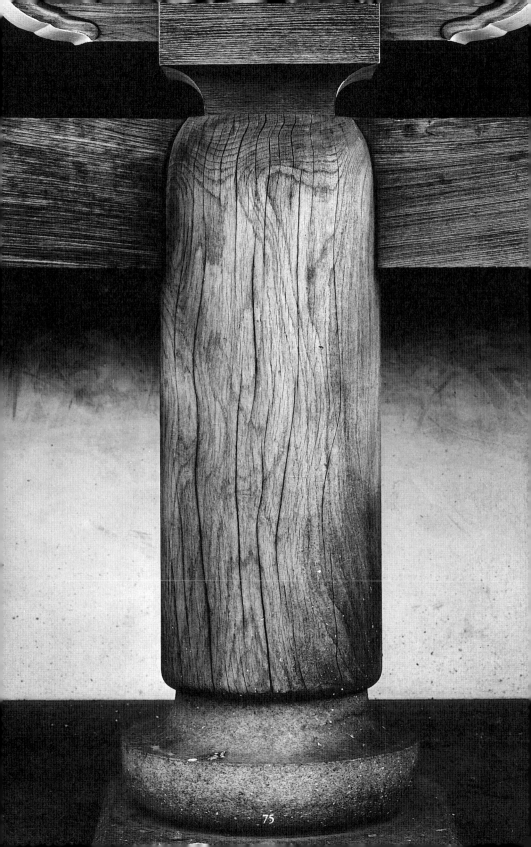

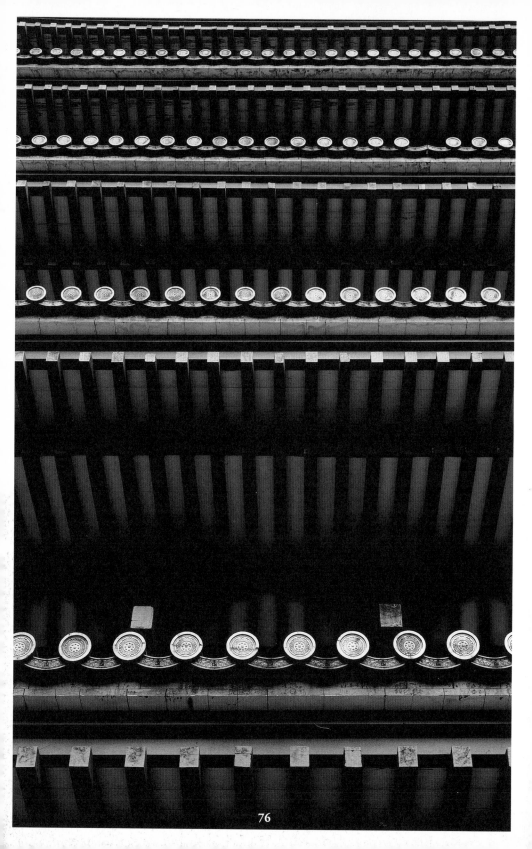

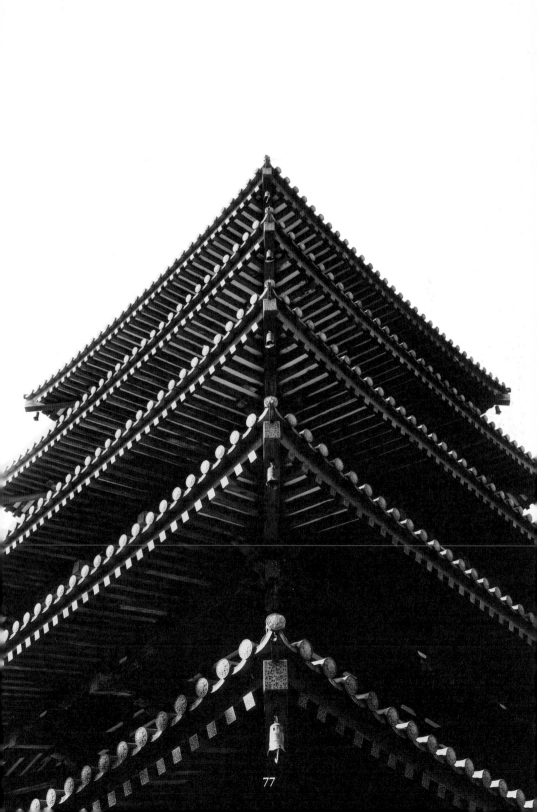

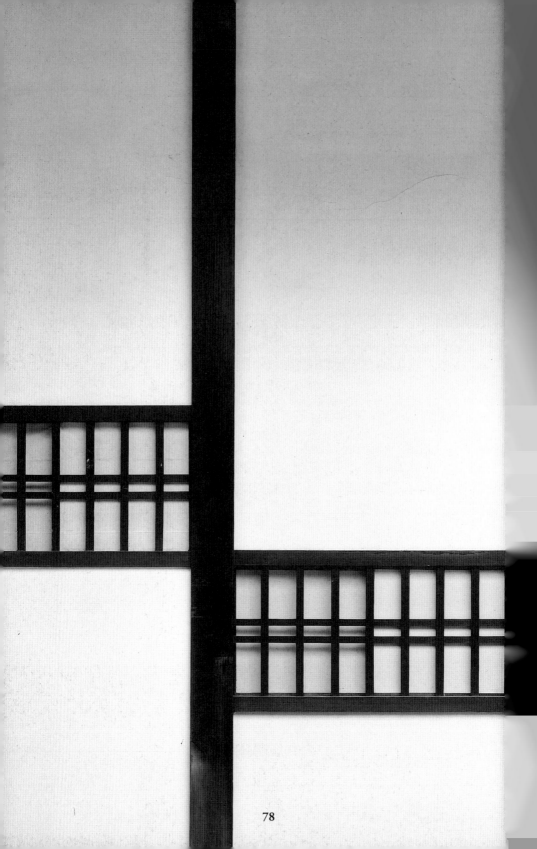

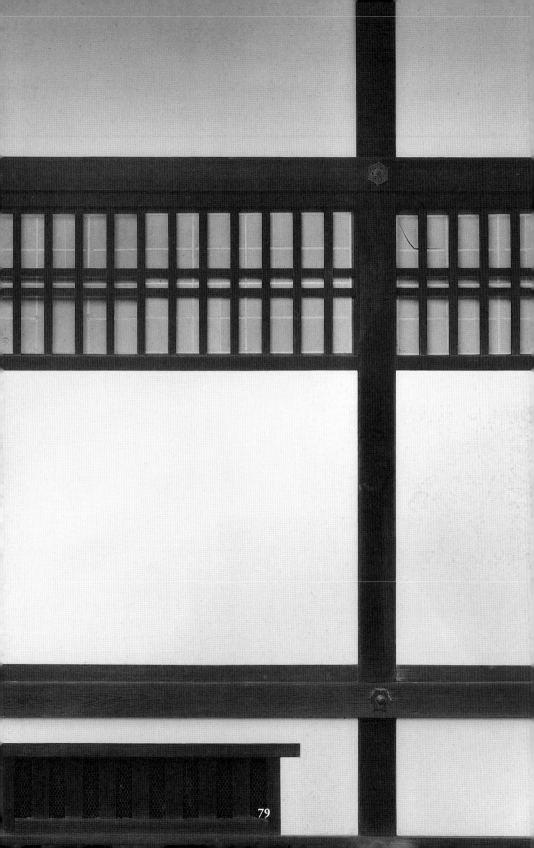

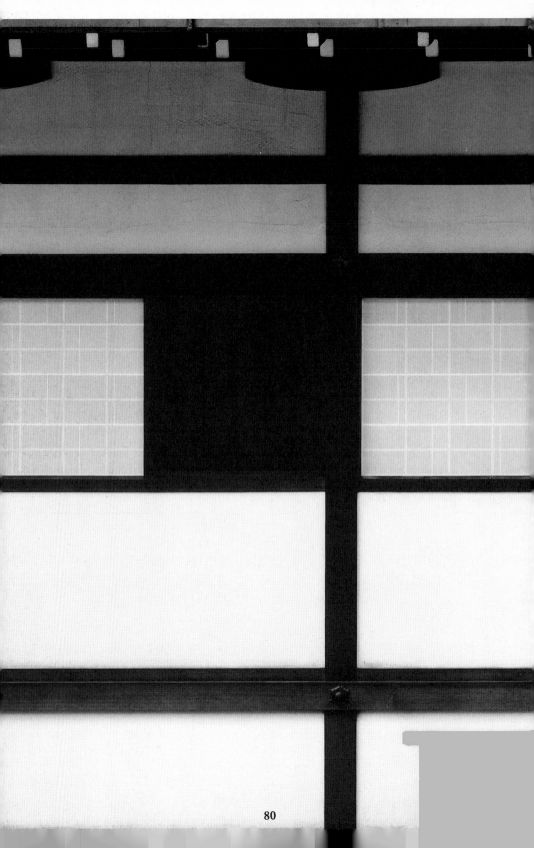

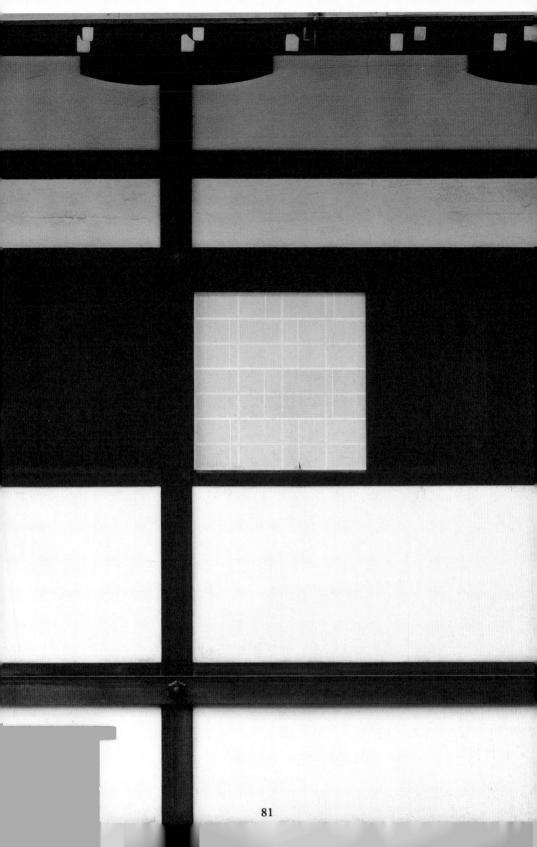

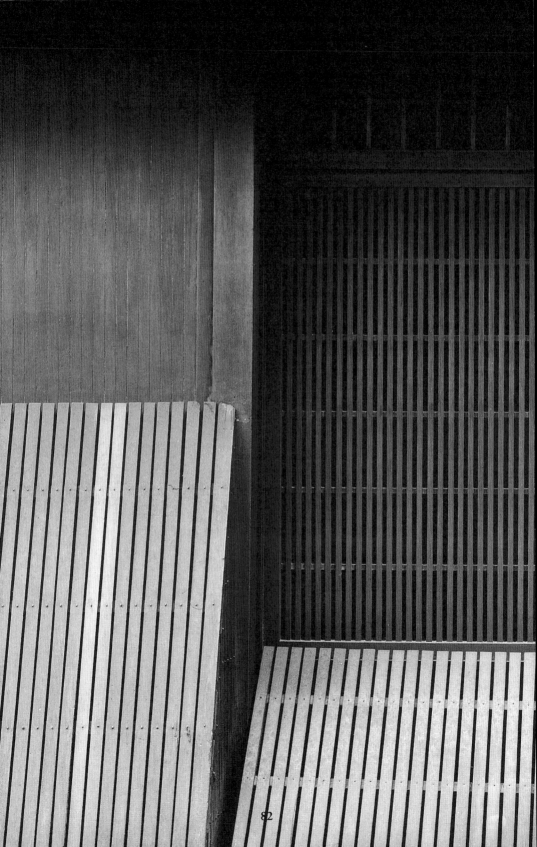

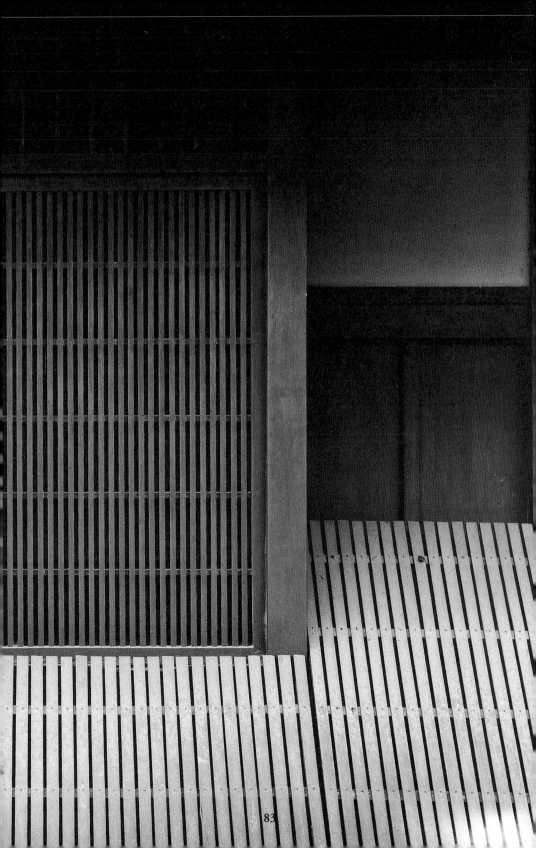

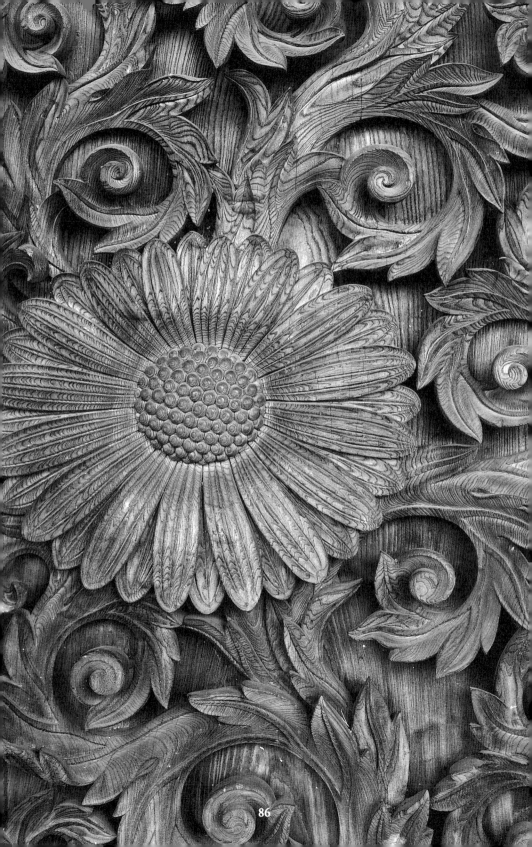

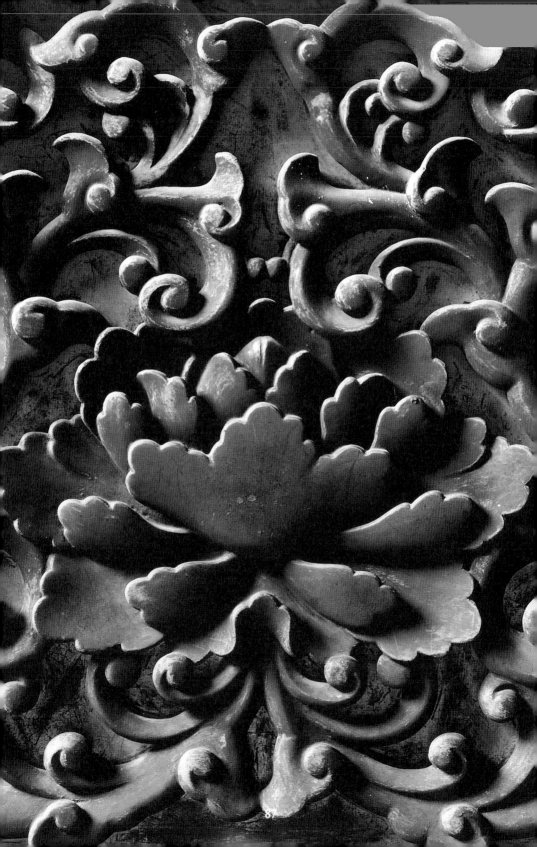

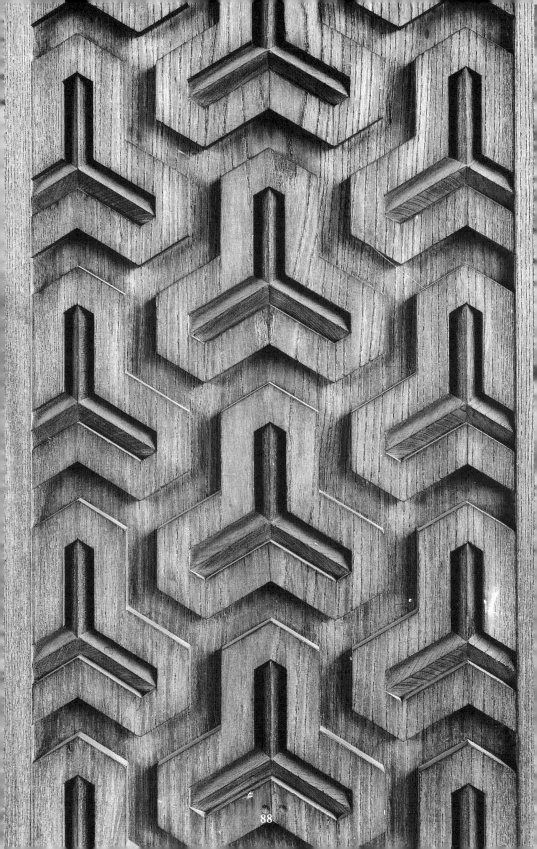

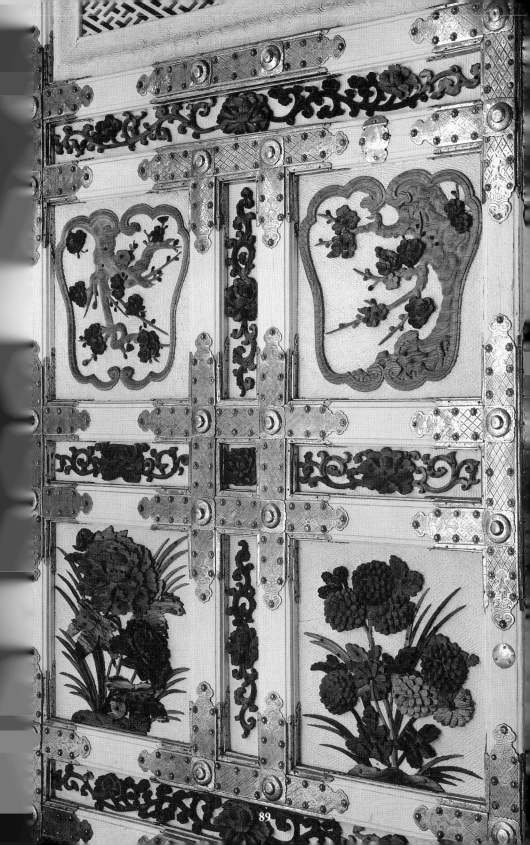

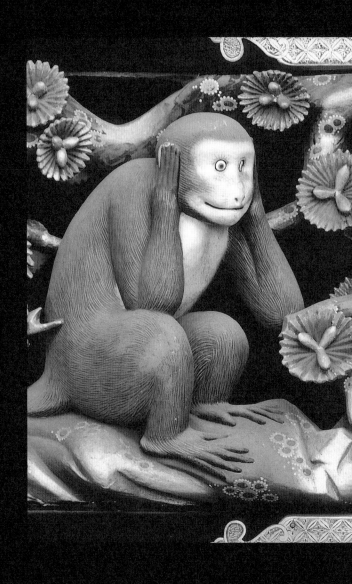

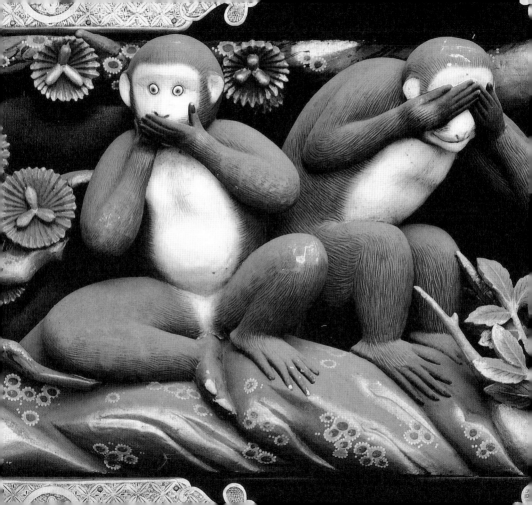

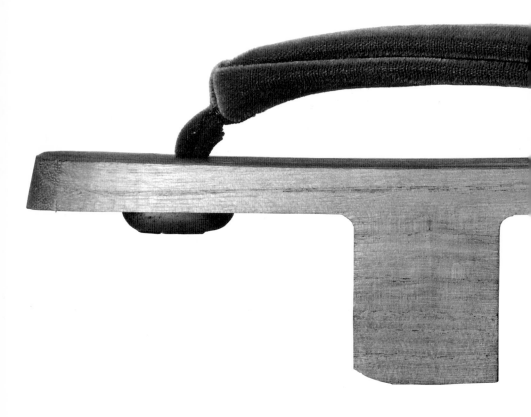

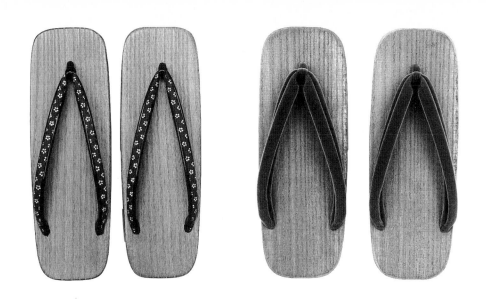

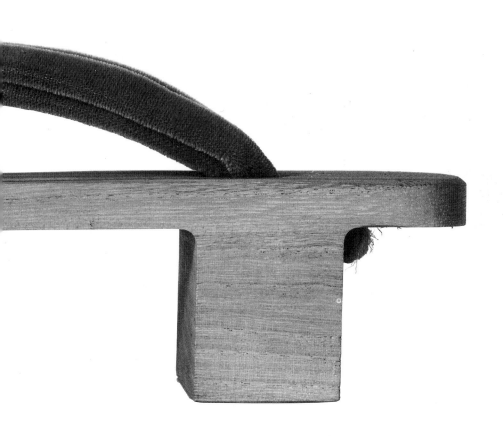

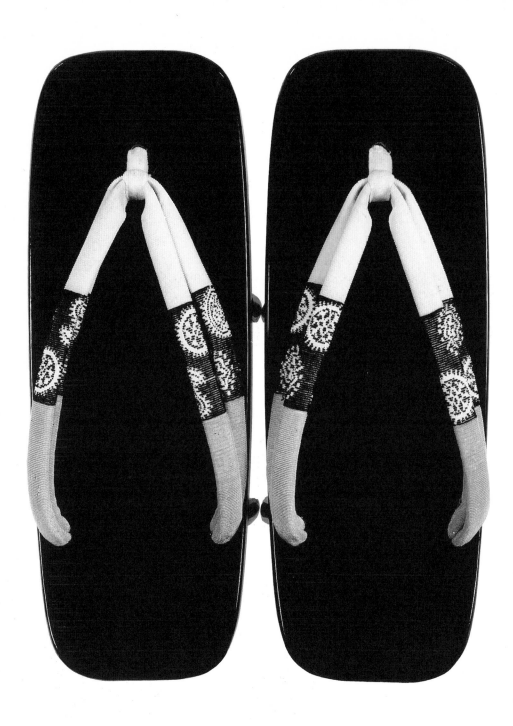

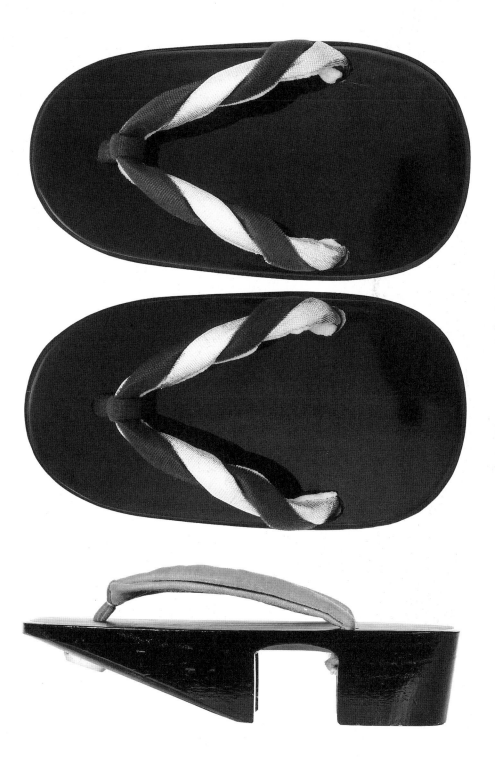

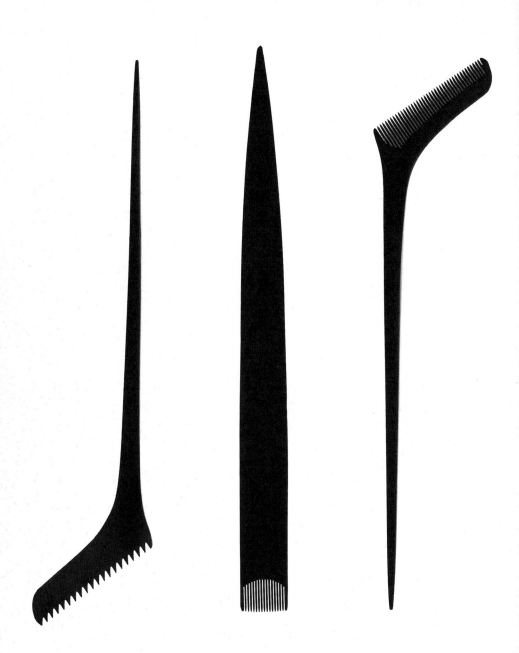

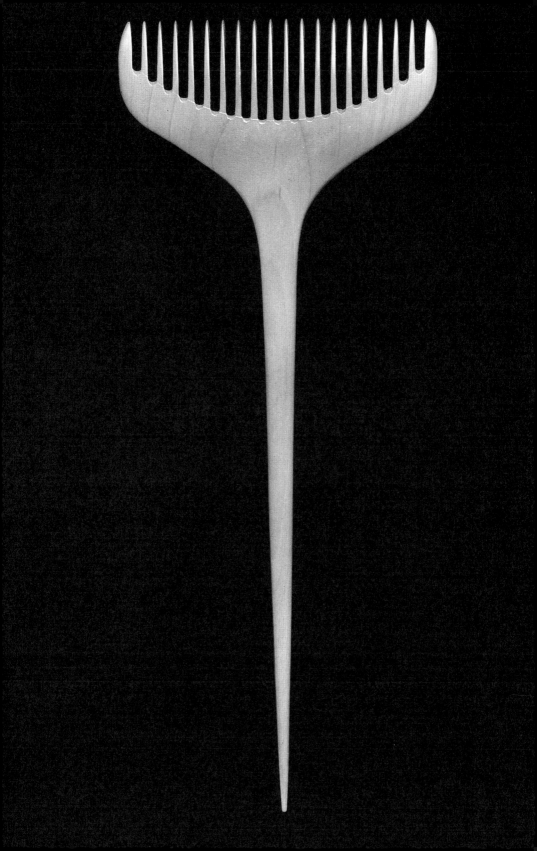

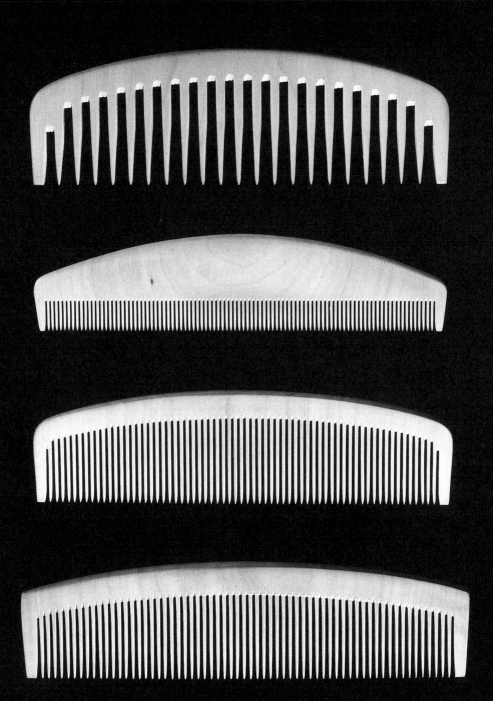

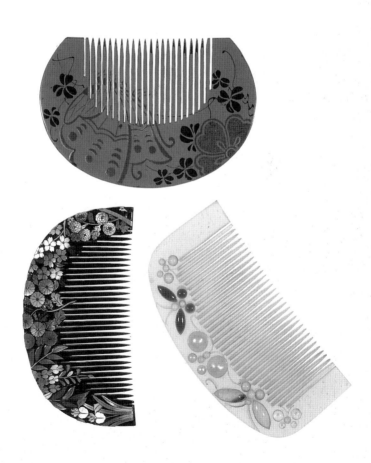

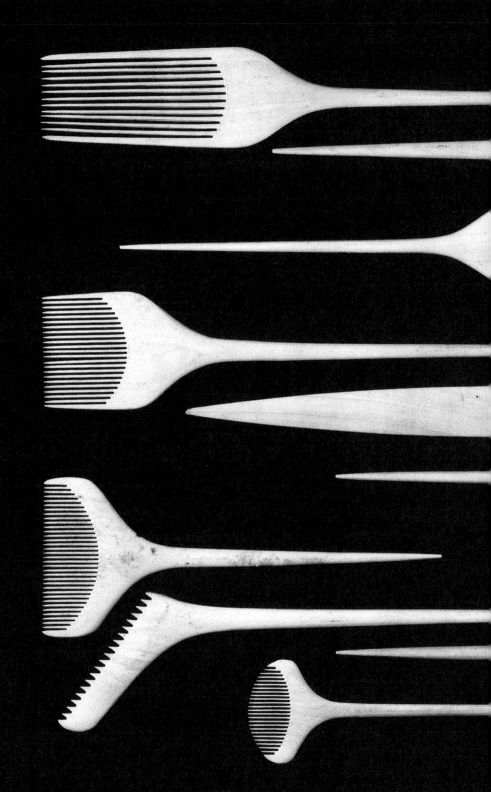

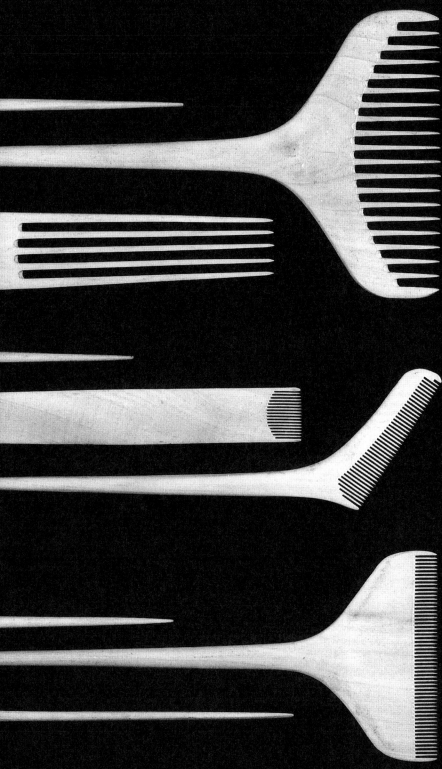

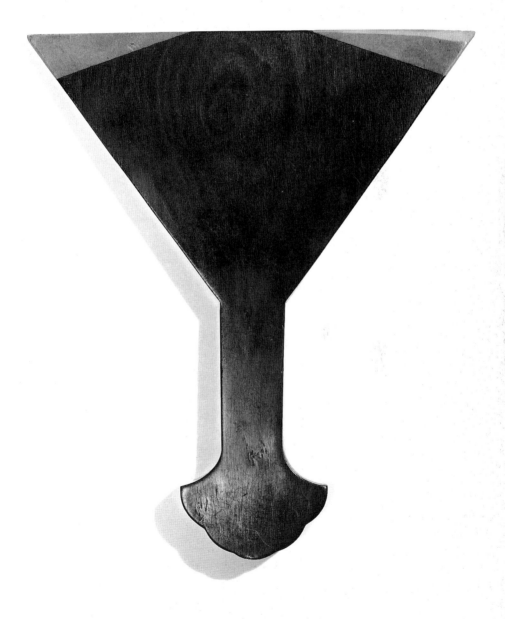

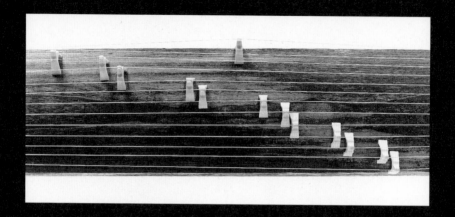

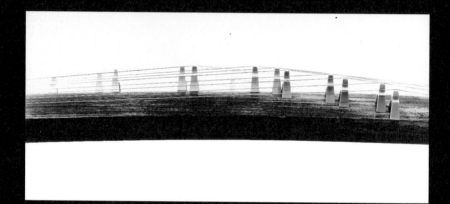

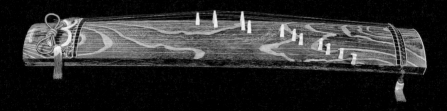

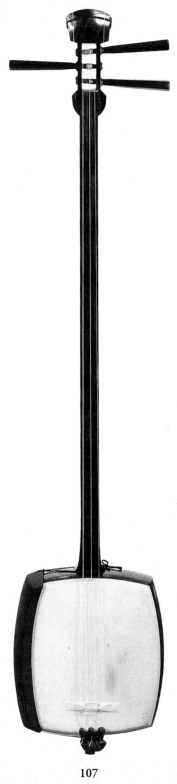

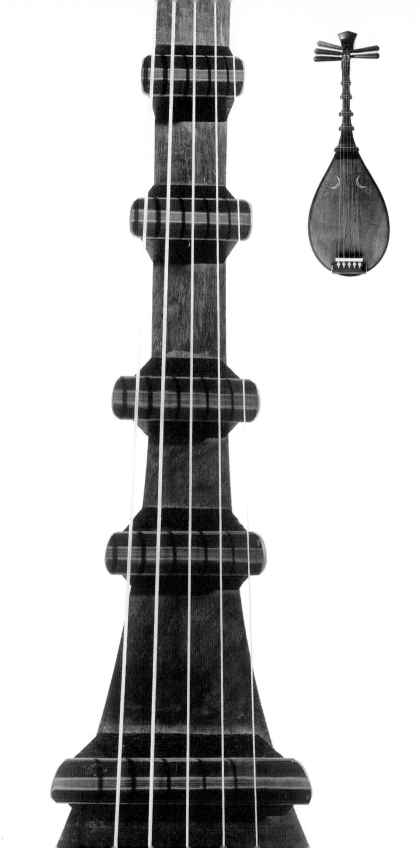

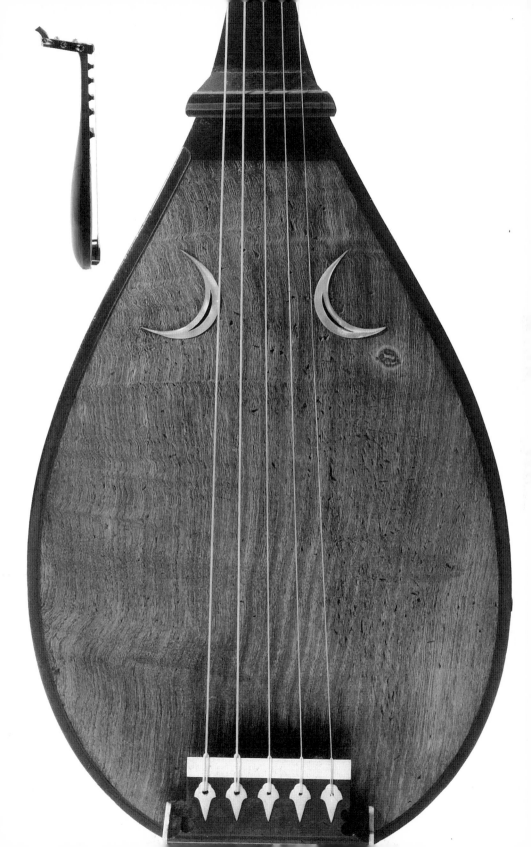

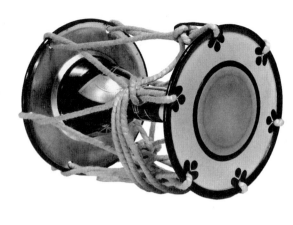

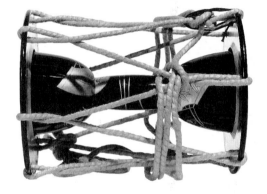

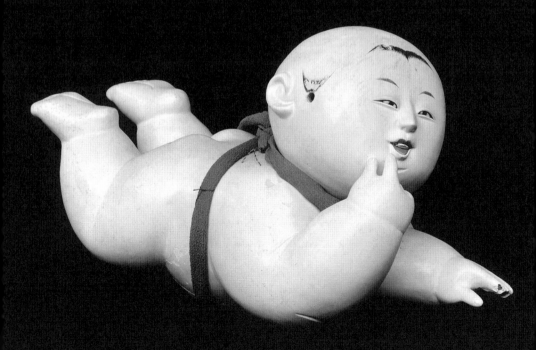

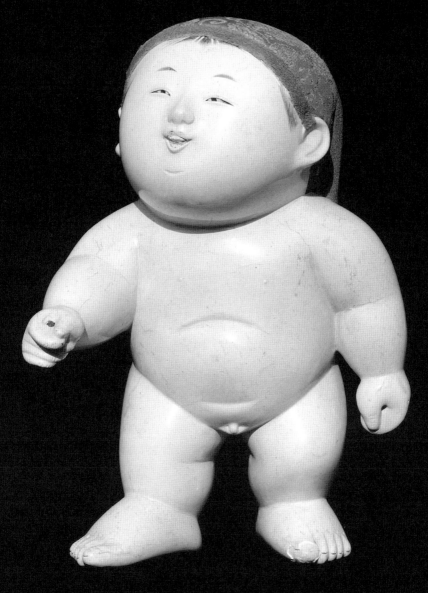

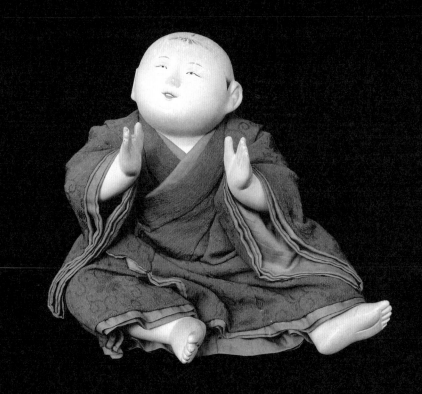

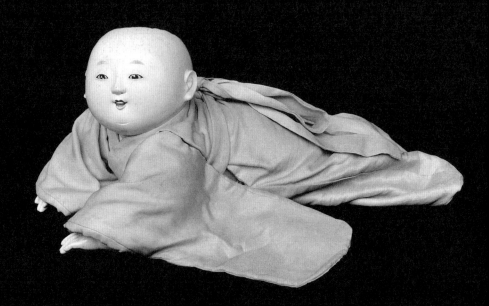

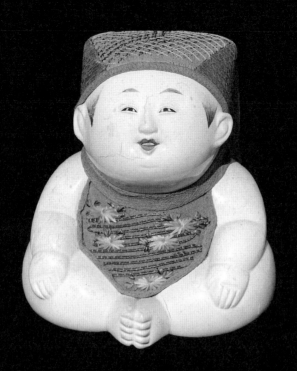

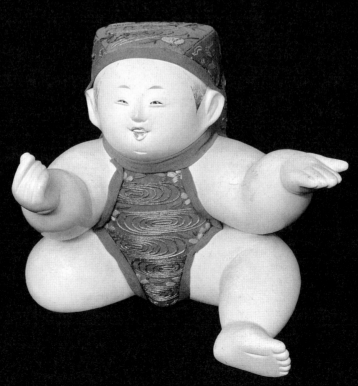

115

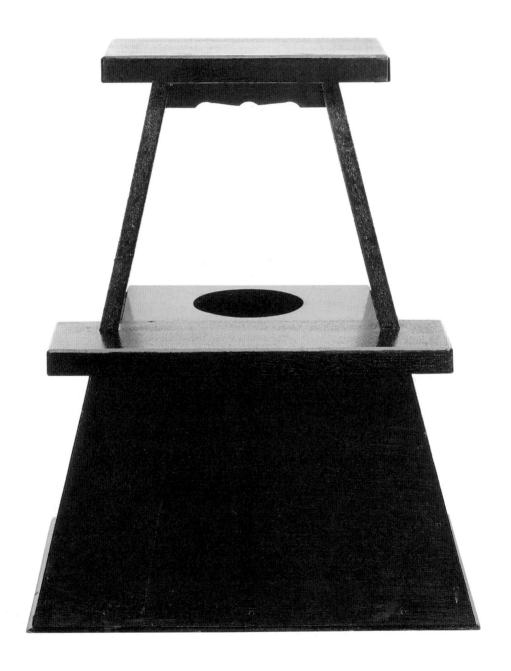

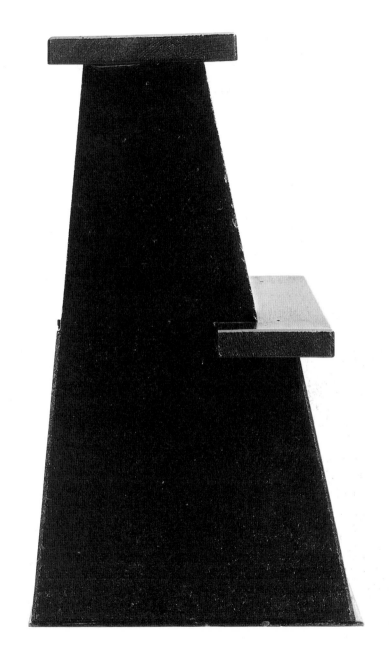

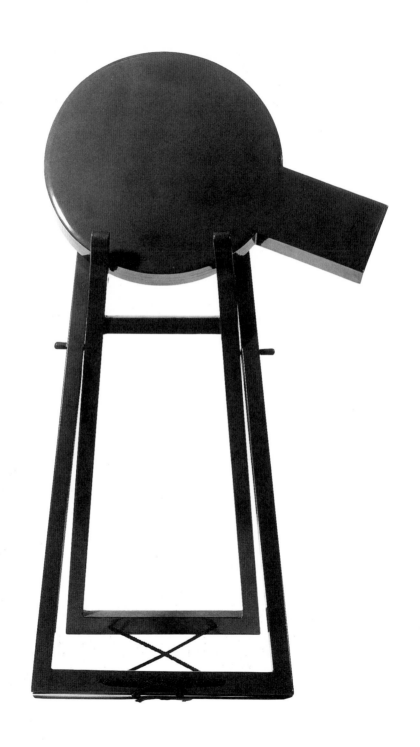

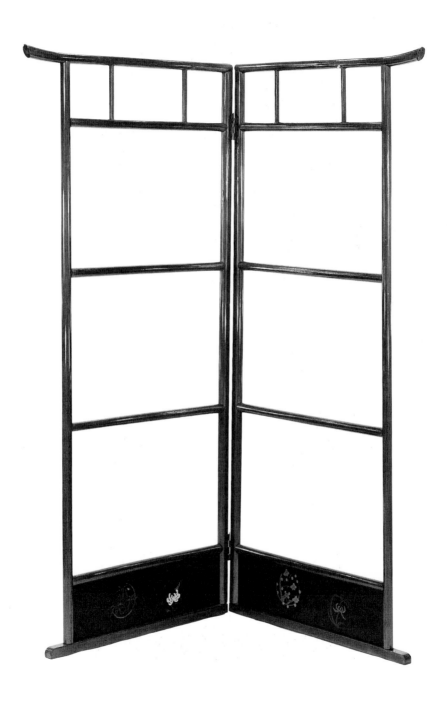

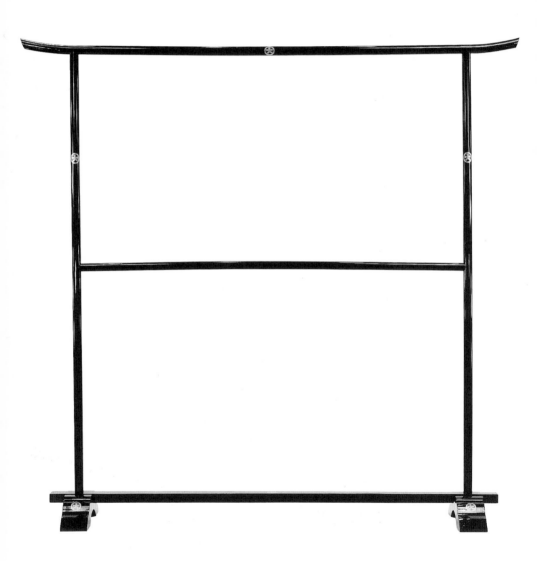

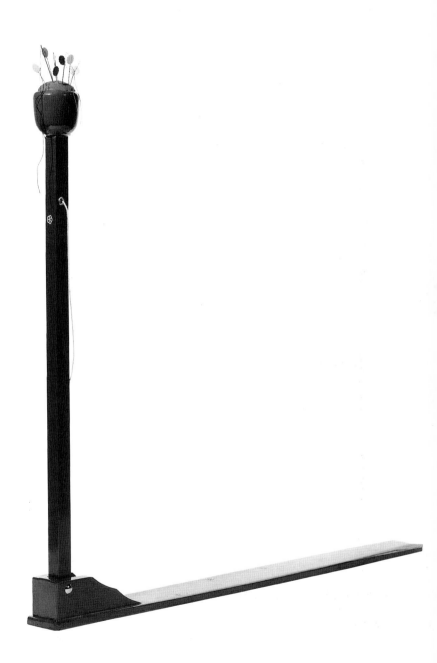

121

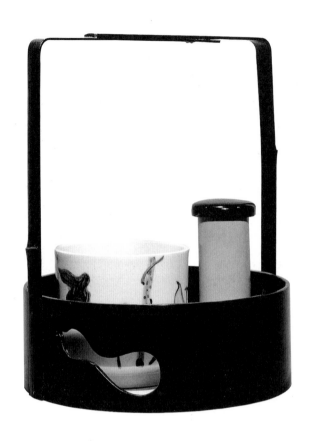

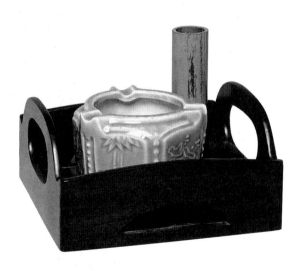

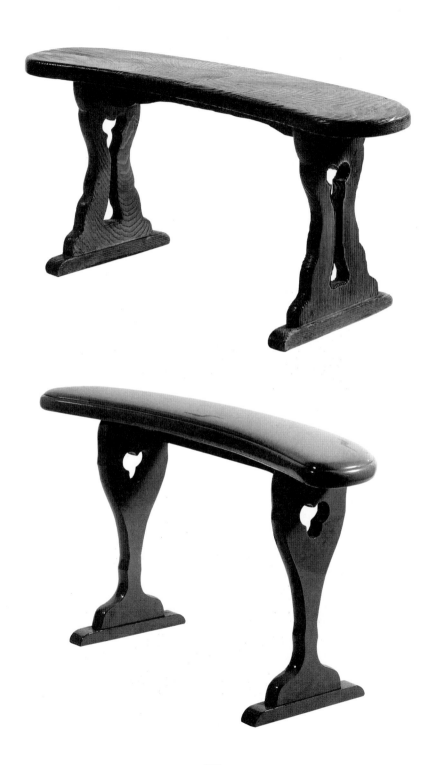

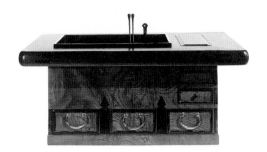

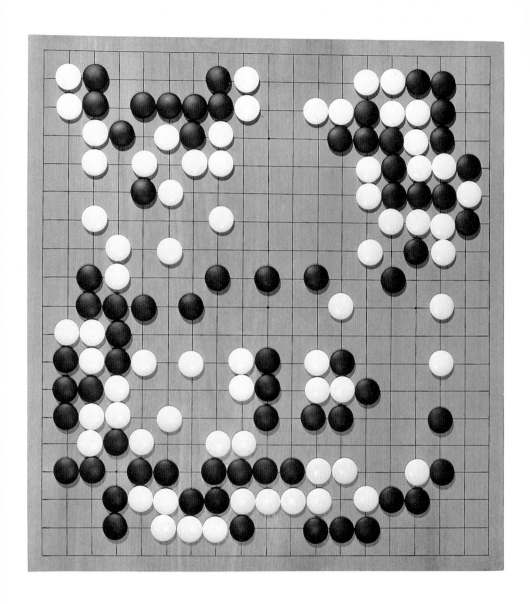

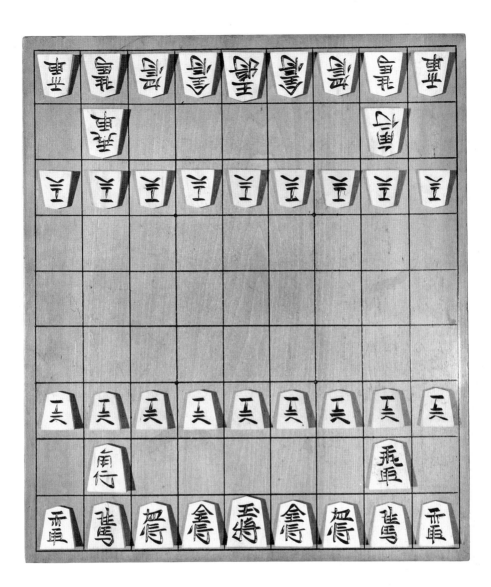

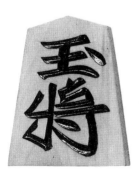

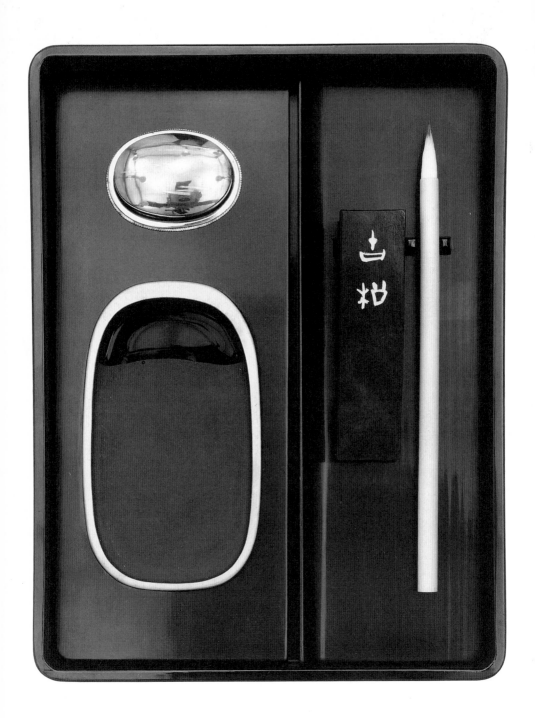

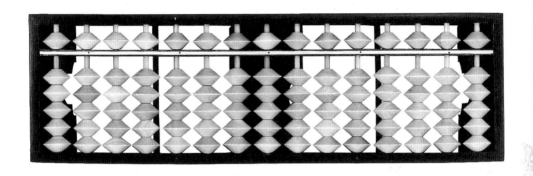

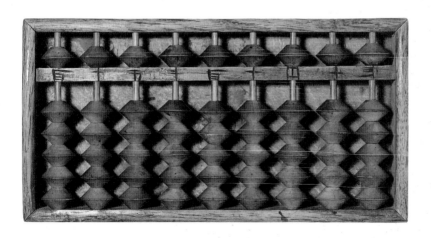

129

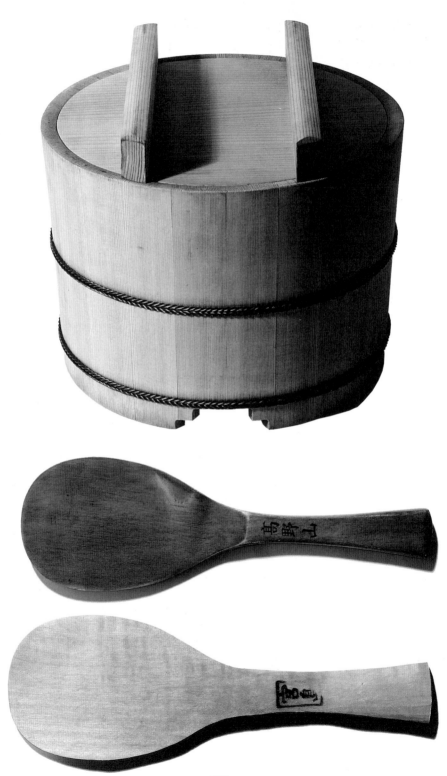

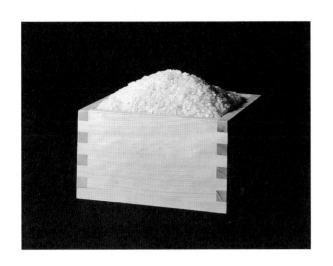

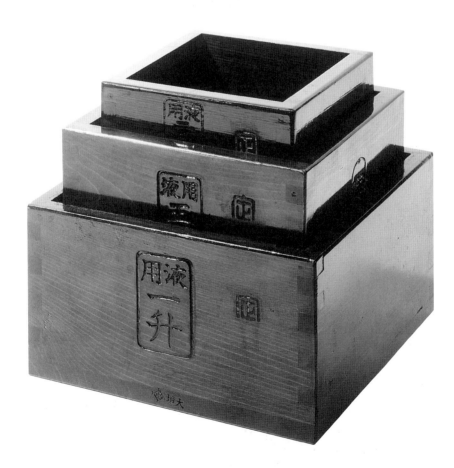

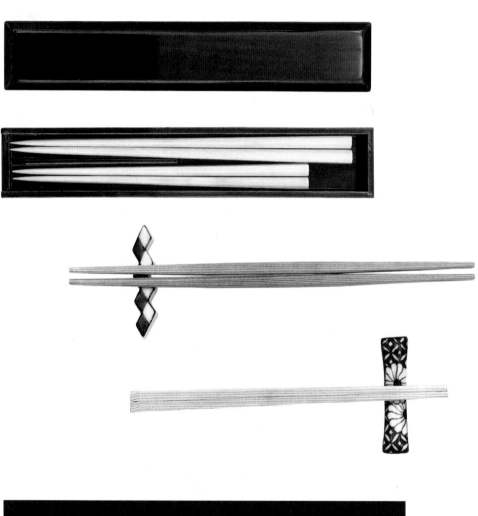

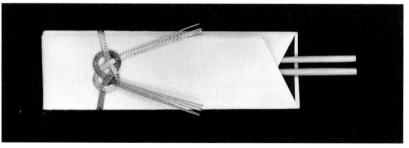

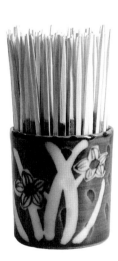

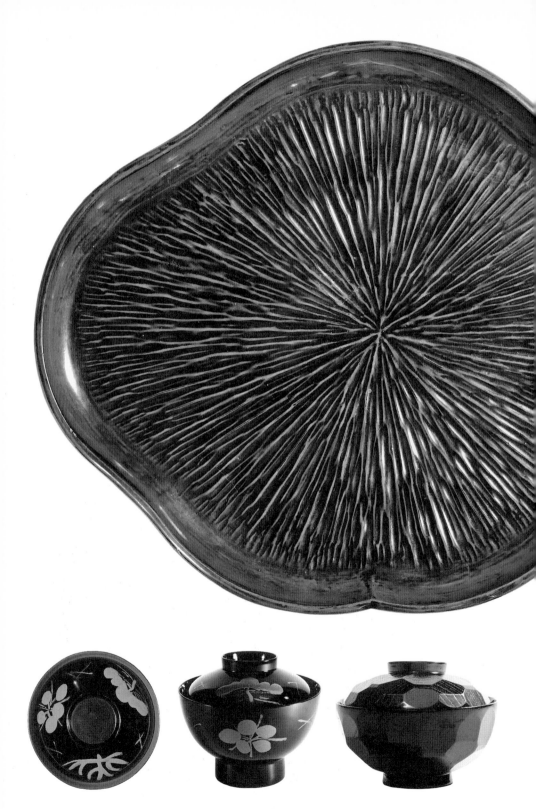

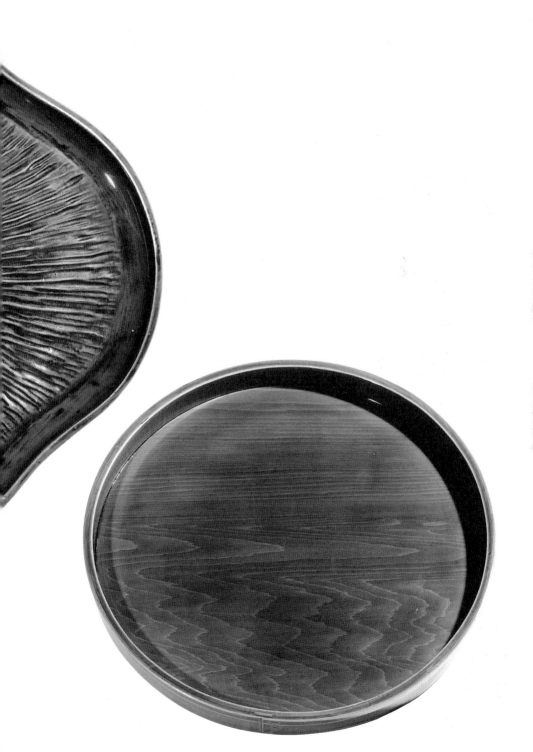

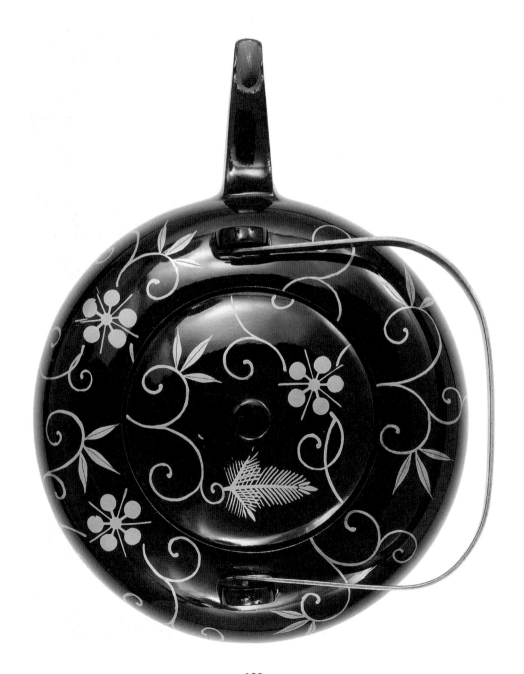

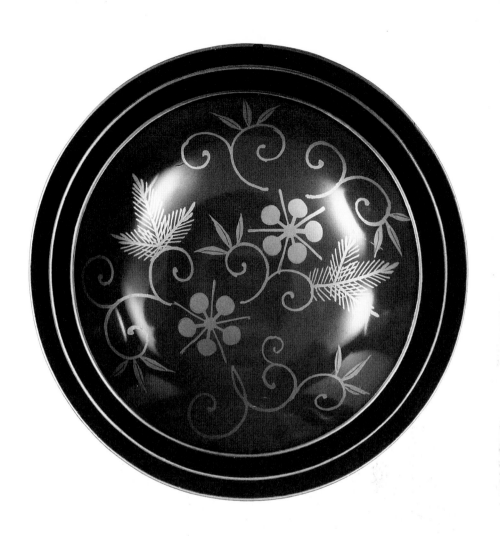

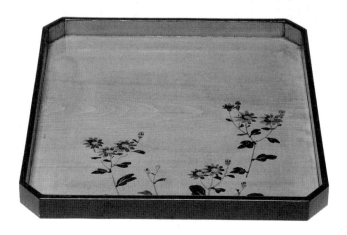

139

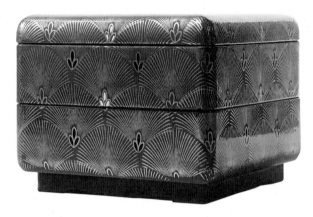

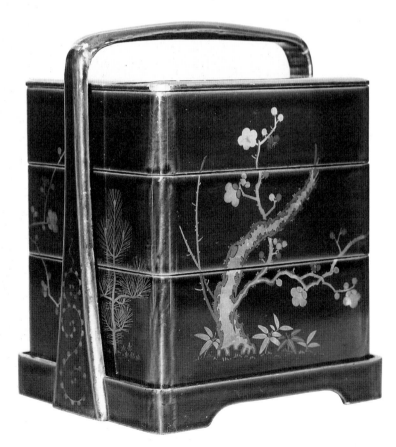

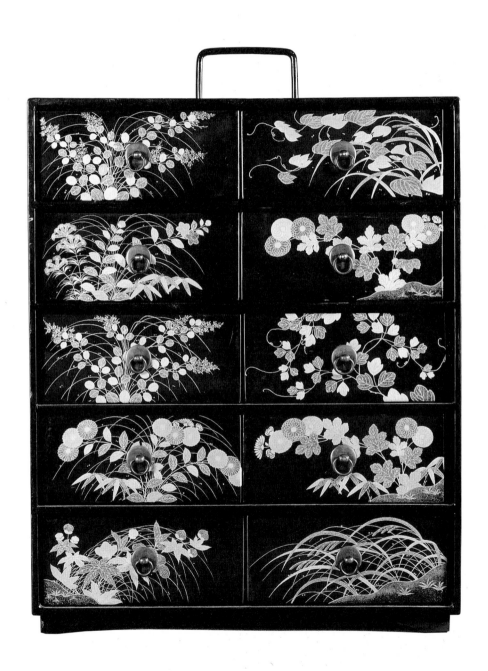

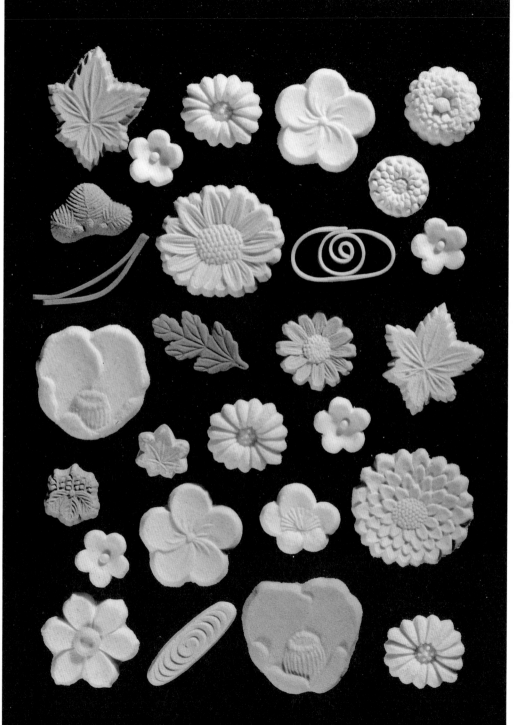

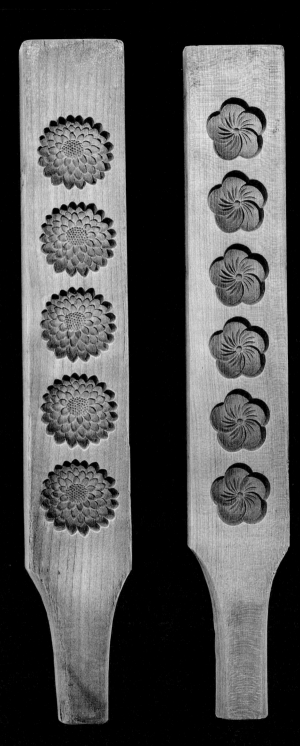

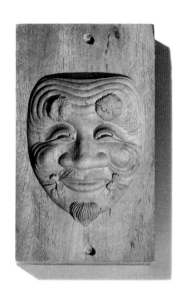

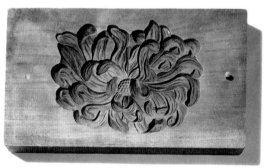

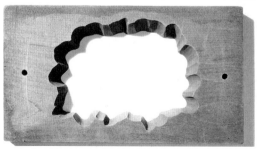

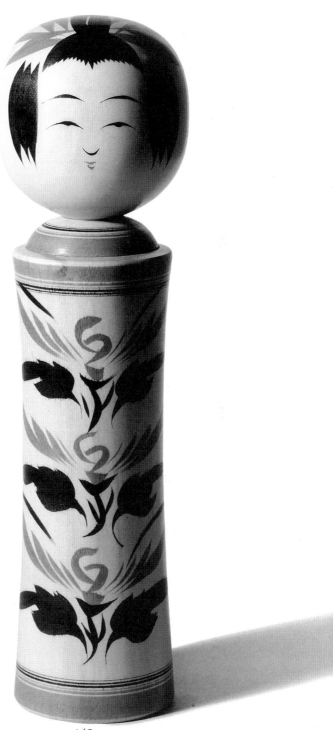

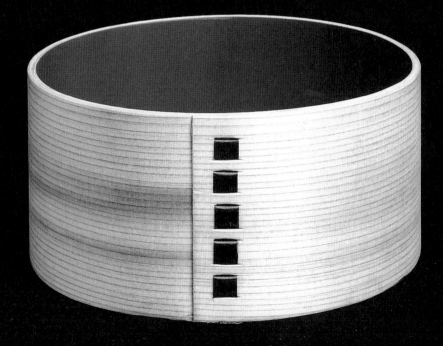

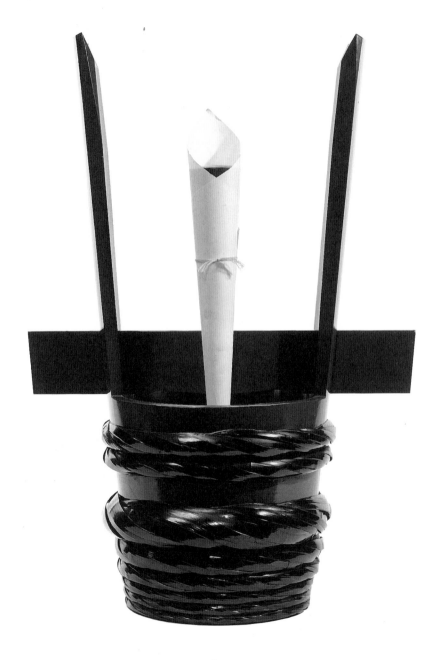

148

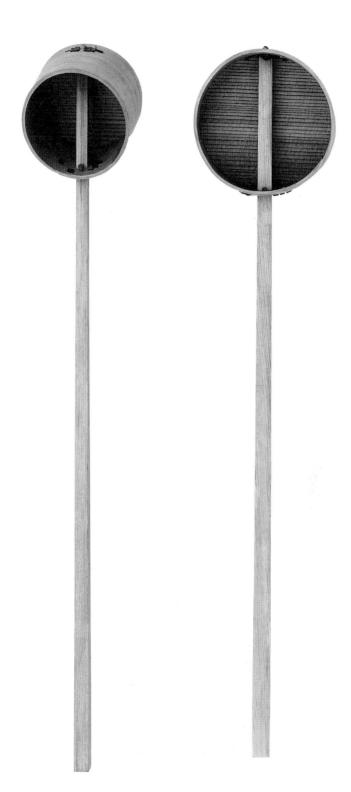

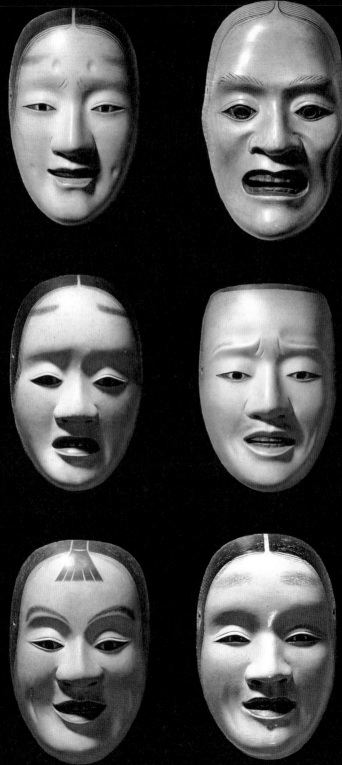

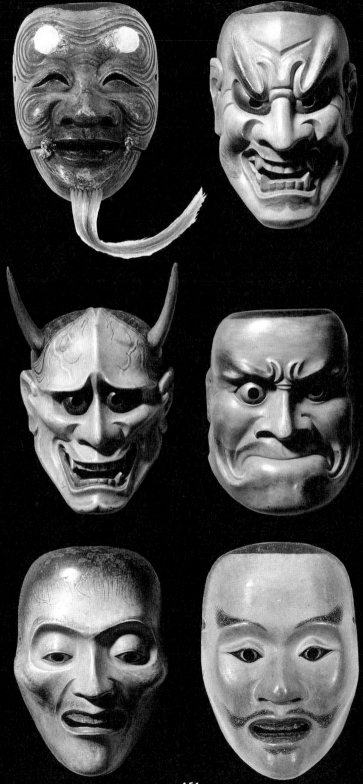

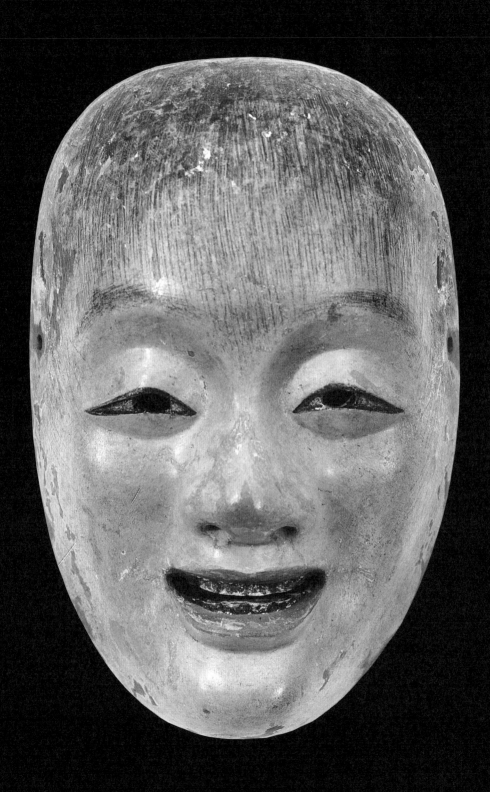

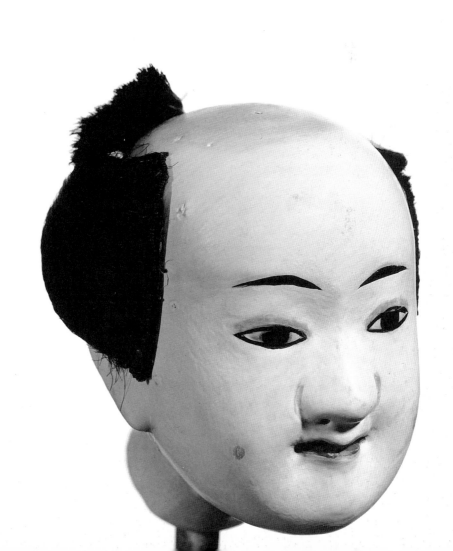

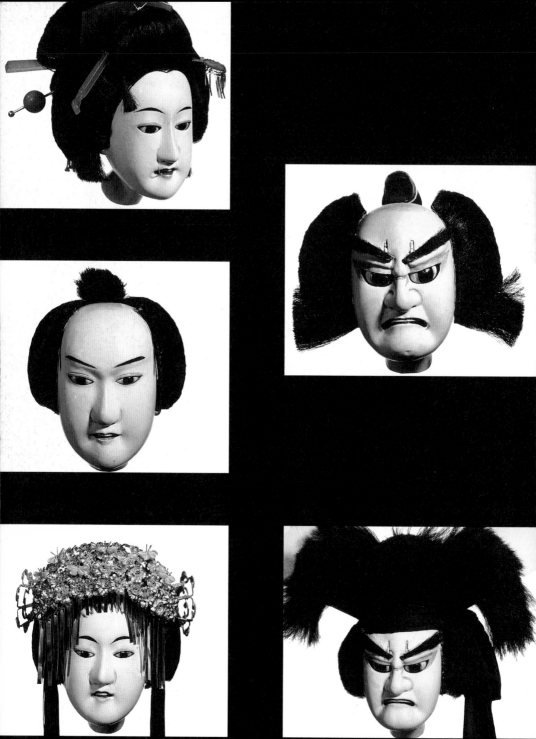

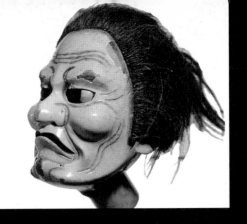

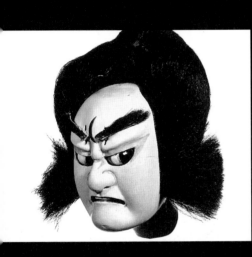

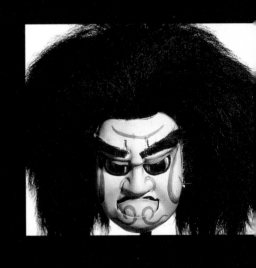

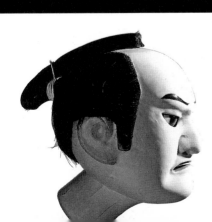

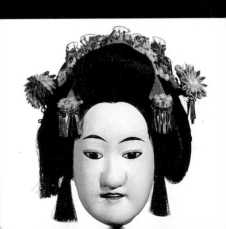

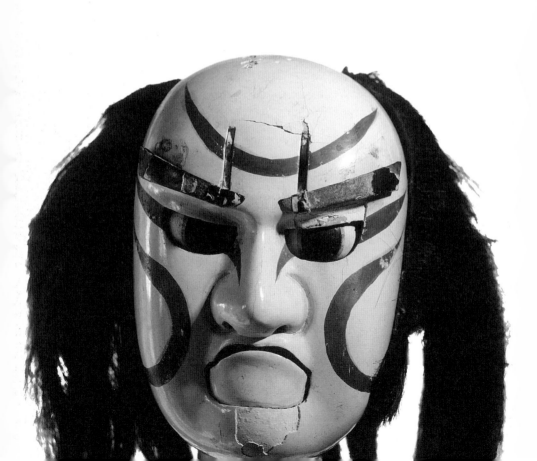

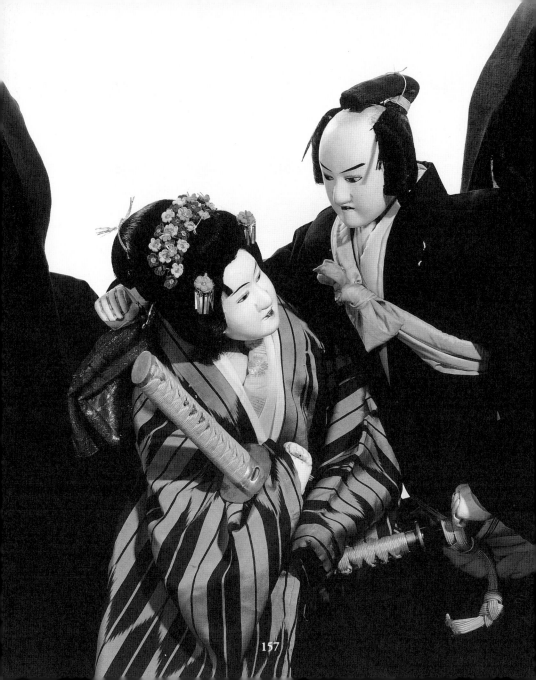

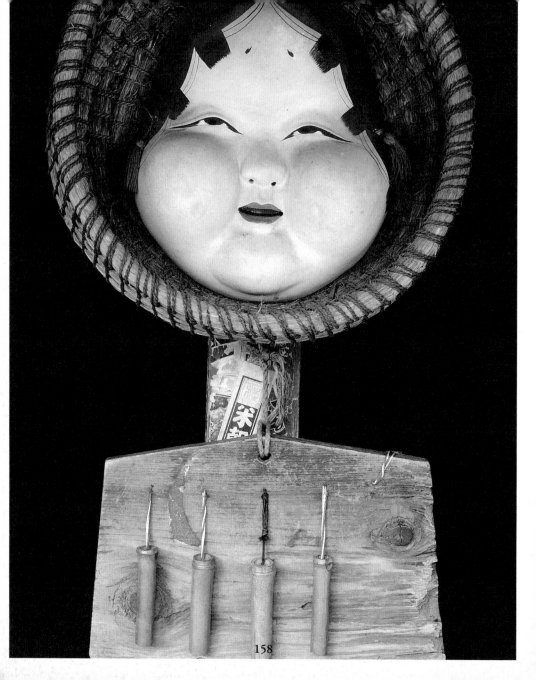

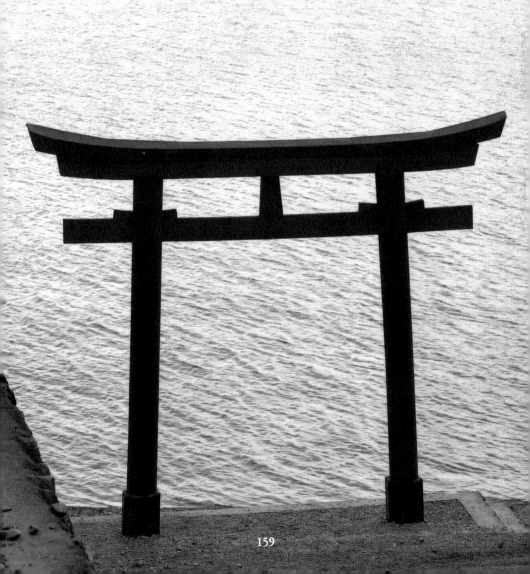

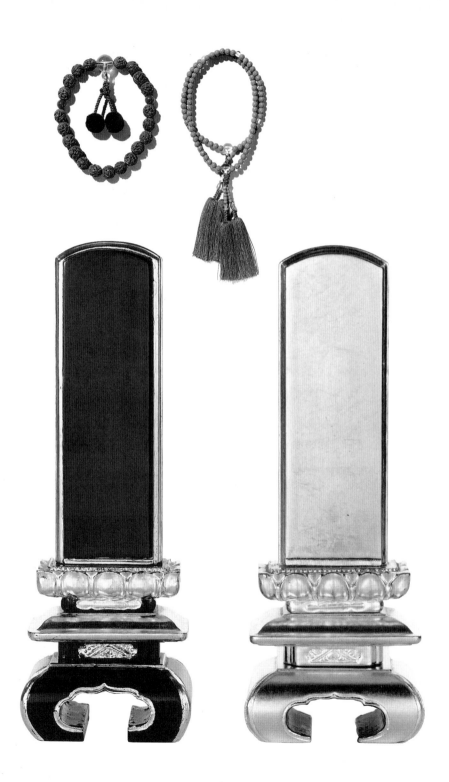

Bamboo

竹

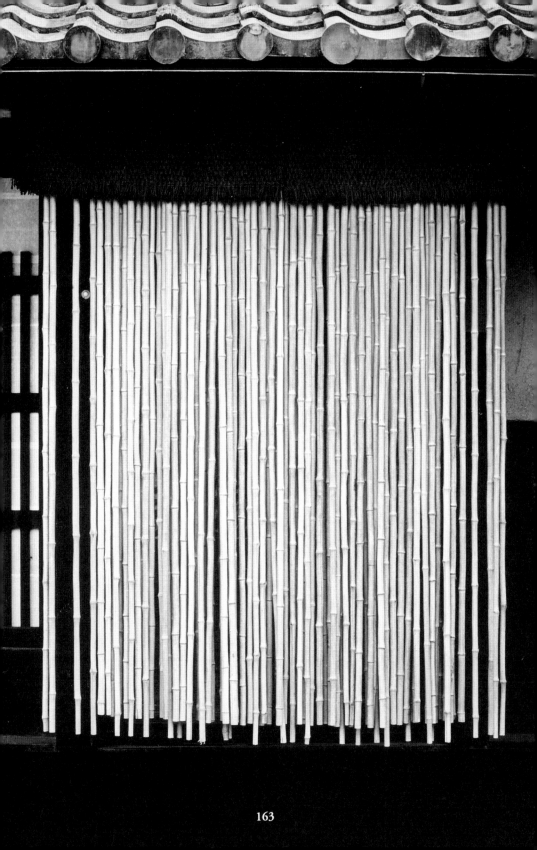

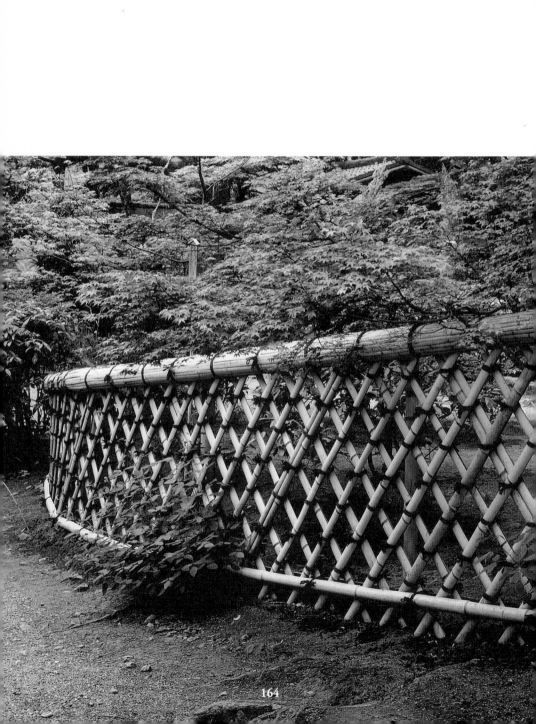

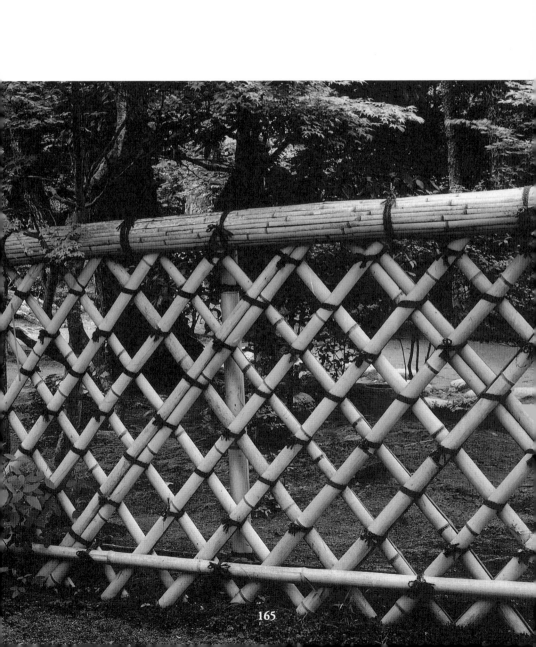

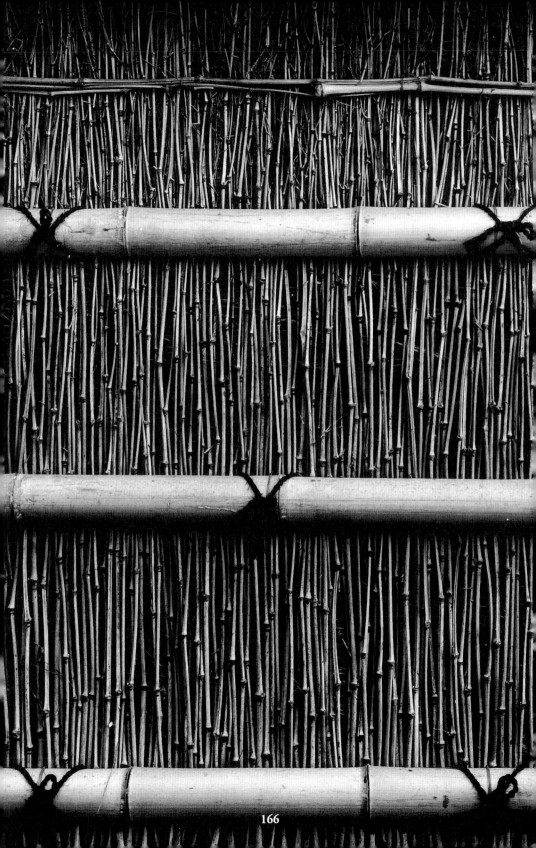

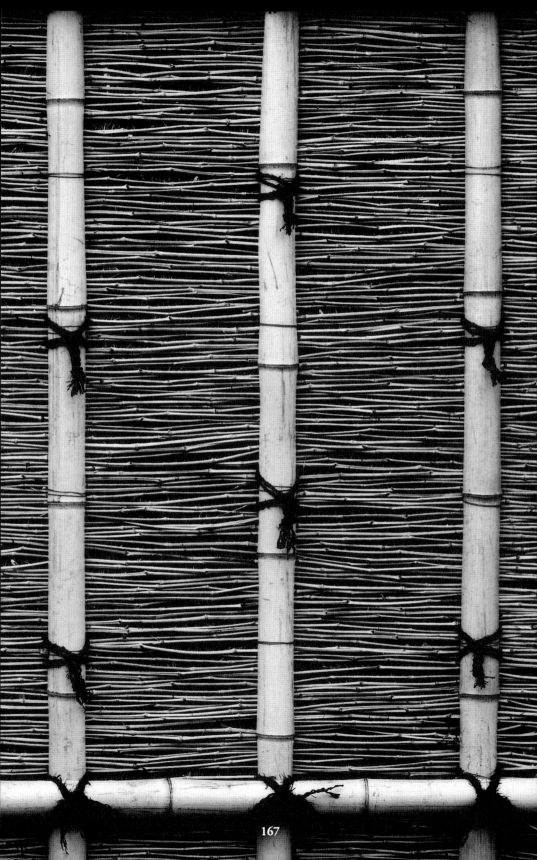

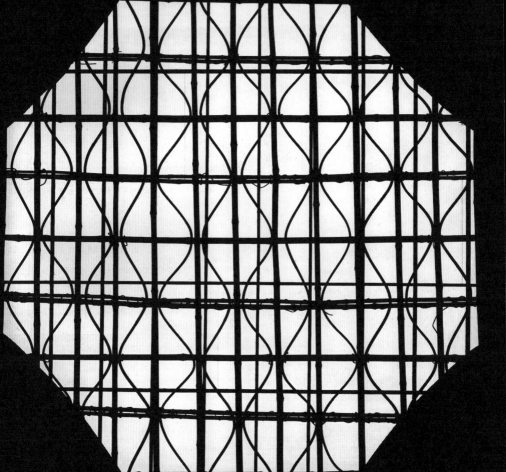

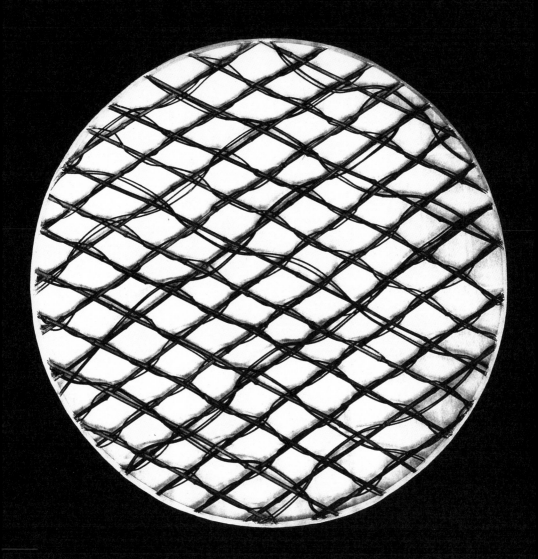

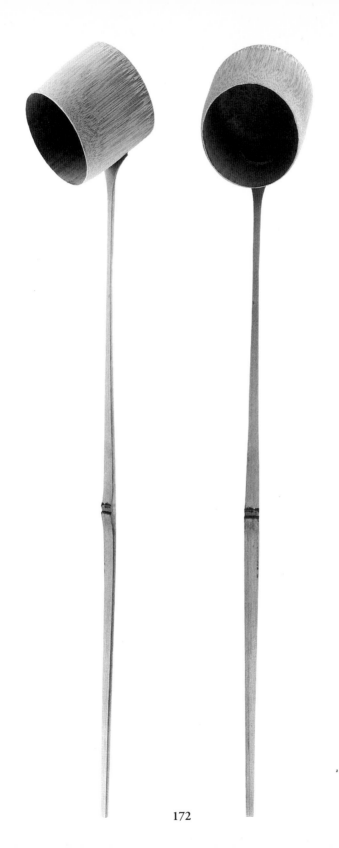

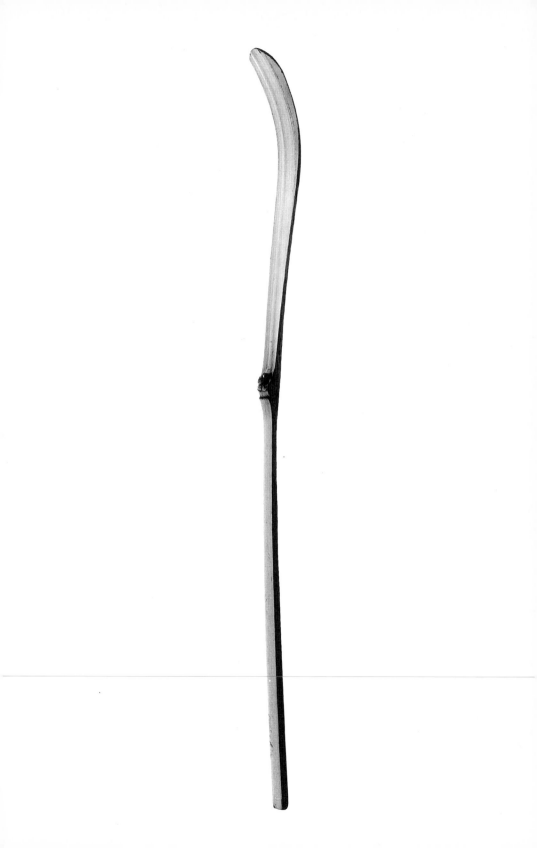

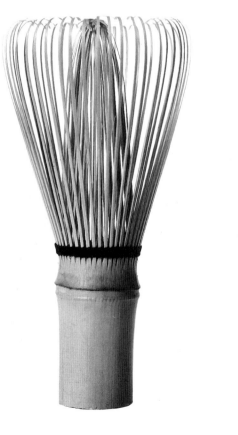
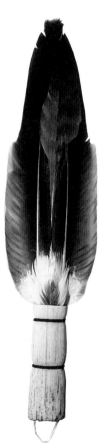

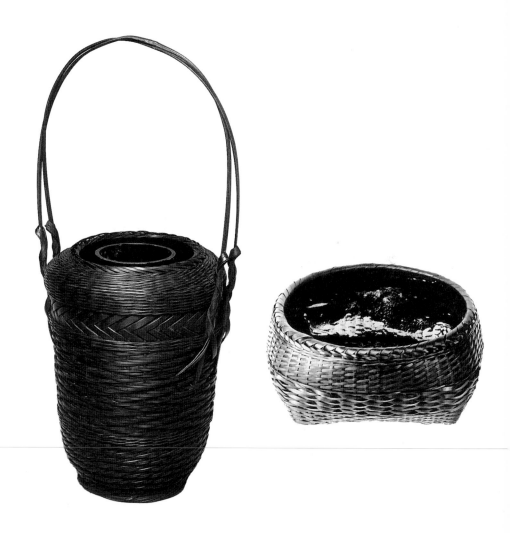

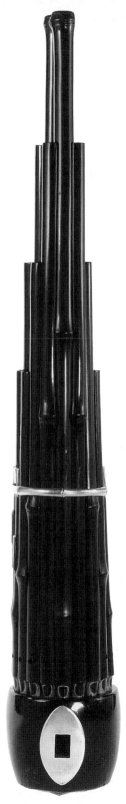
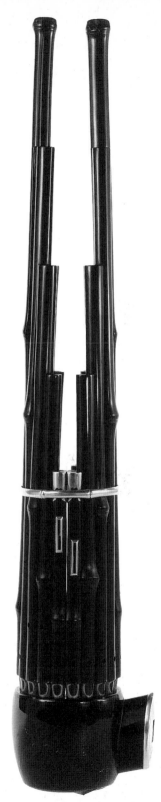

177

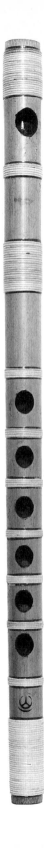
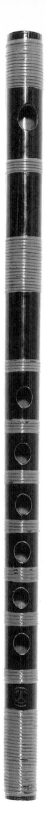

178

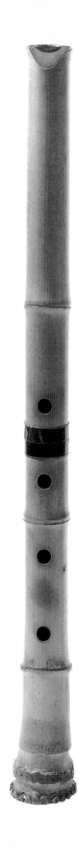
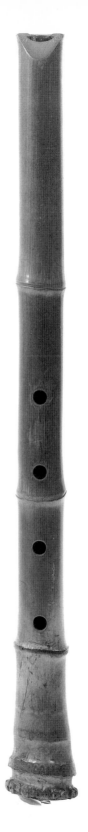

179

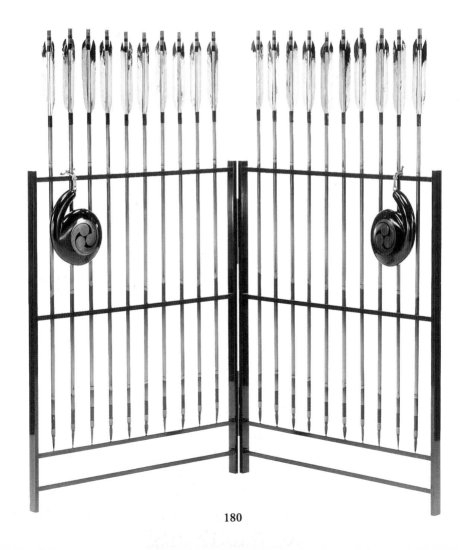

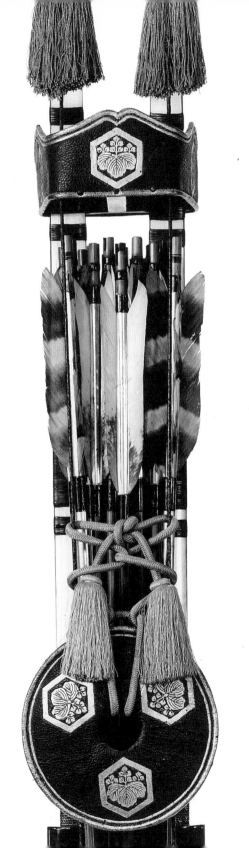
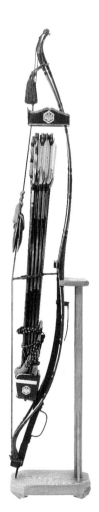

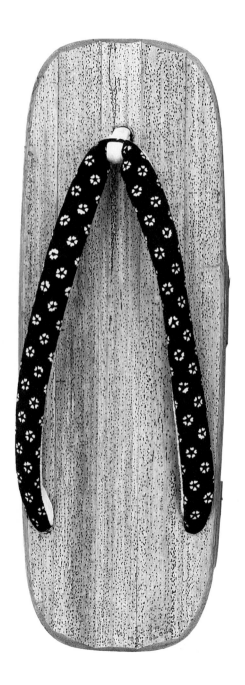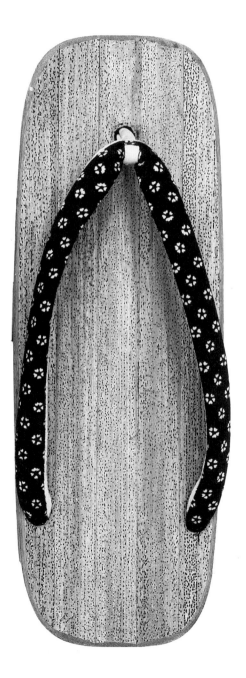

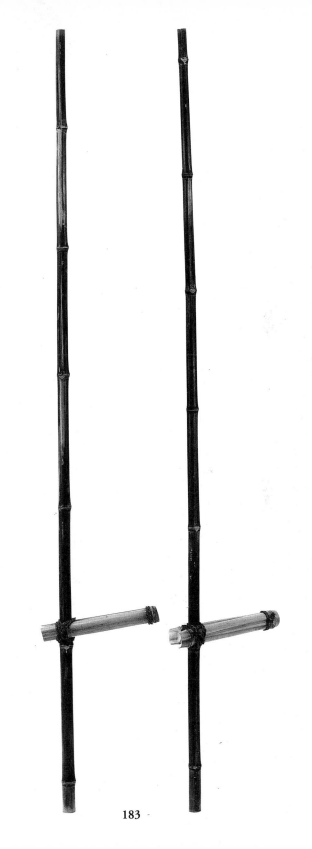

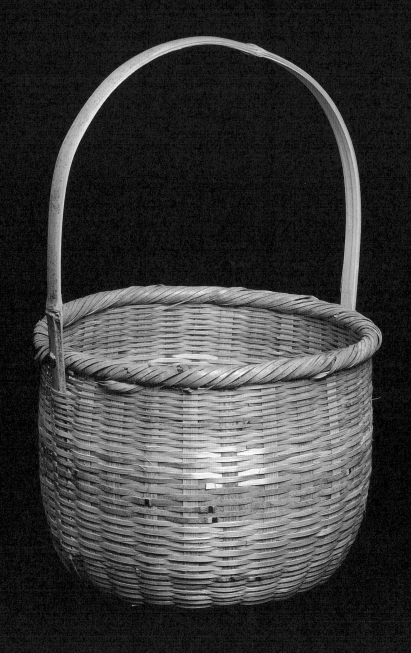

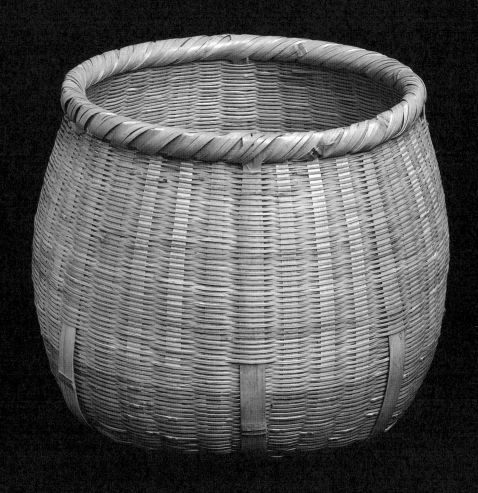

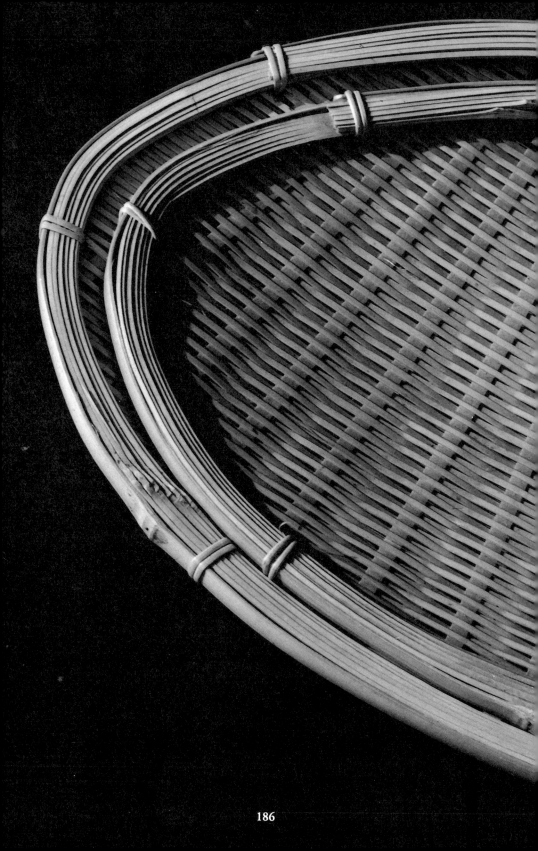

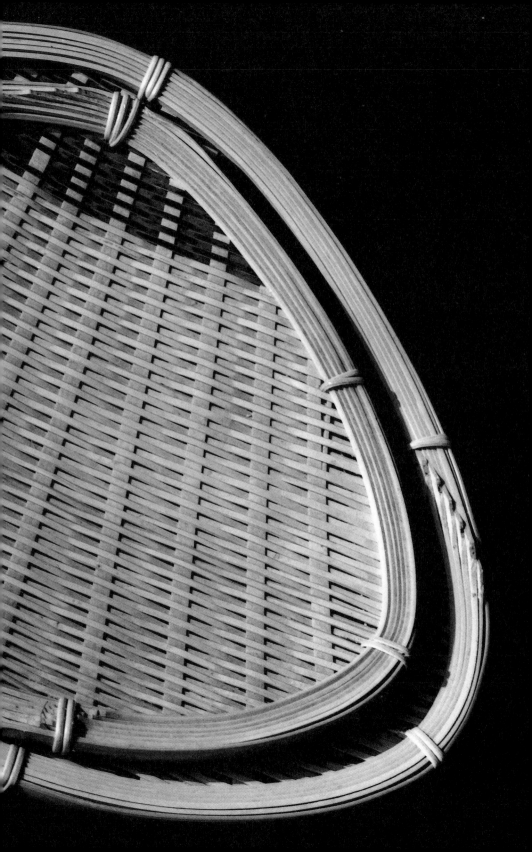

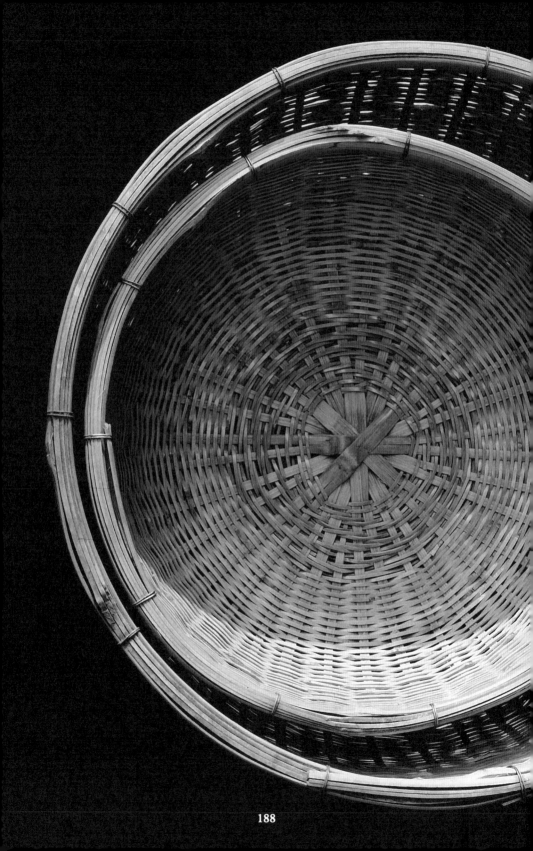

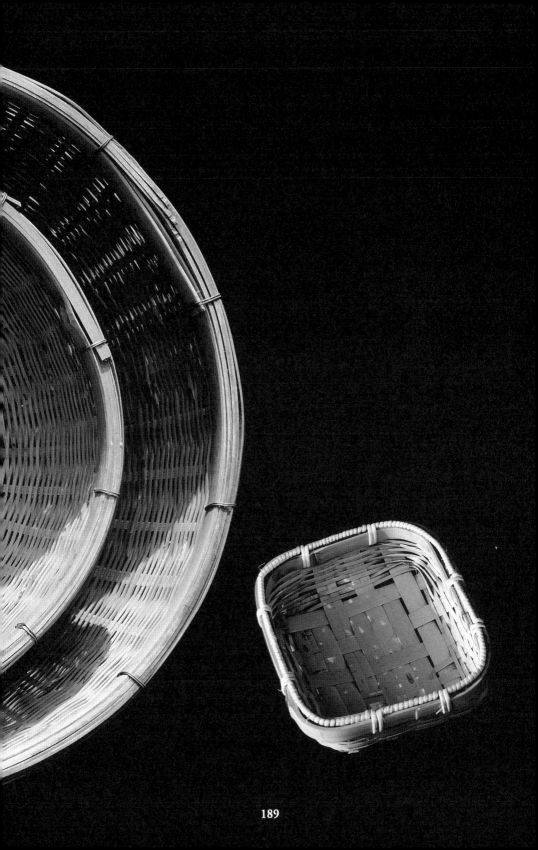

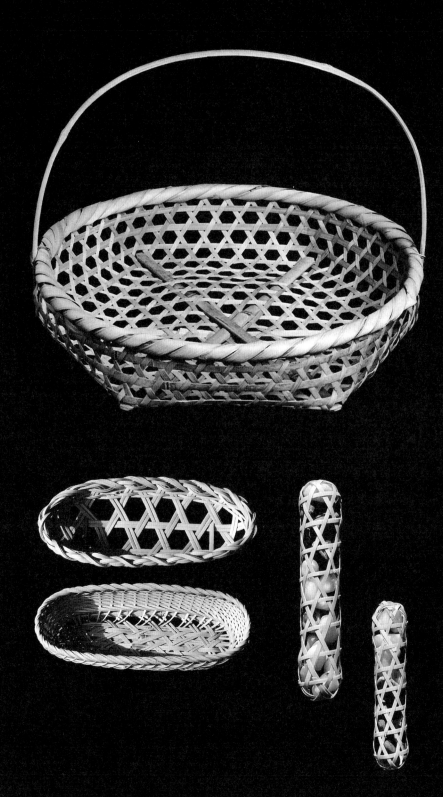

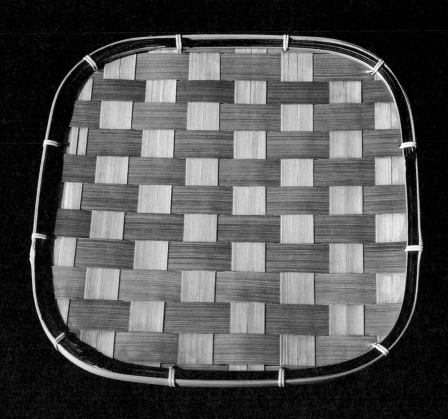

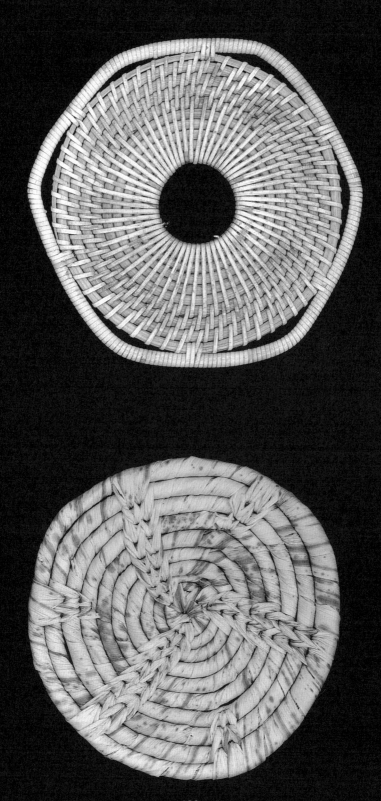

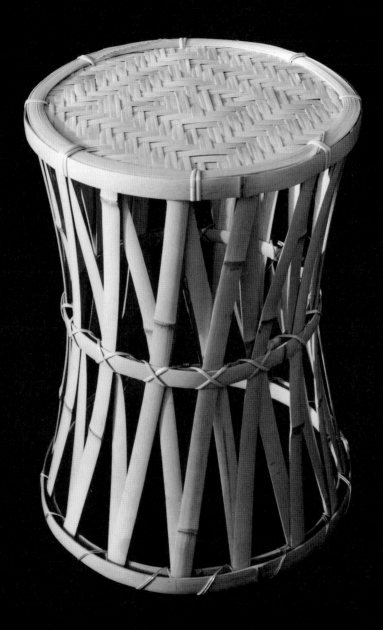

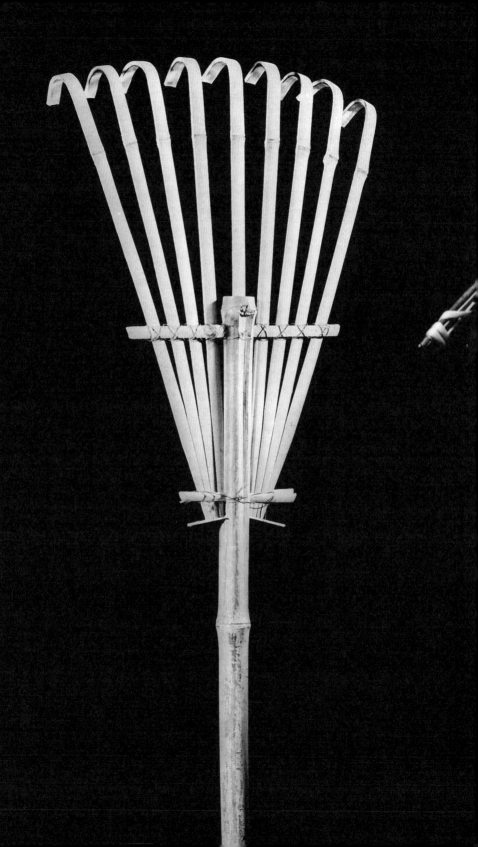

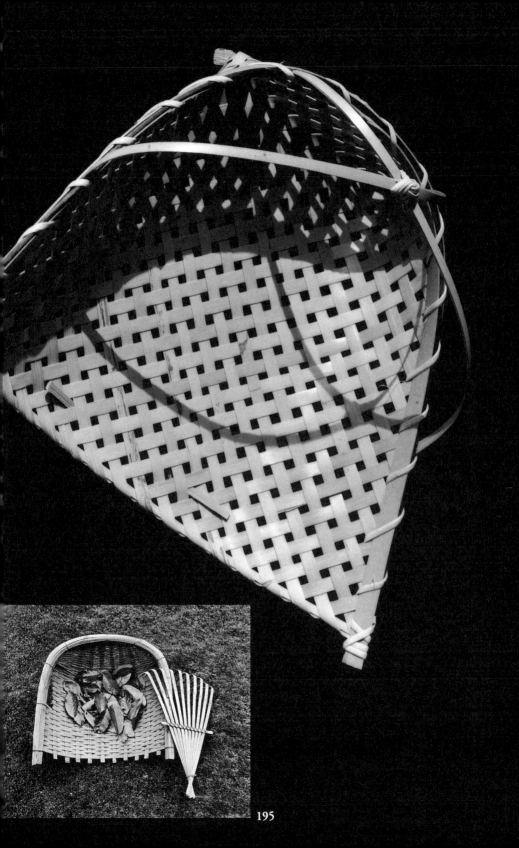

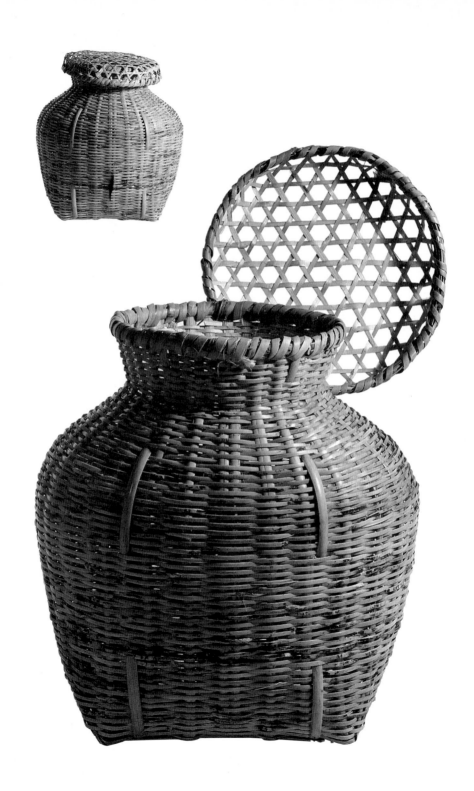

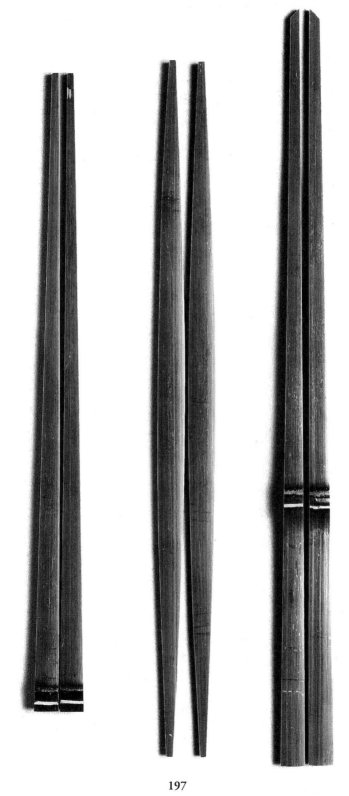

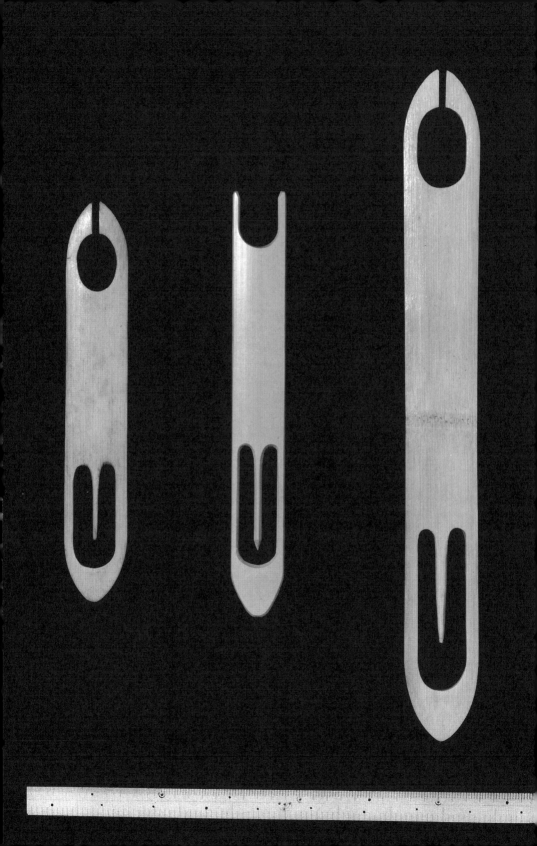

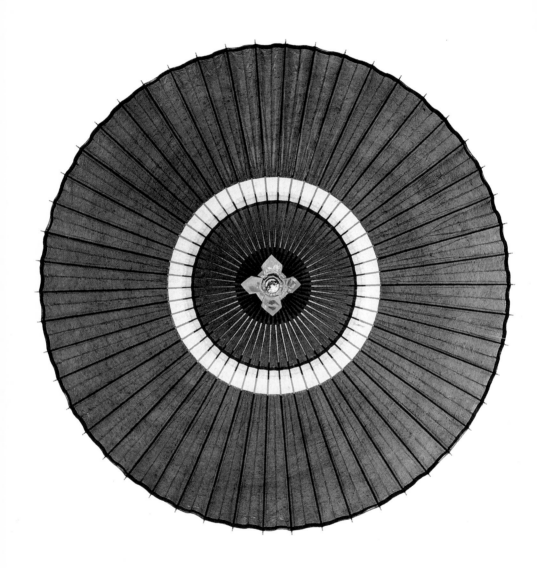

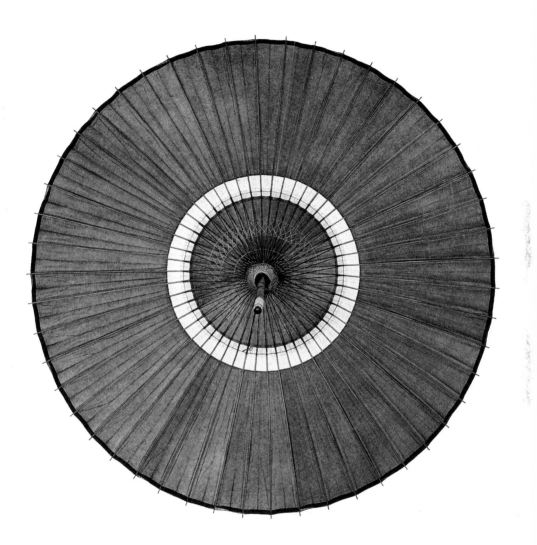

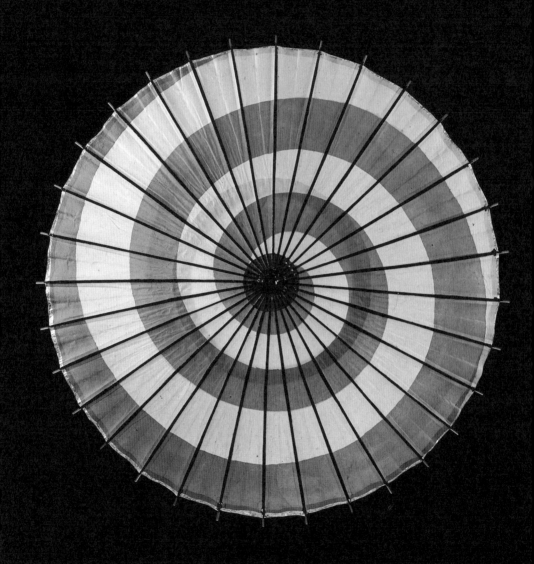

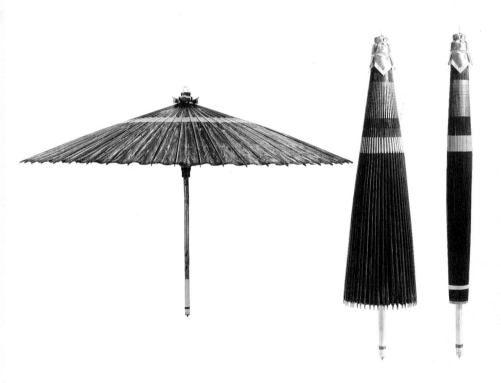

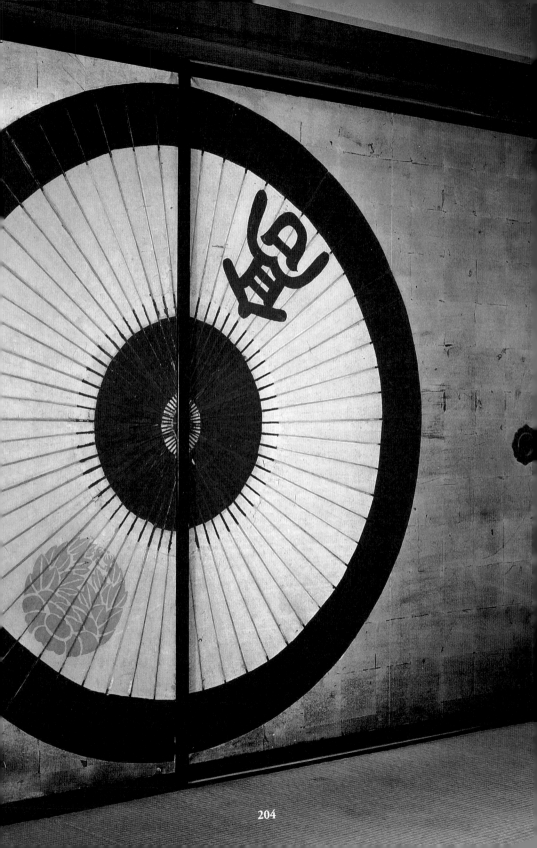

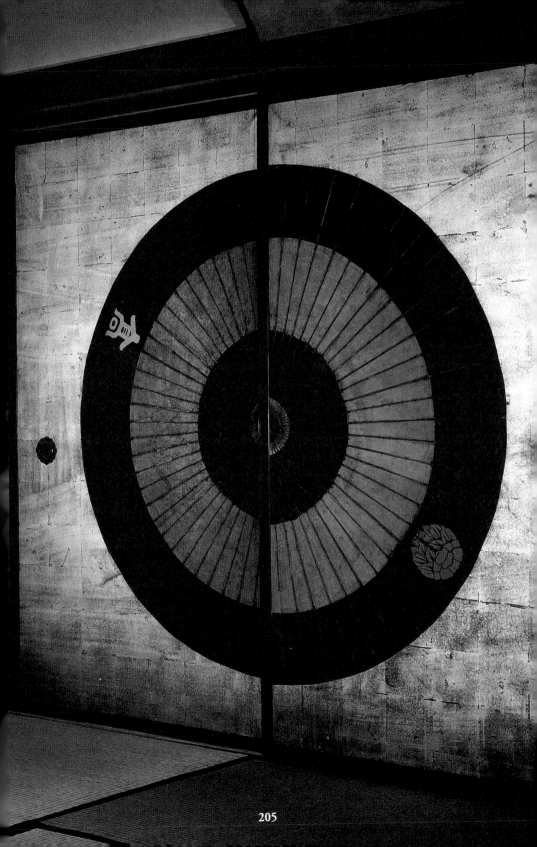

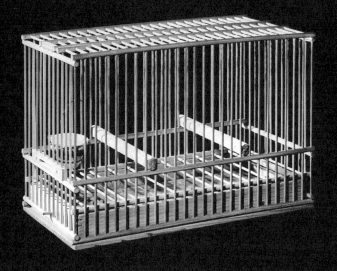

Fiber

繊

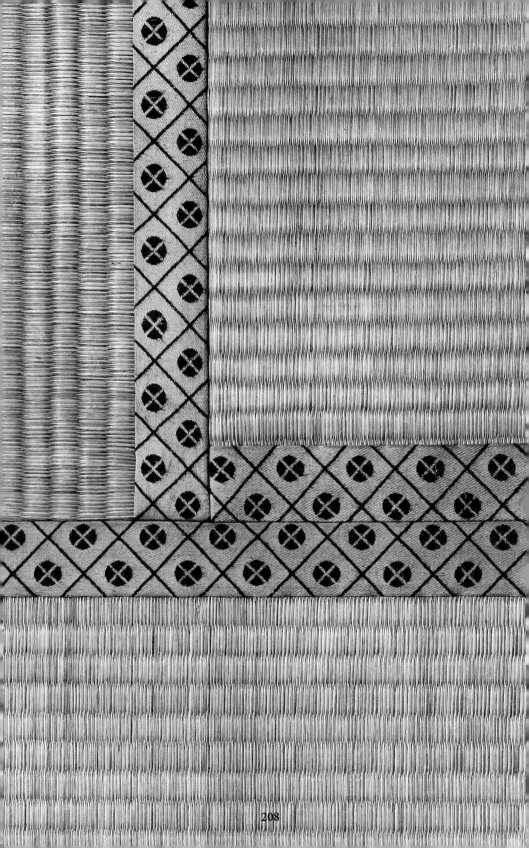

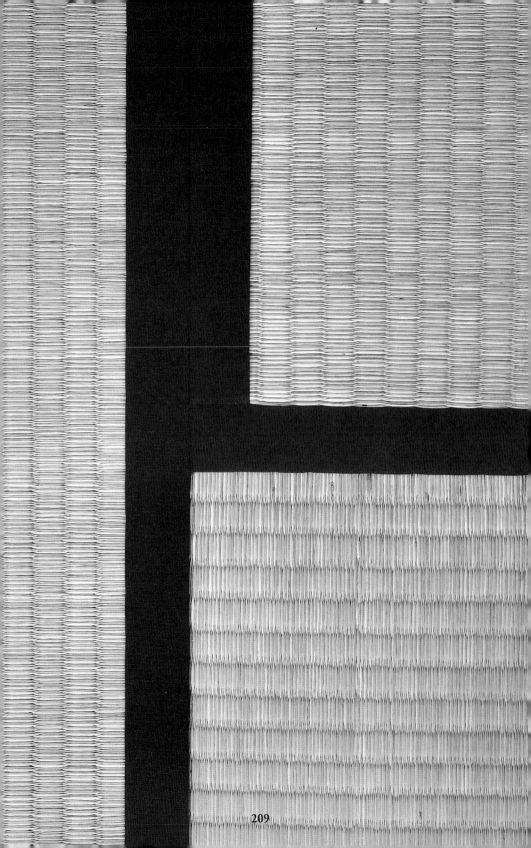

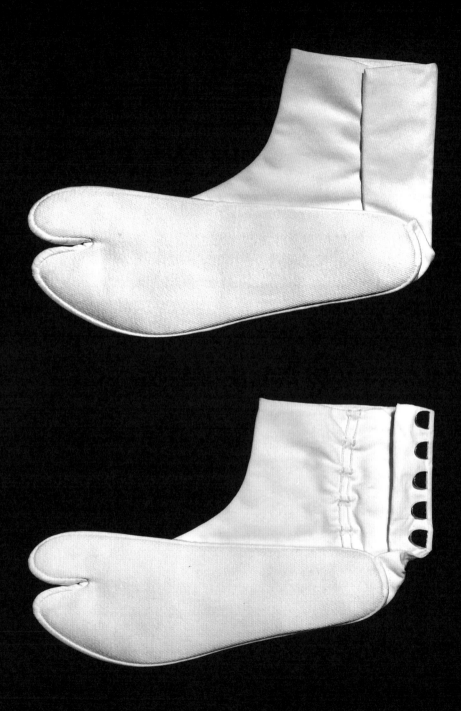

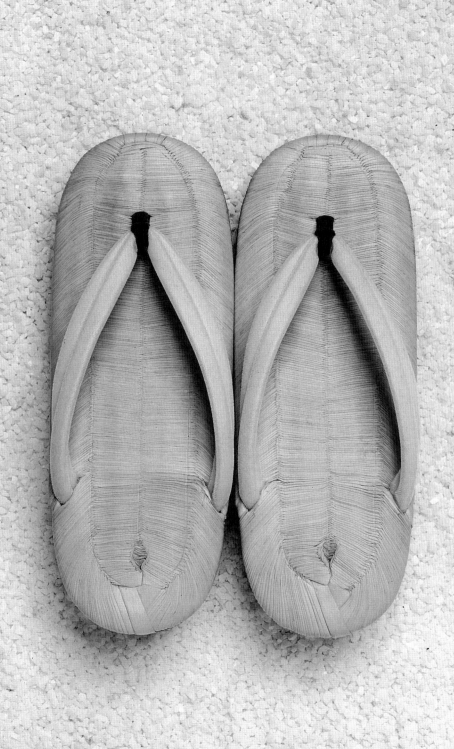

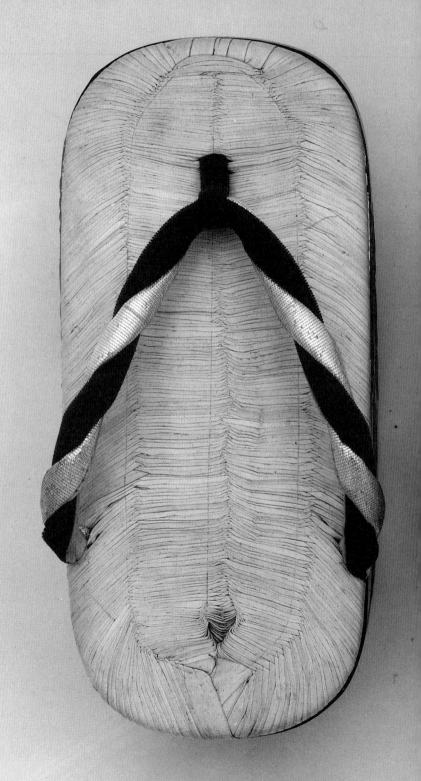

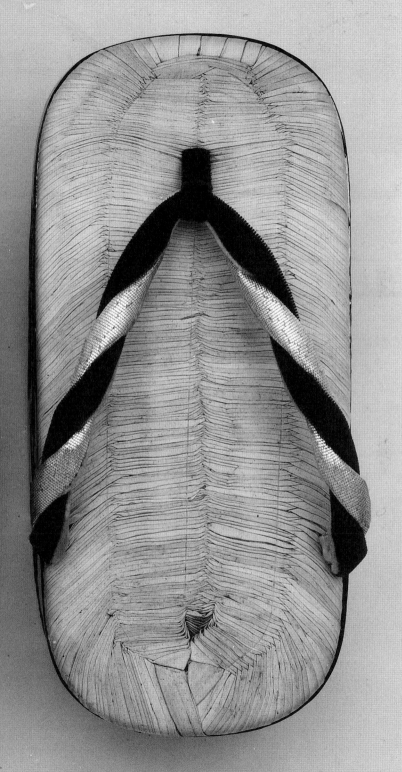

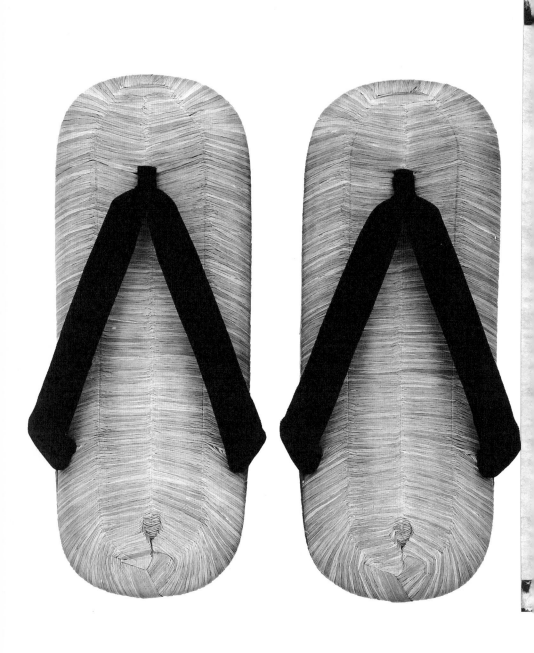

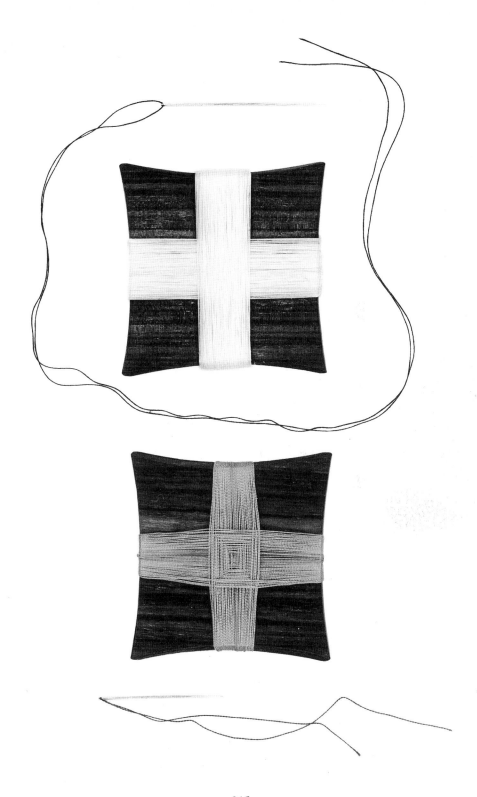

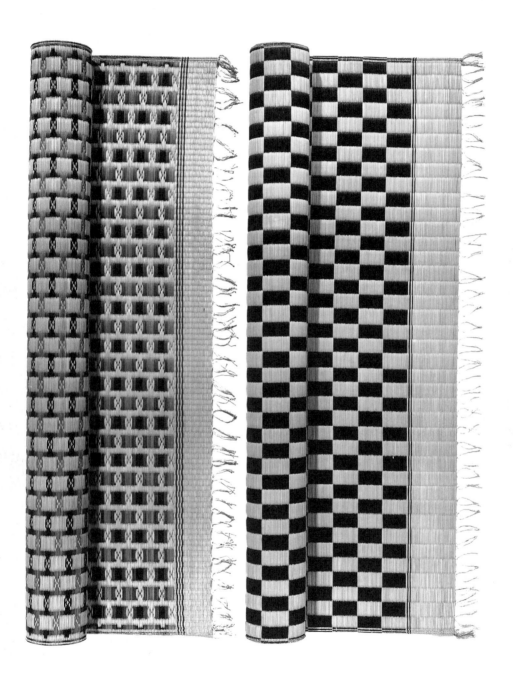

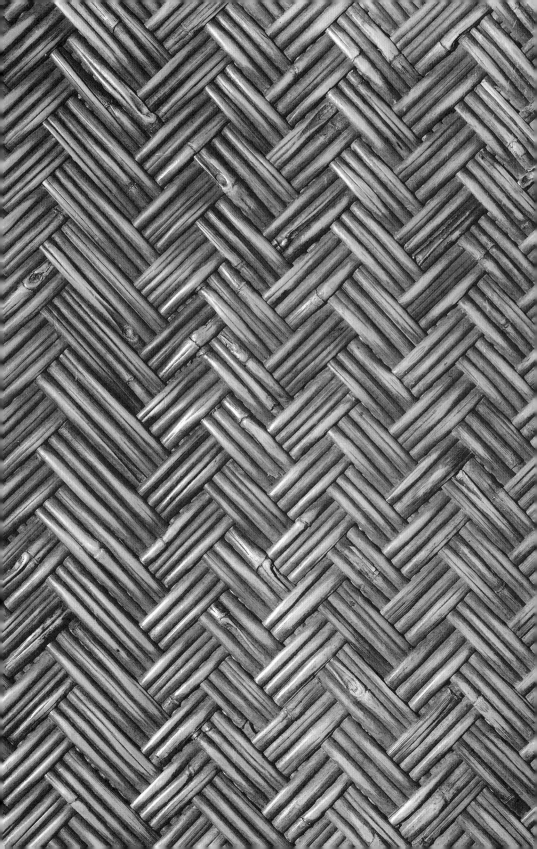

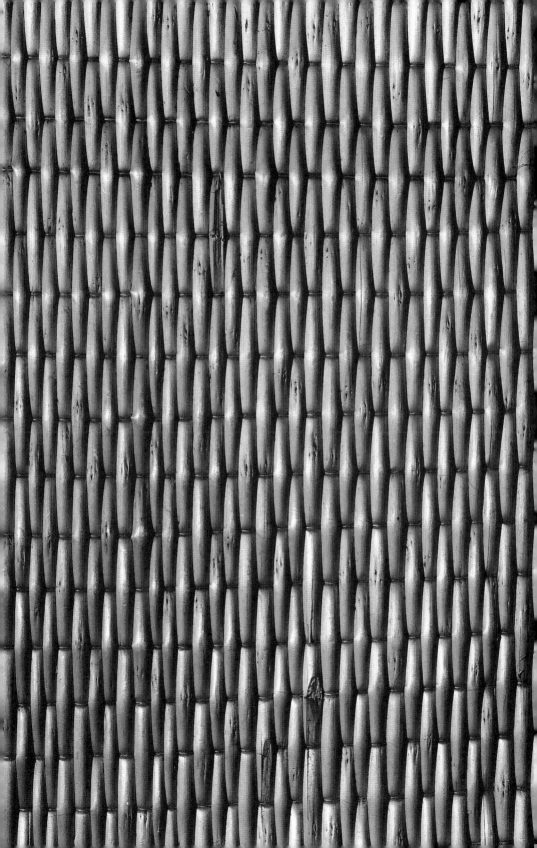

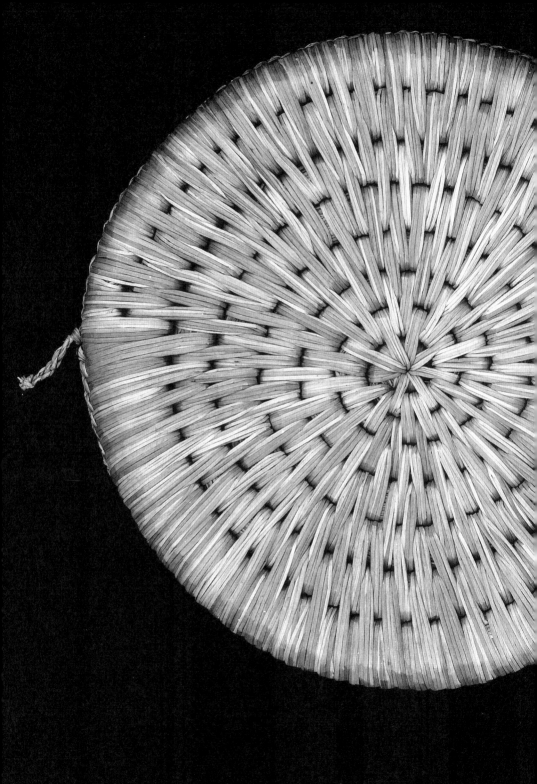

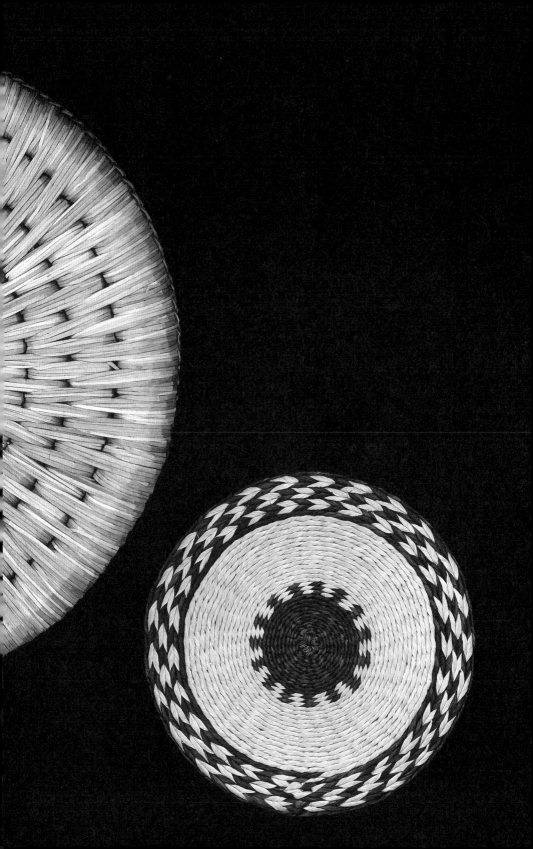

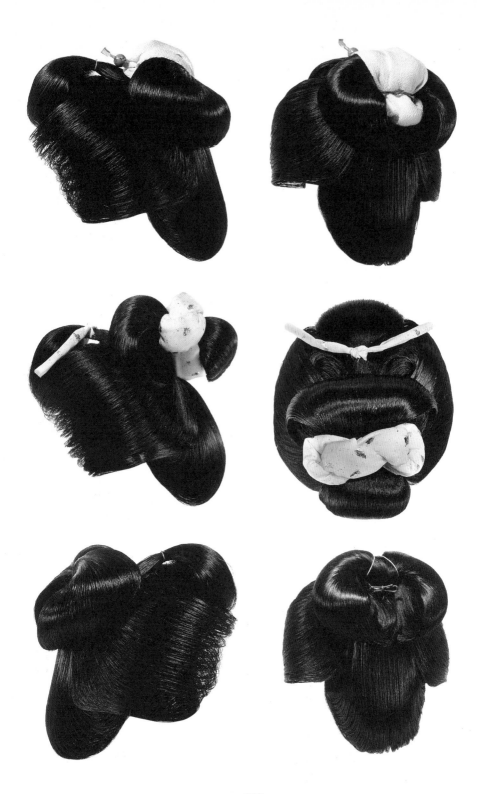

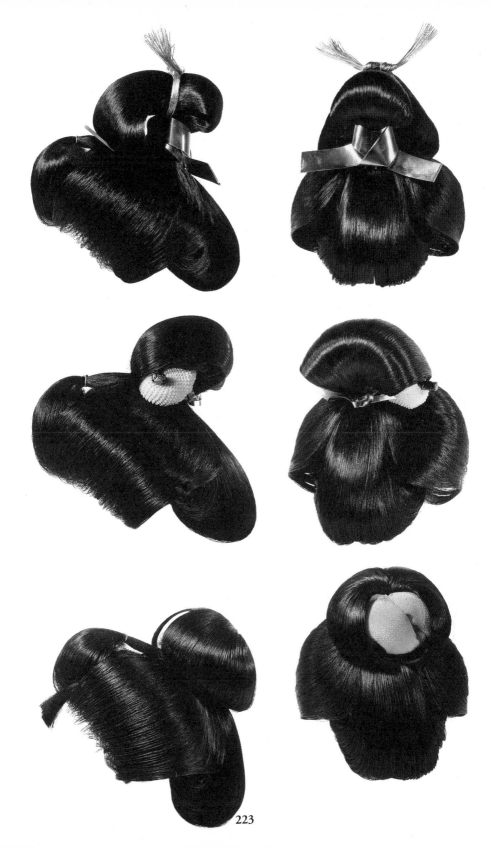

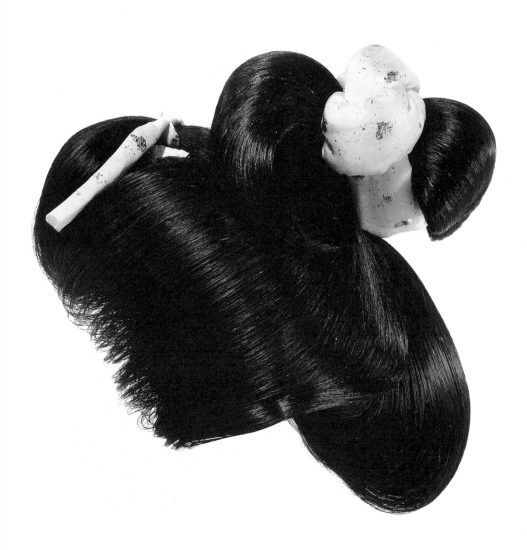

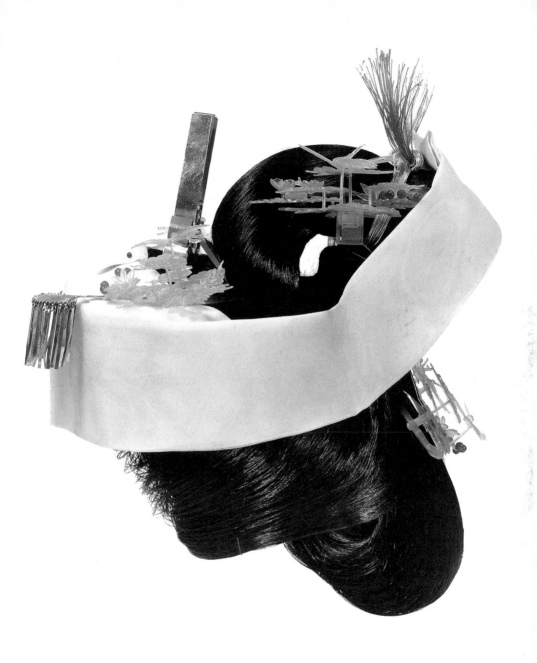

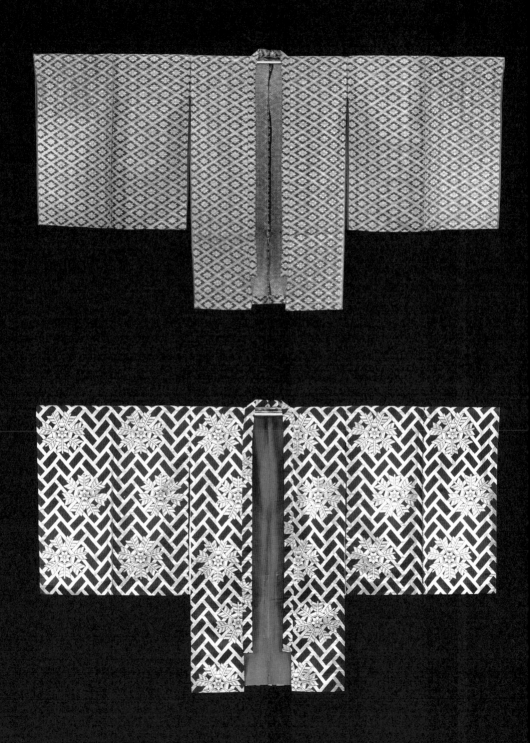

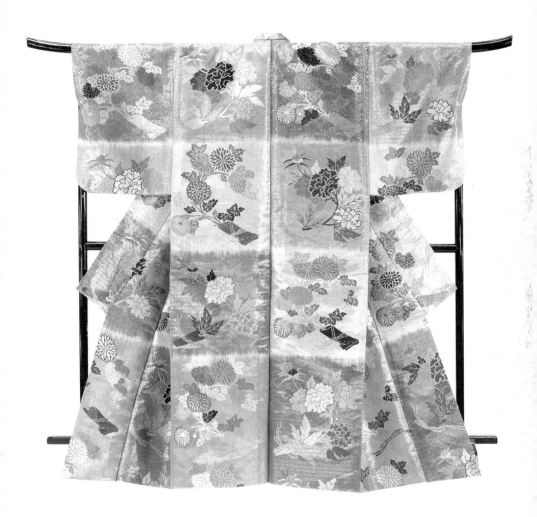

227

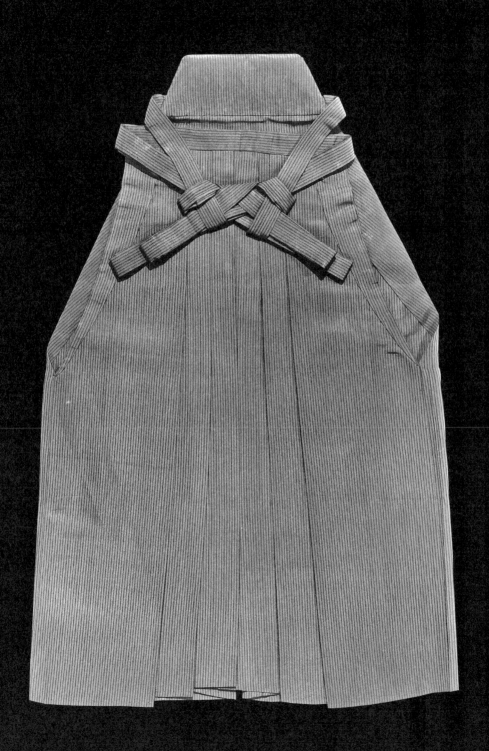

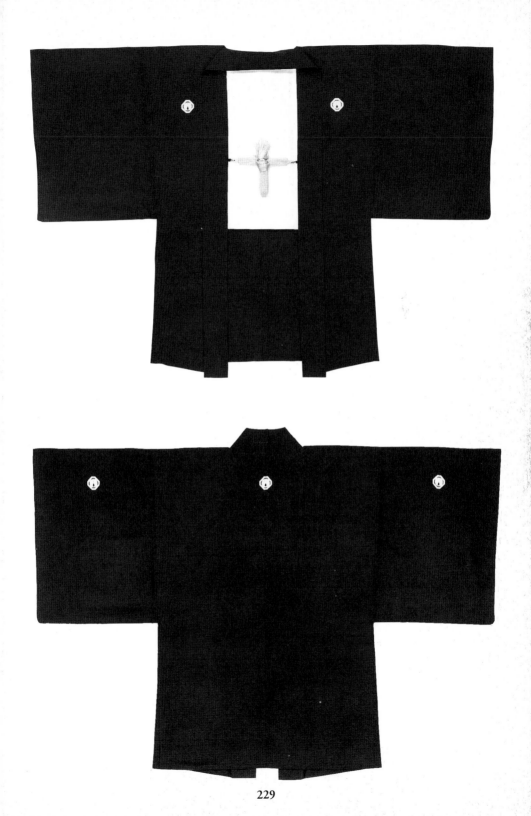

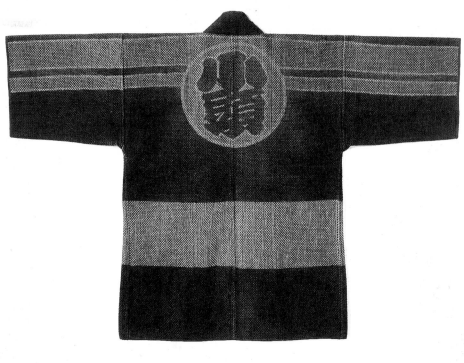

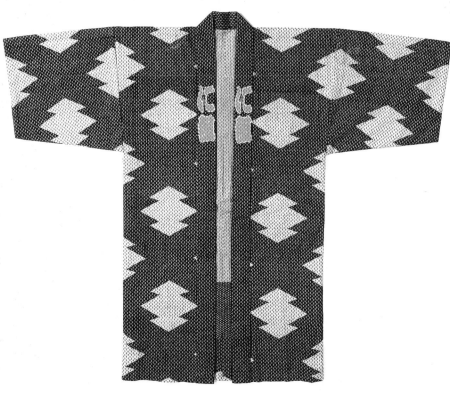

230

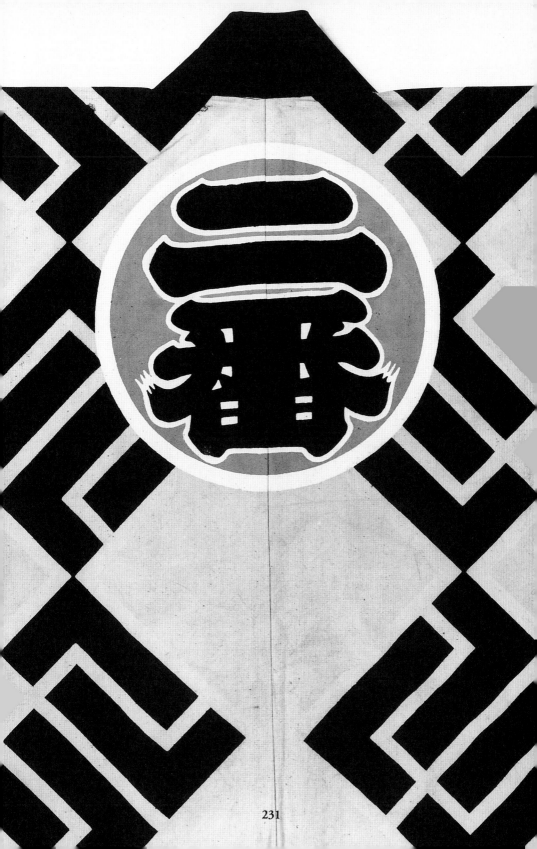

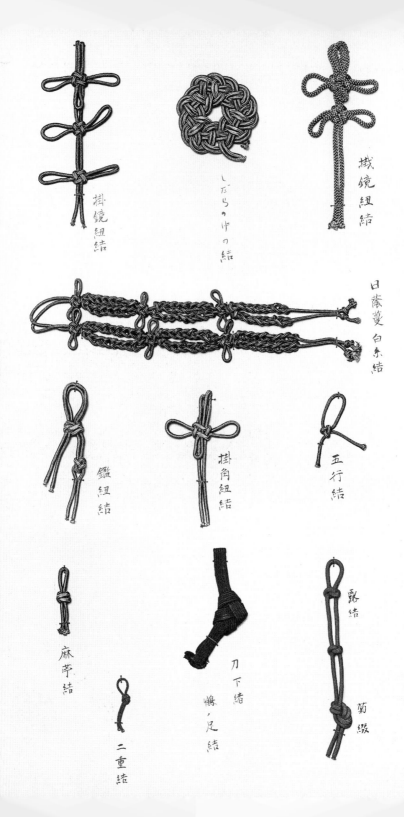

掛鏡紐結

しだらの作の結

幟鏡紐結

日蔭蔓白朱結

鑑紐結

掛角紐結

五行結

露結

麻苧結

刀下緒懸ノ足結

菊綴

二重結

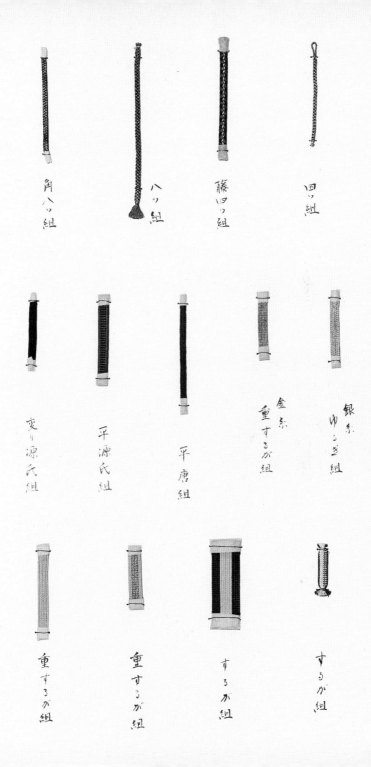

角八ッ組

八ッ組

藤四ッ組

四ッ組

交り源氏組

平源氏組

平唐組

金糸
重するが組

銀糸
ゆるぎ組

重するが組

重するが組

するが組

するか組

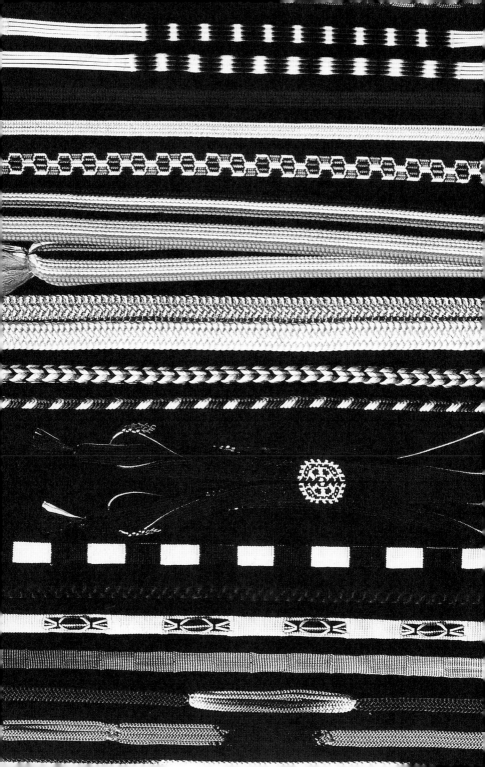

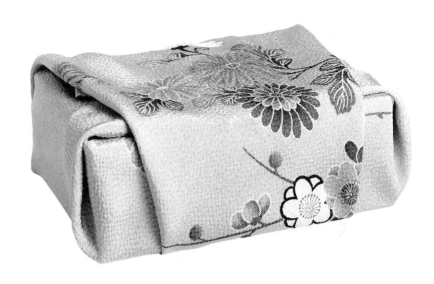

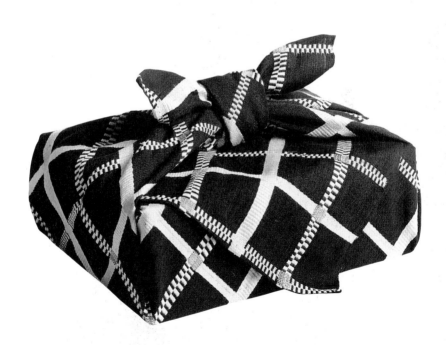

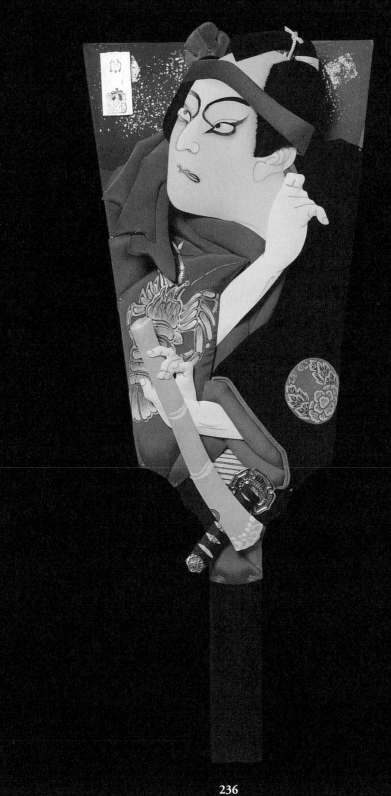

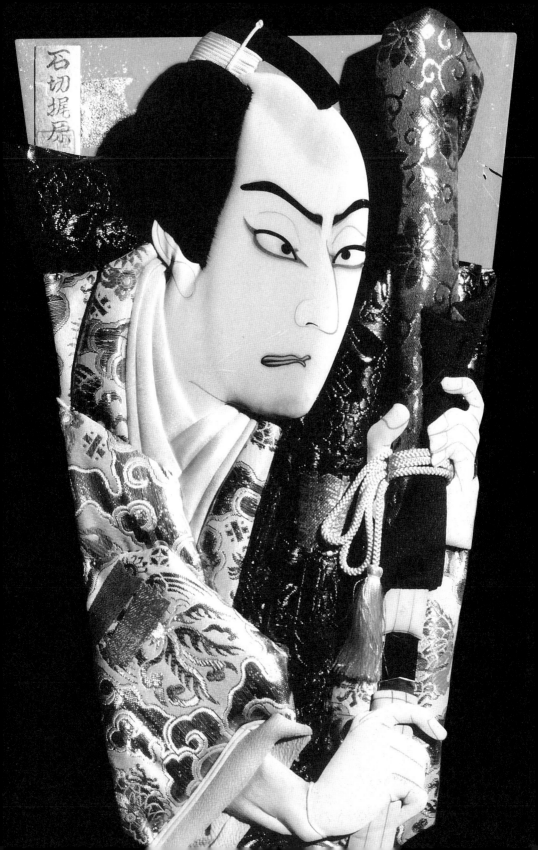

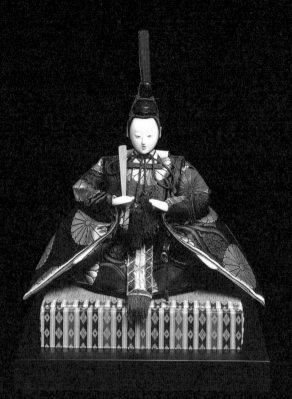

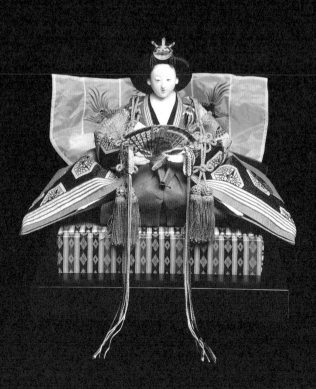

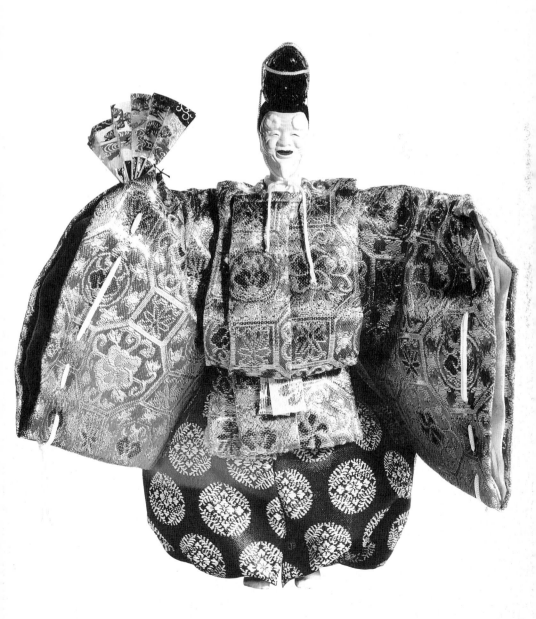

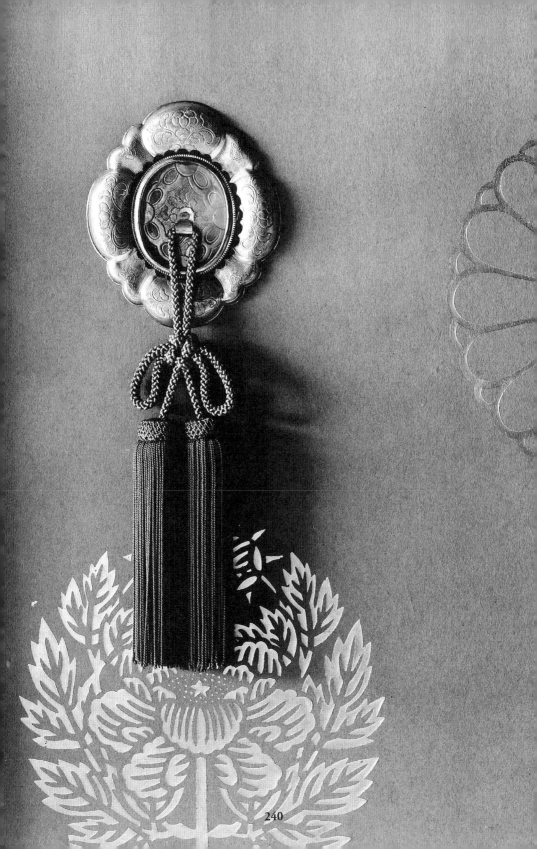

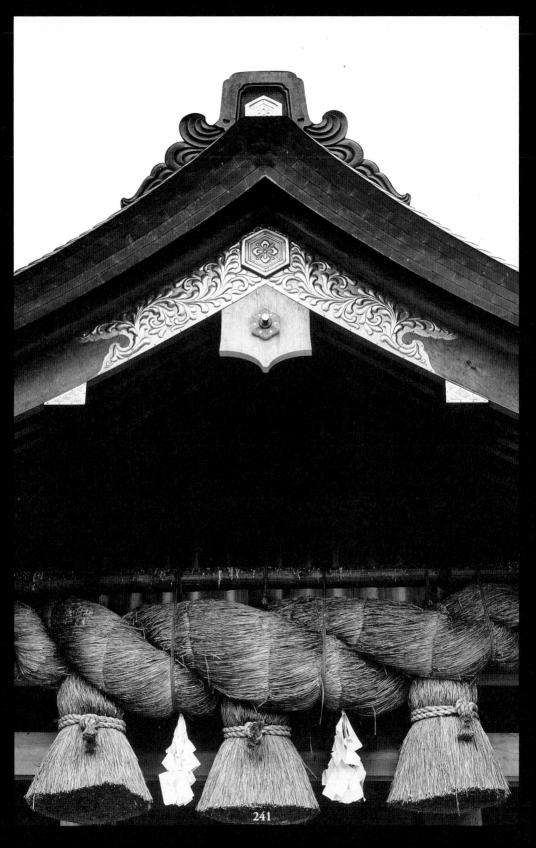

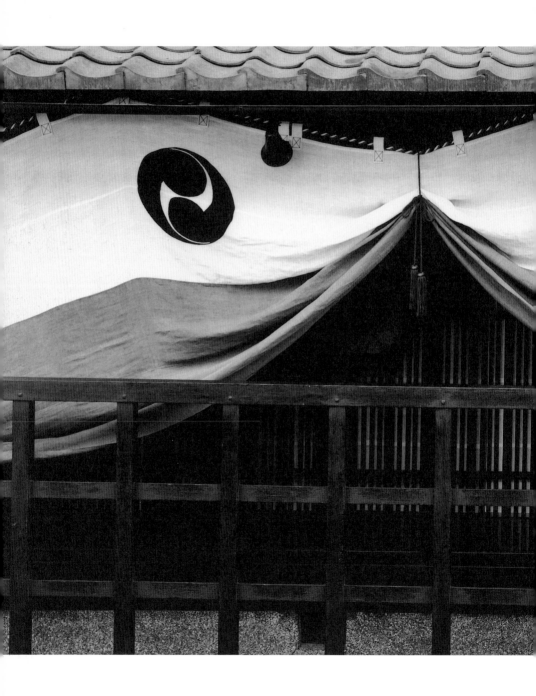

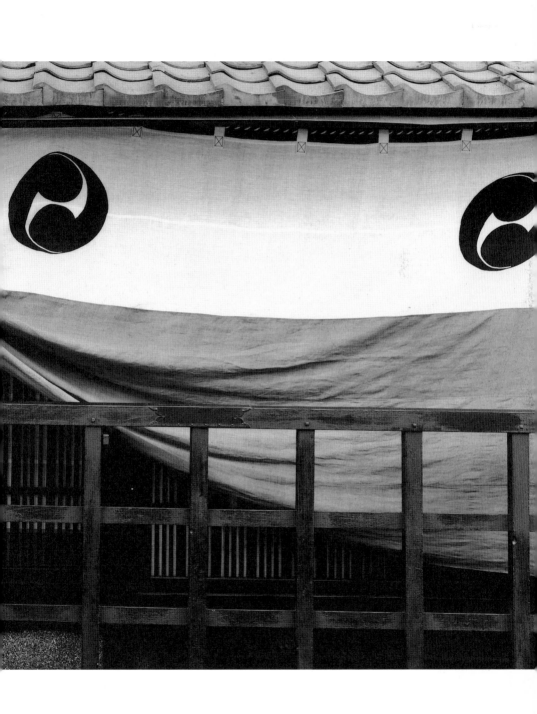

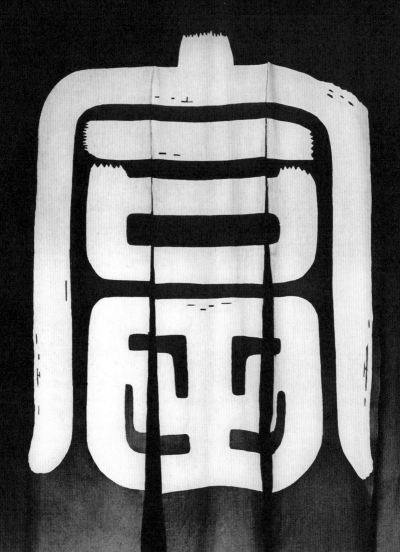

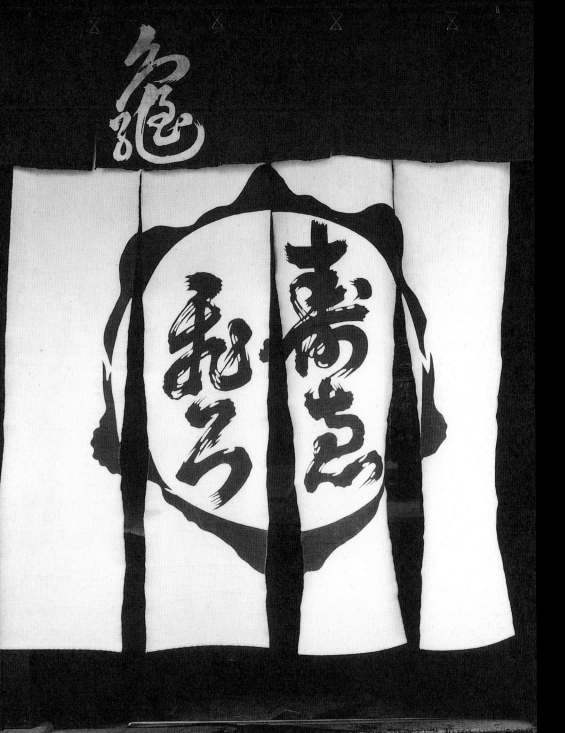

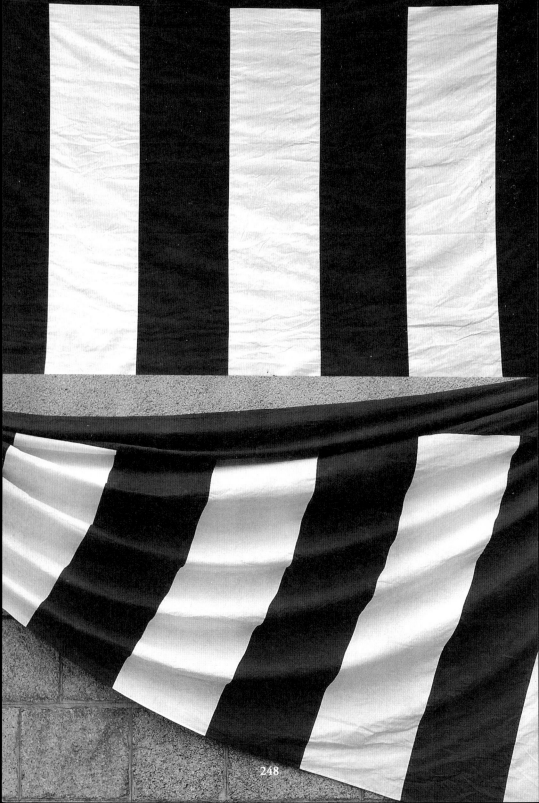

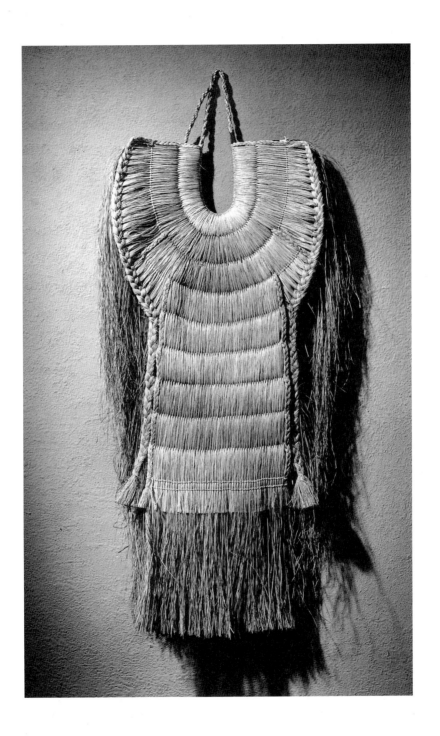

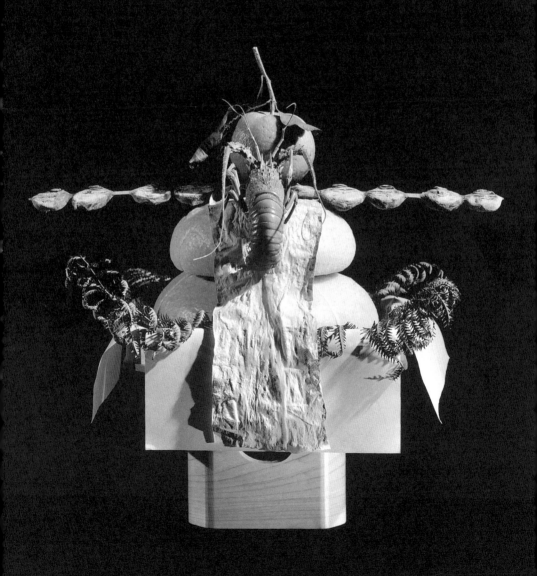

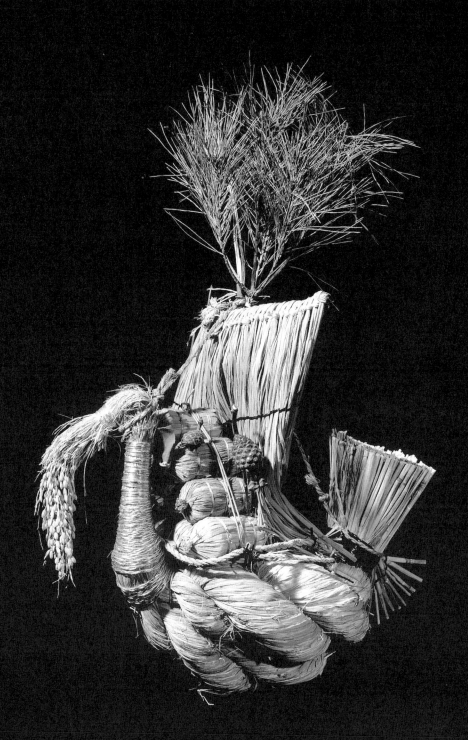

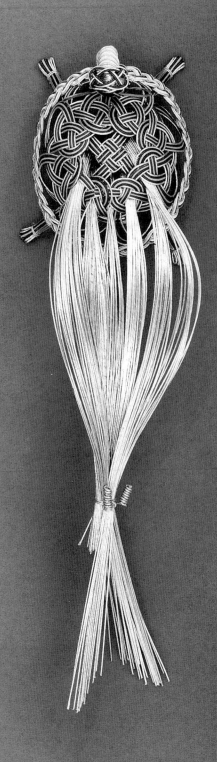

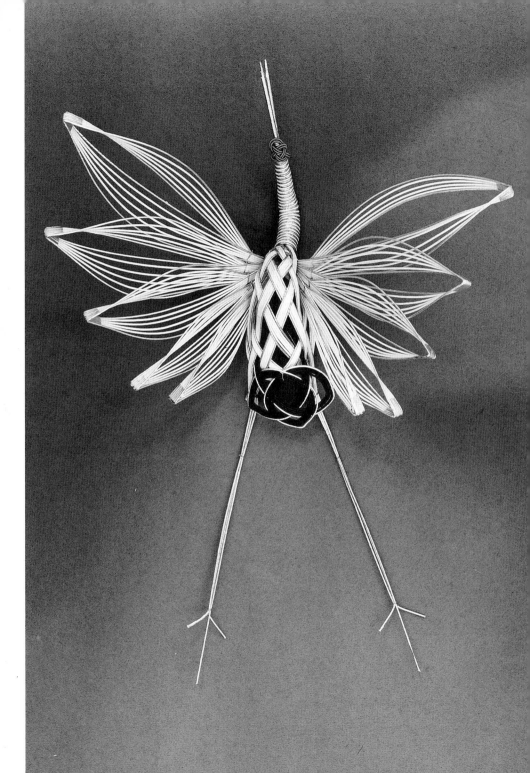

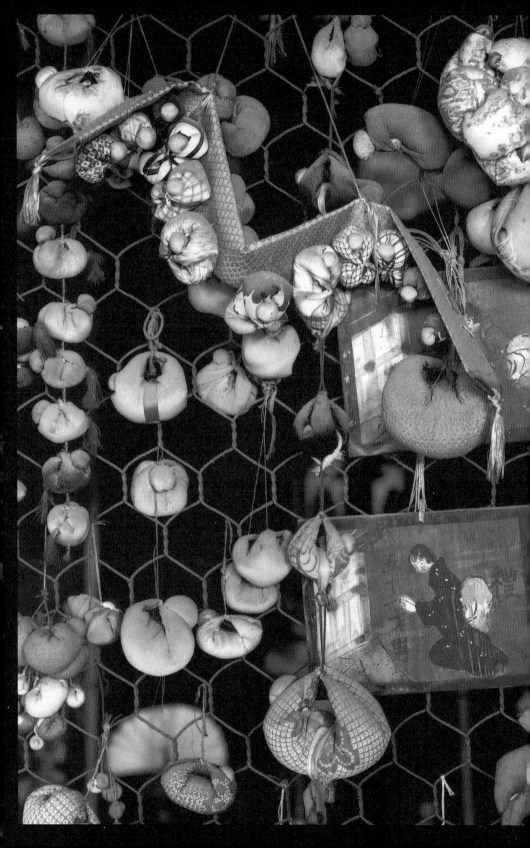

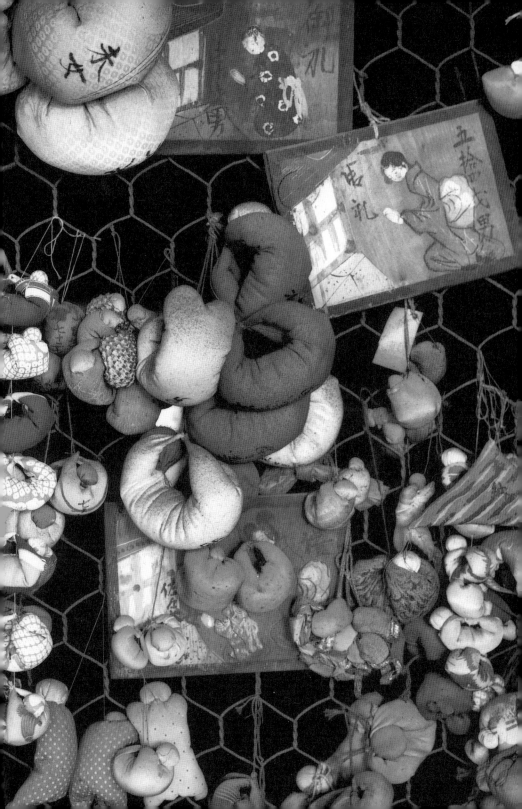

Clay

土

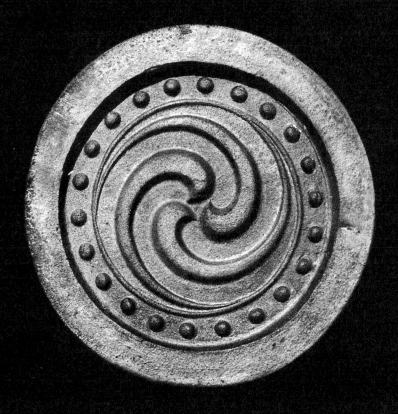

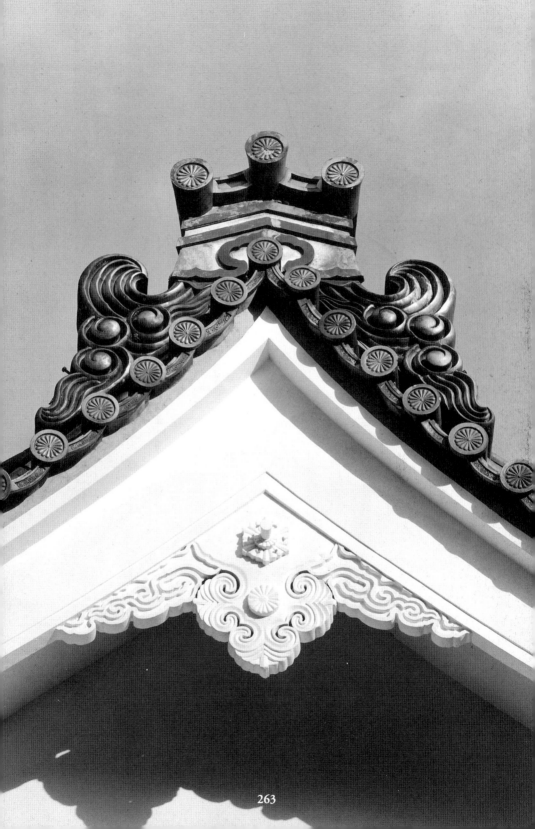

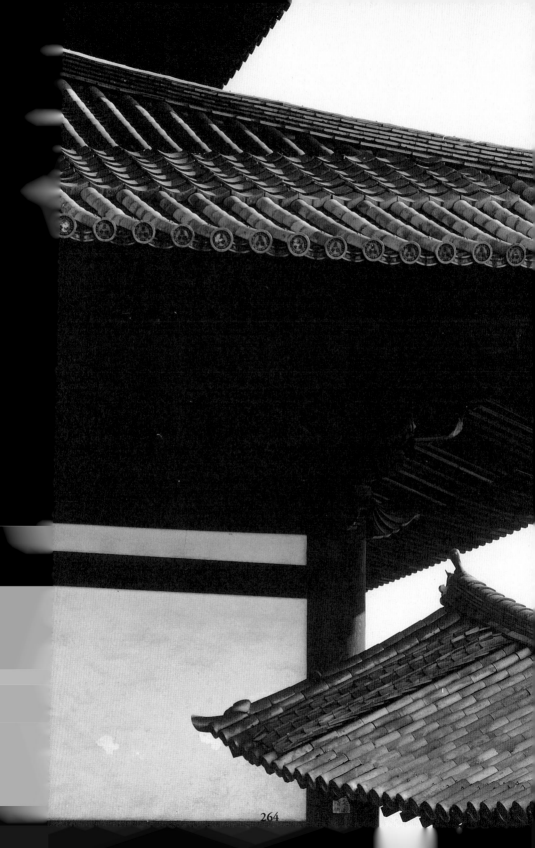

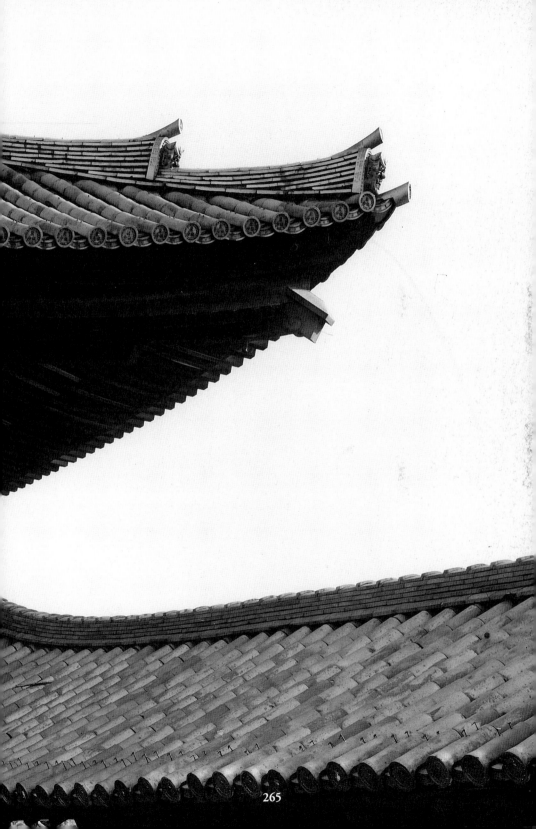

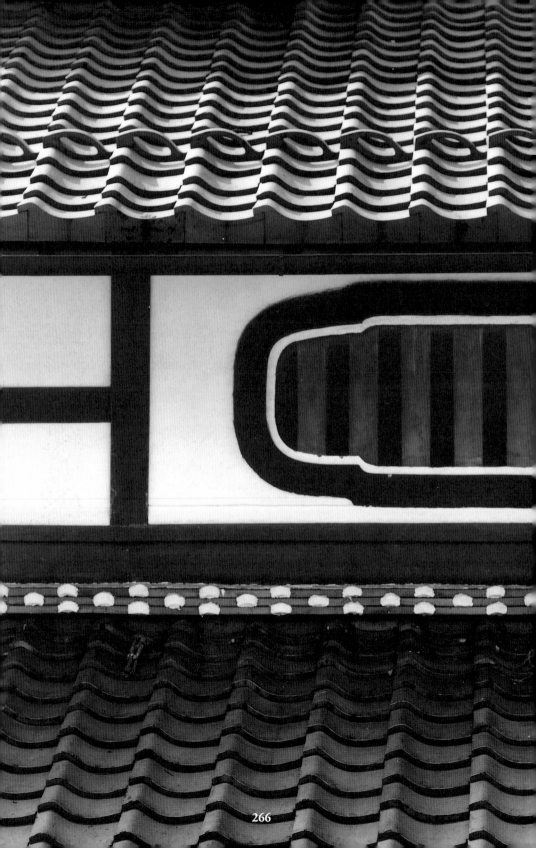

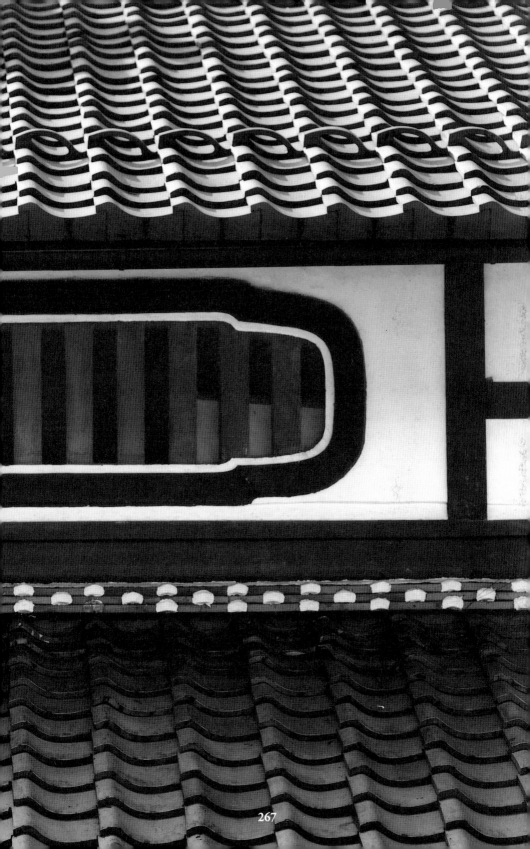

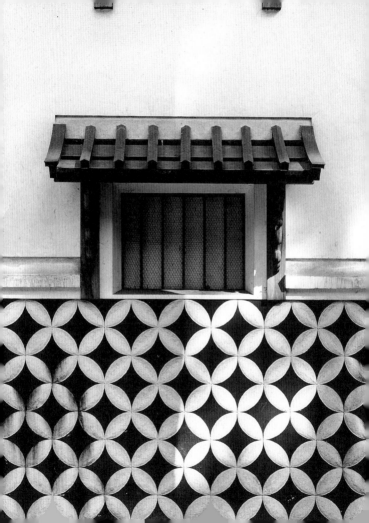

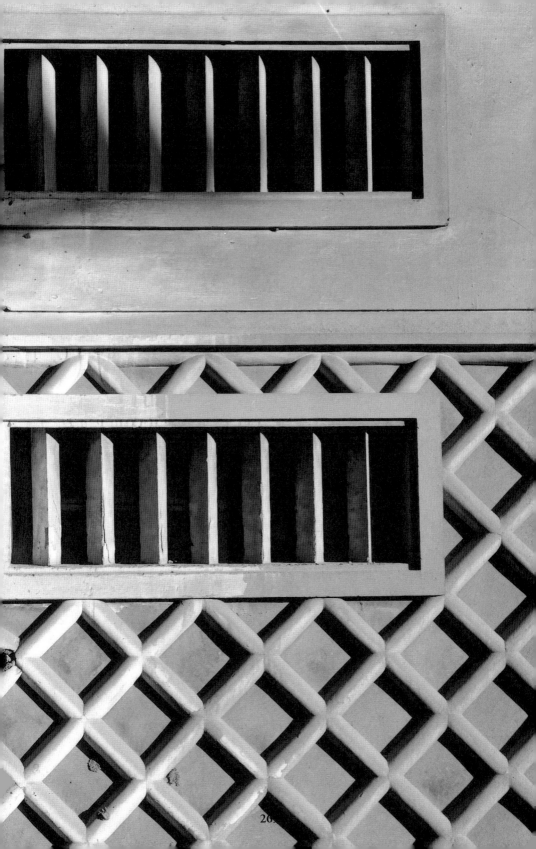

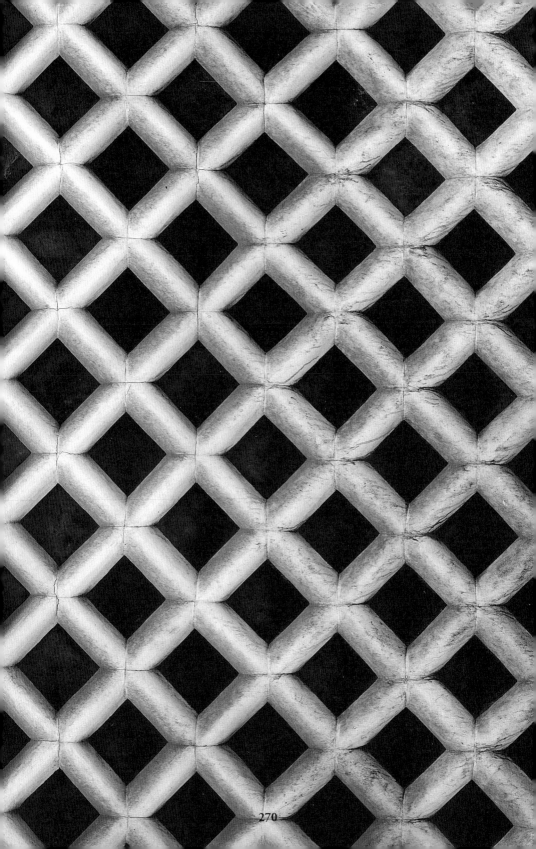

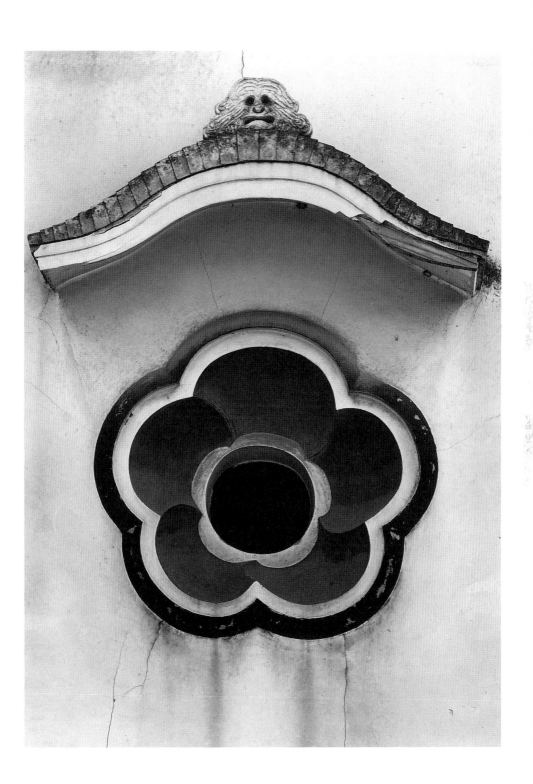

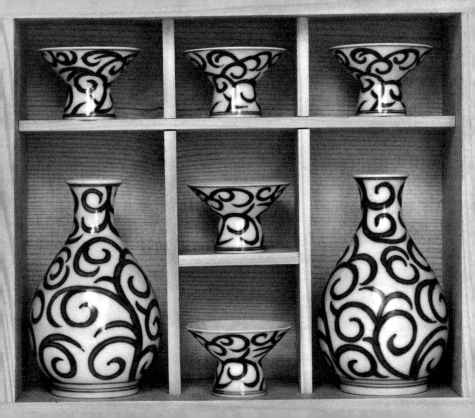

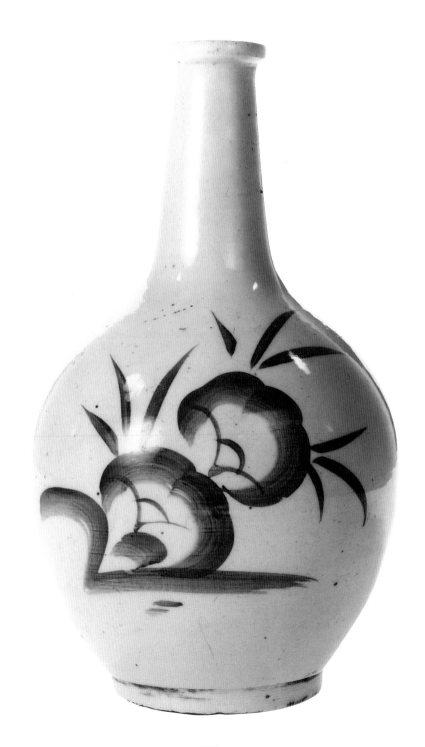

280

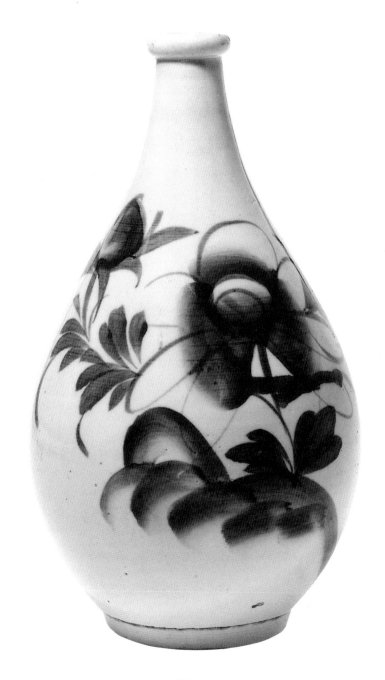

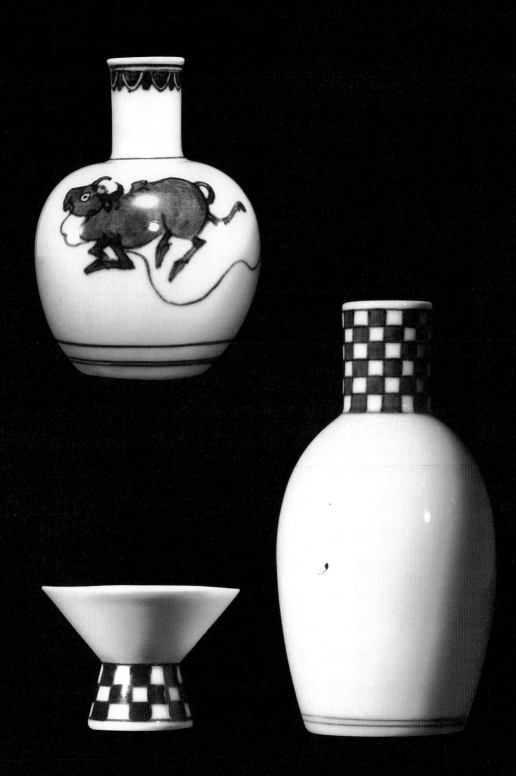

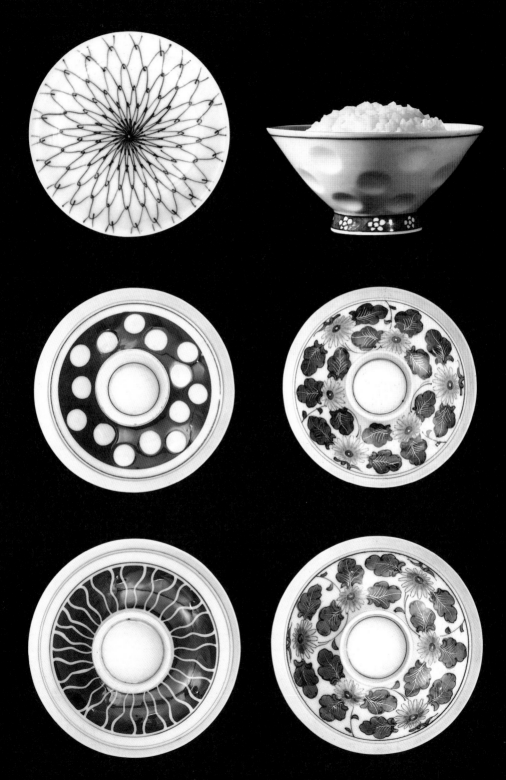

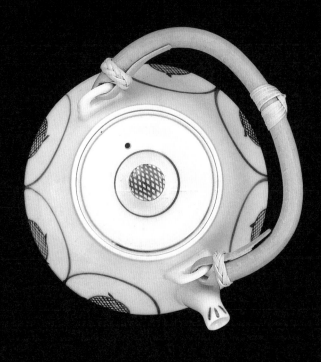

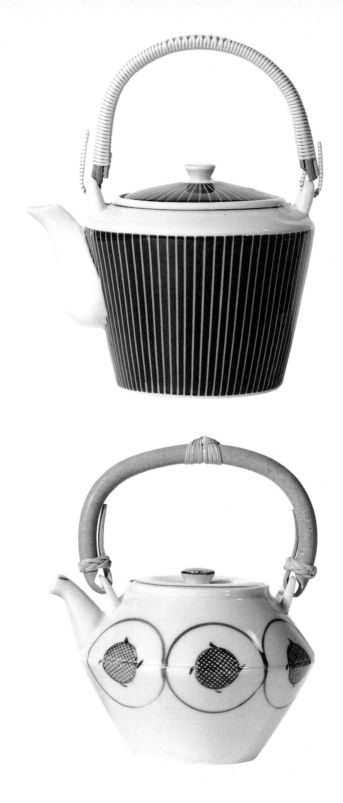

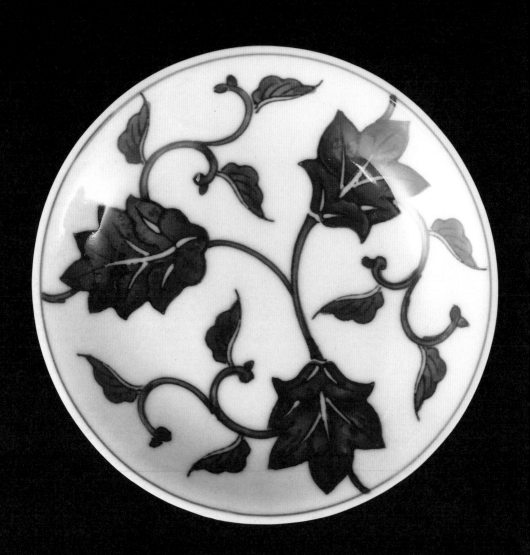

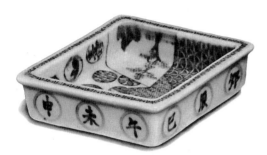
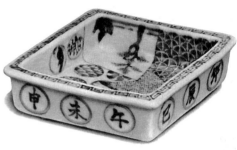

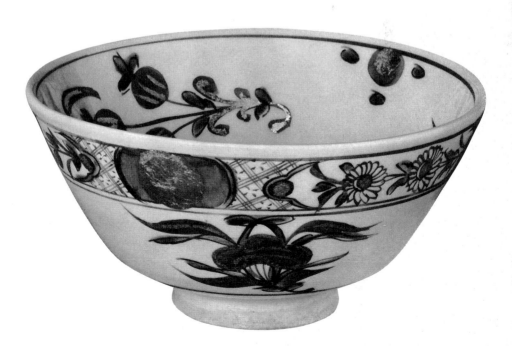

287

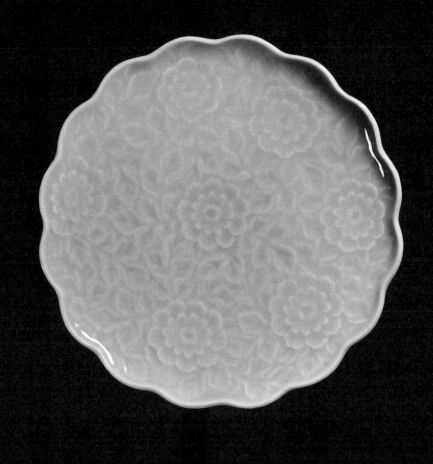

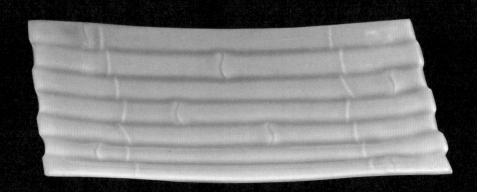

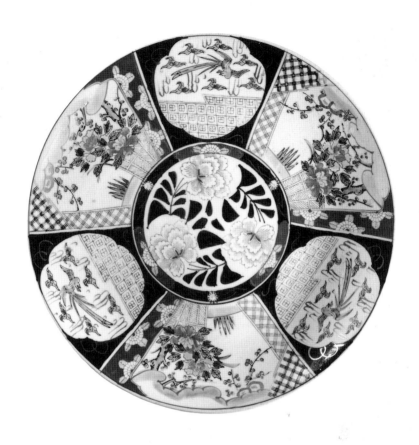

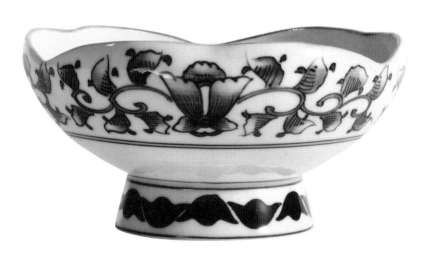

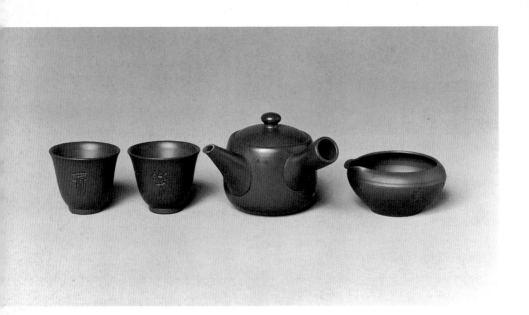

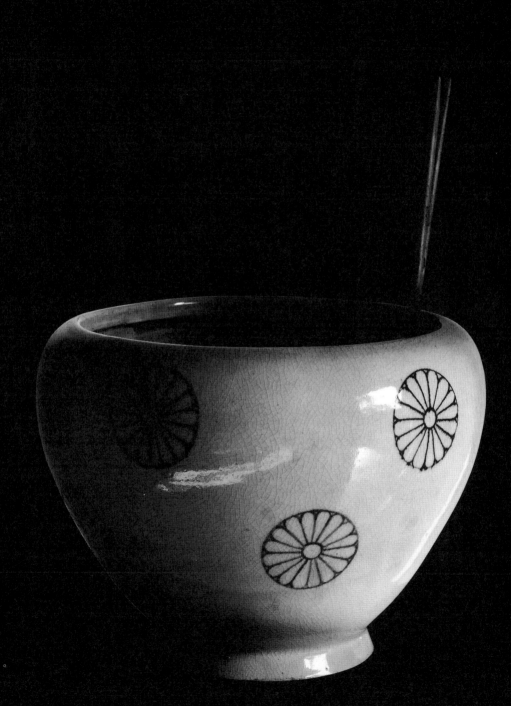

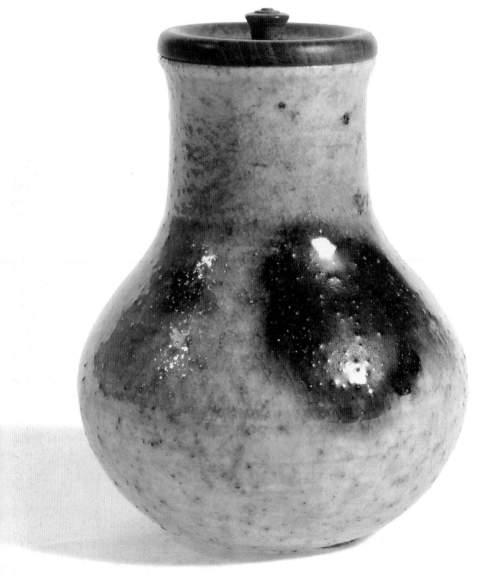

292

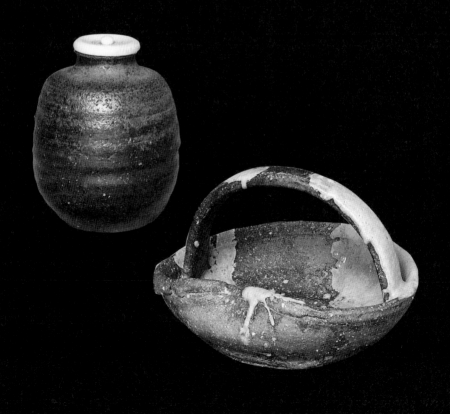

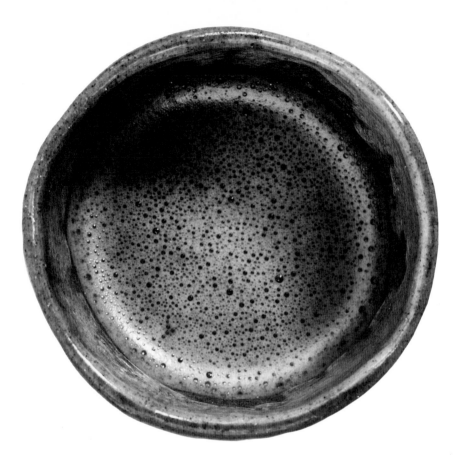

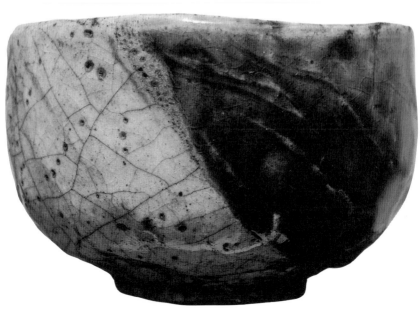

294

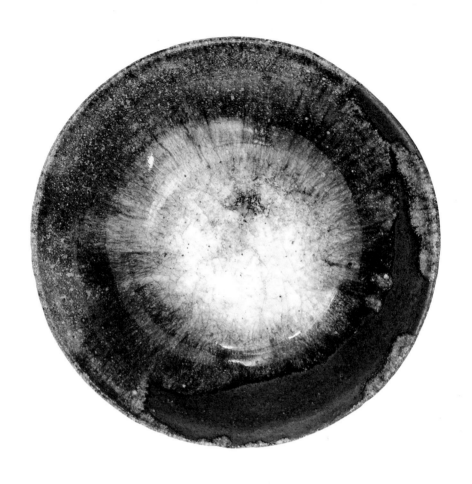

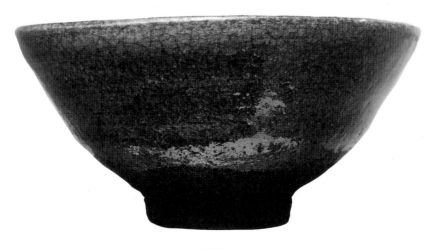

295

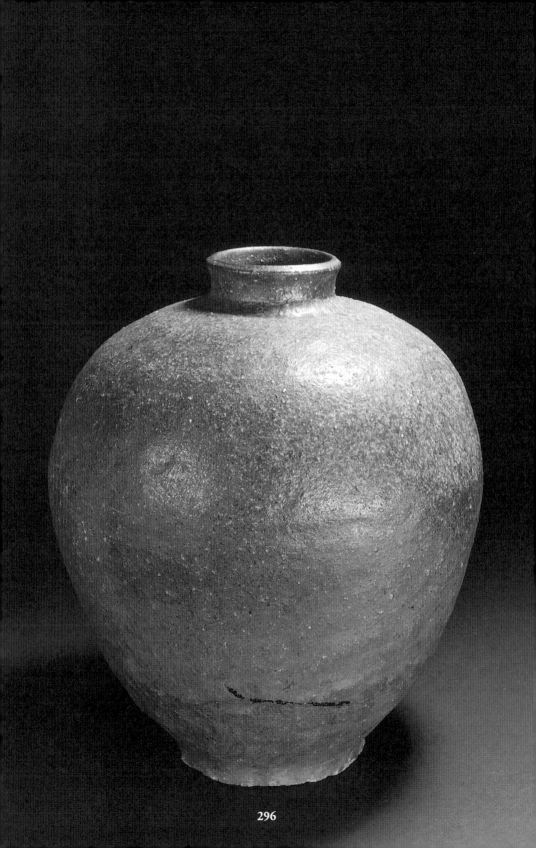

296

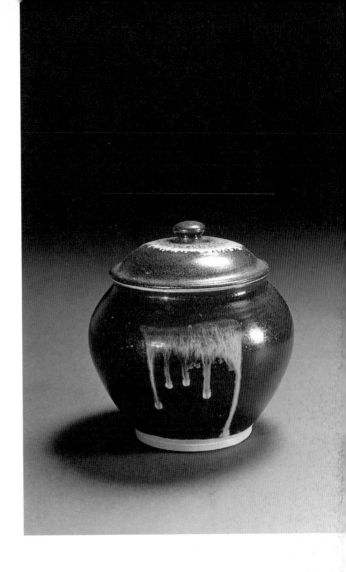

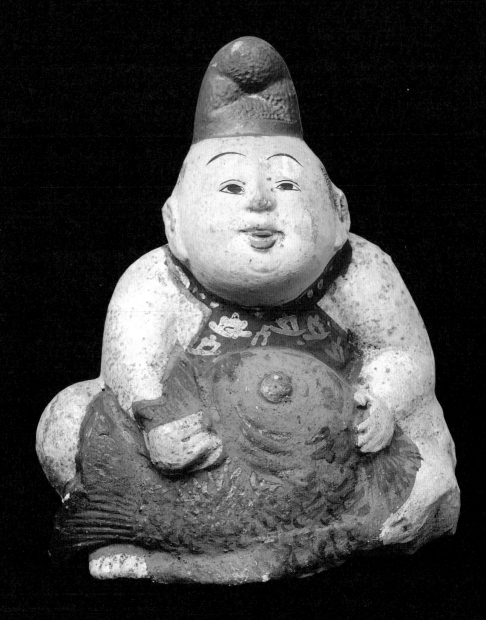

300

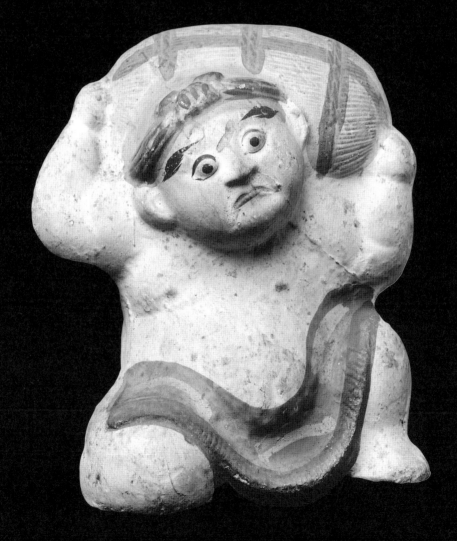

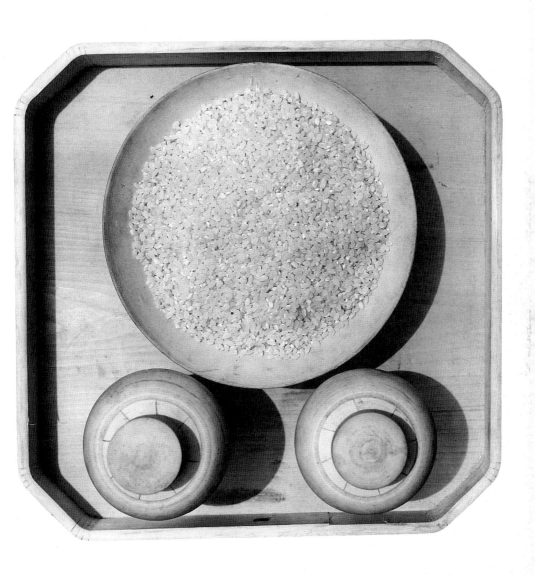

Metal

鉄

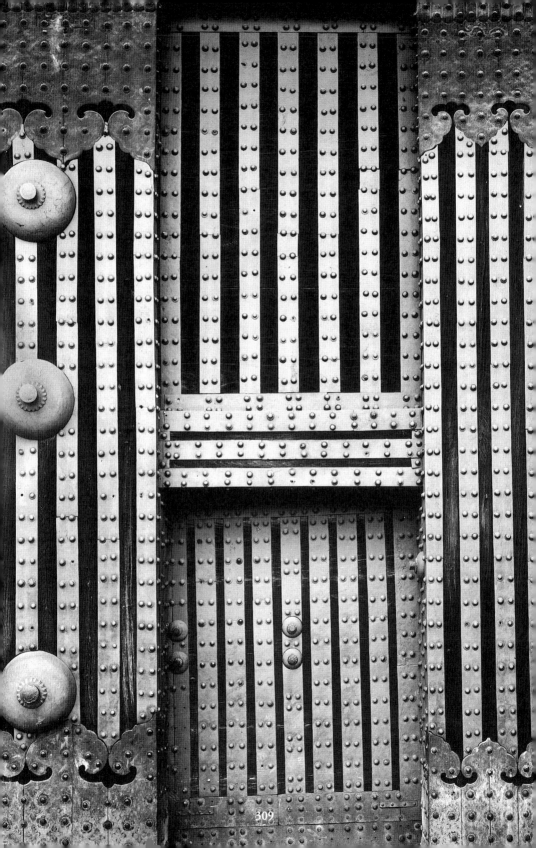

309

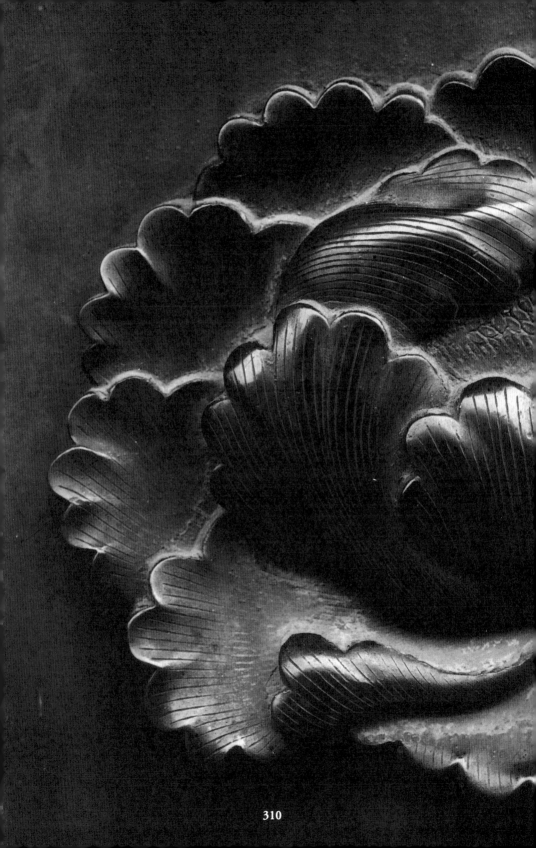

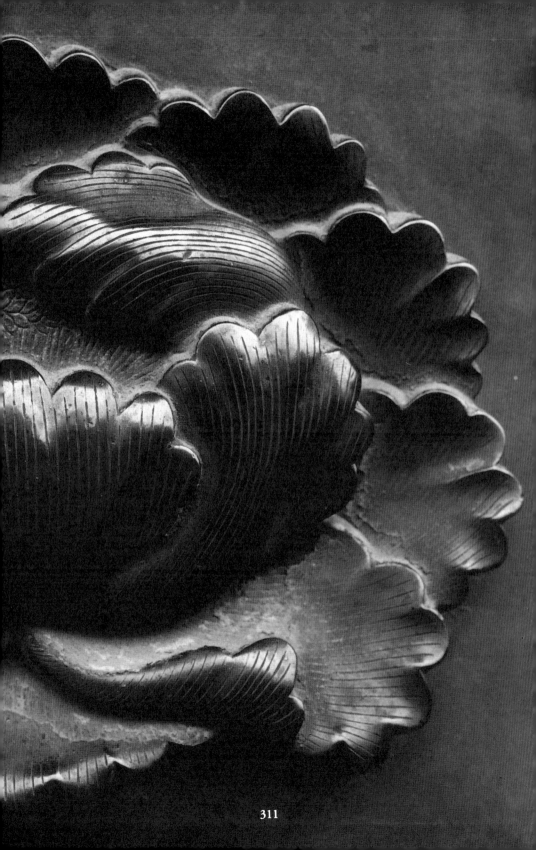

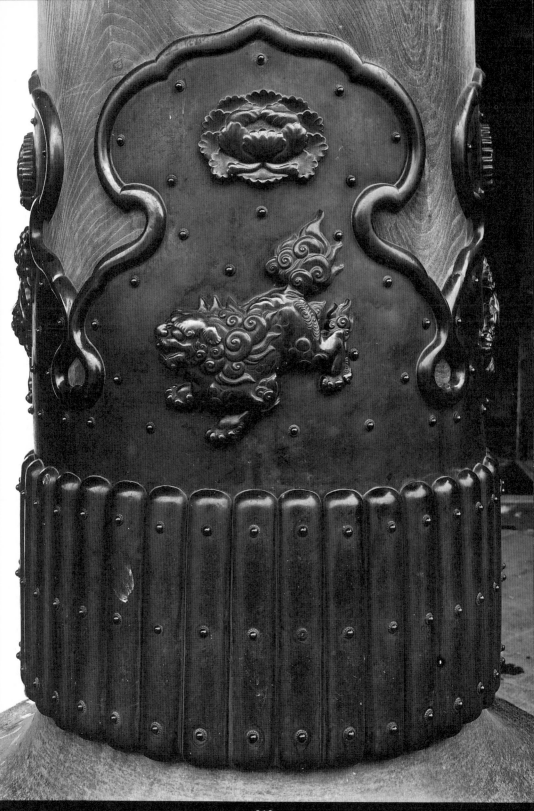

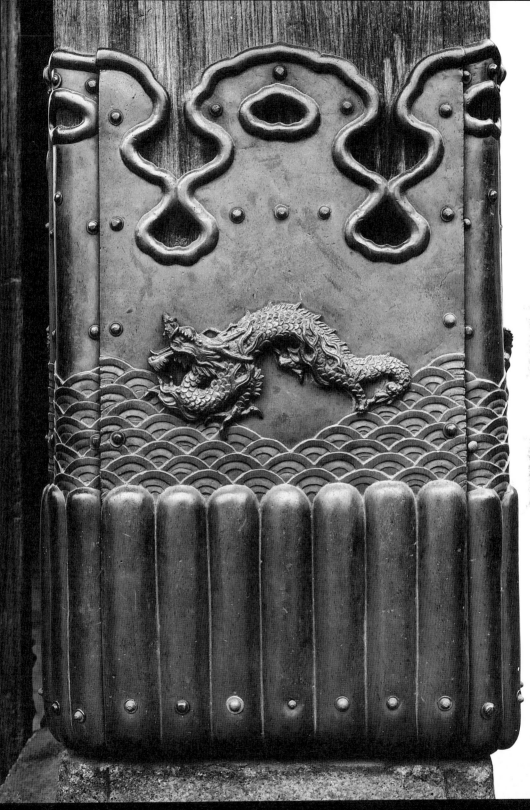

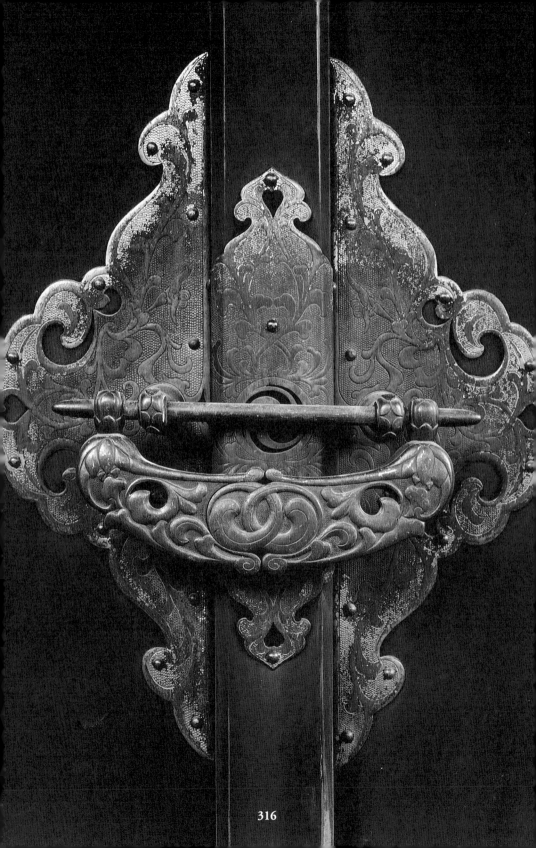

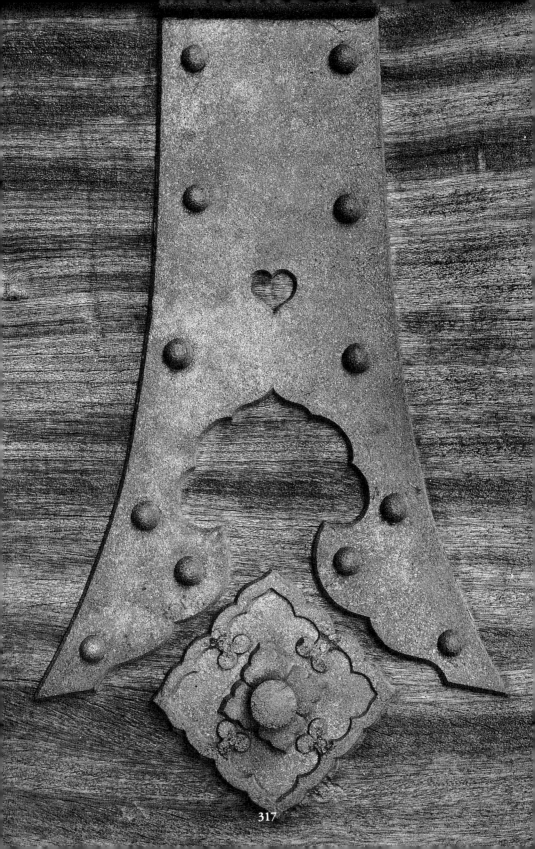

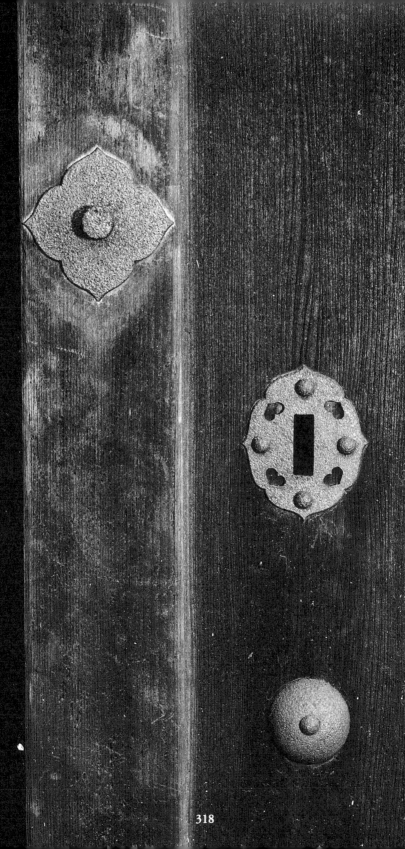

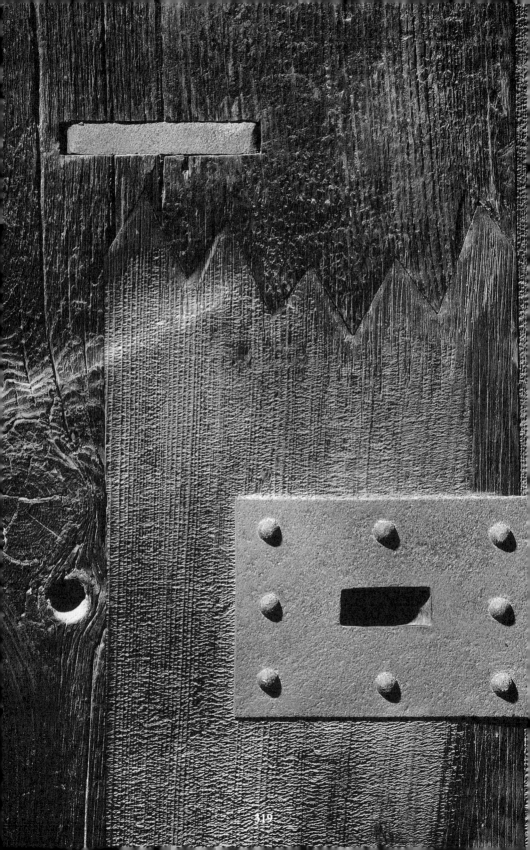

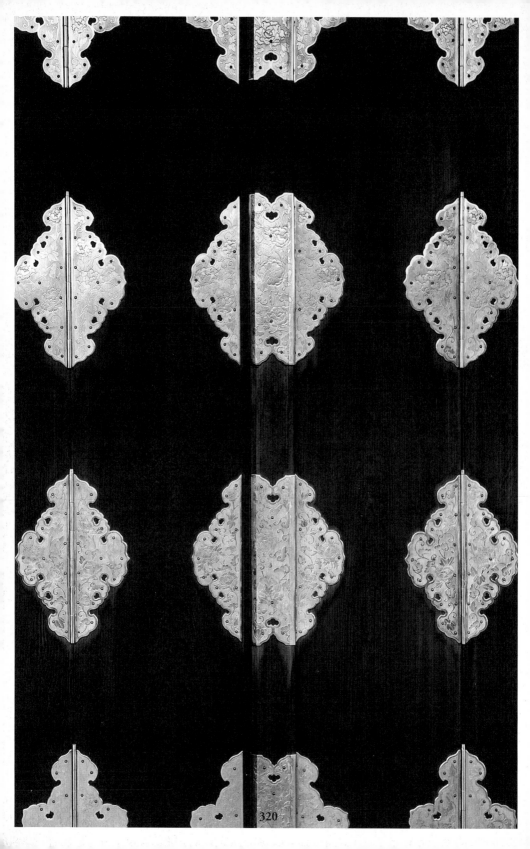

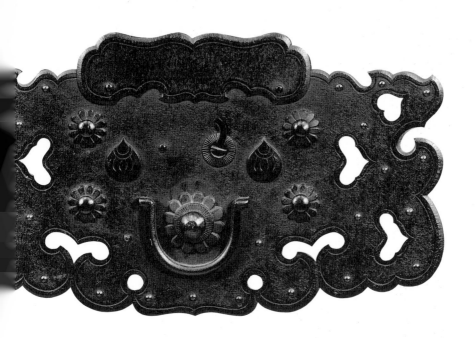

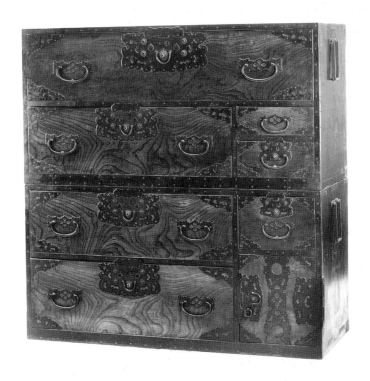

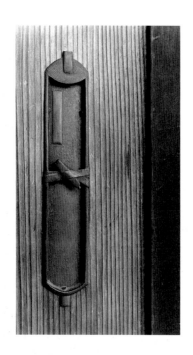

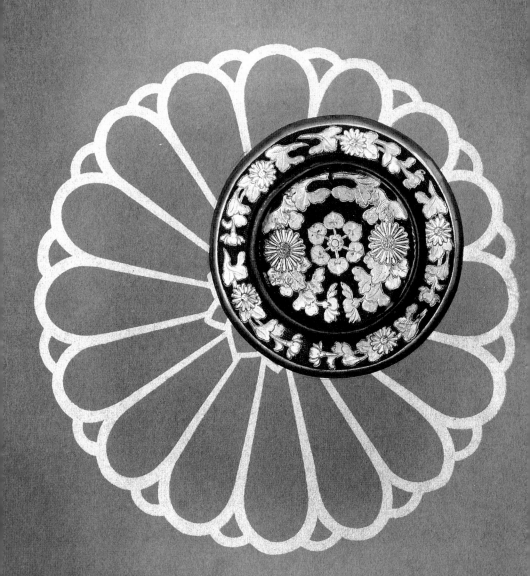

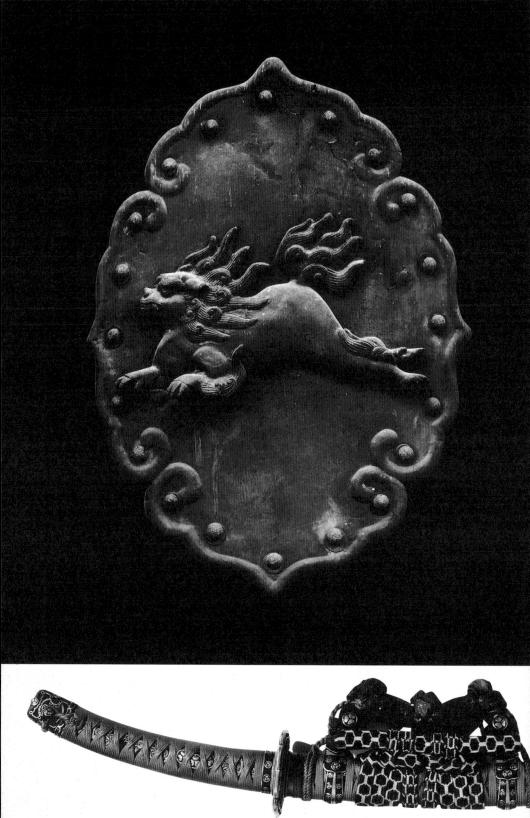

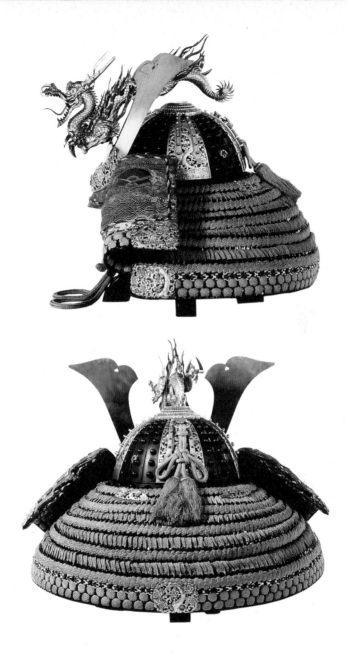

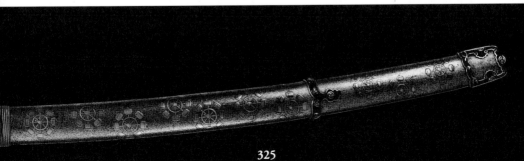

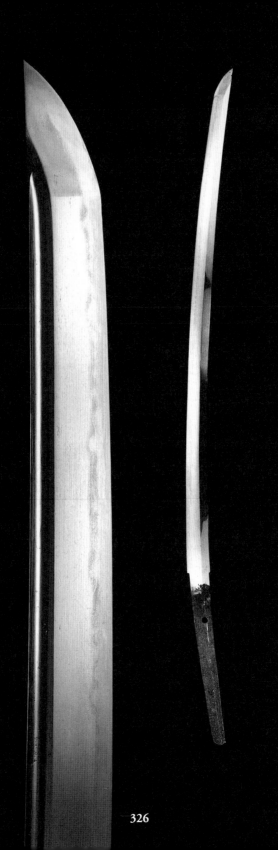

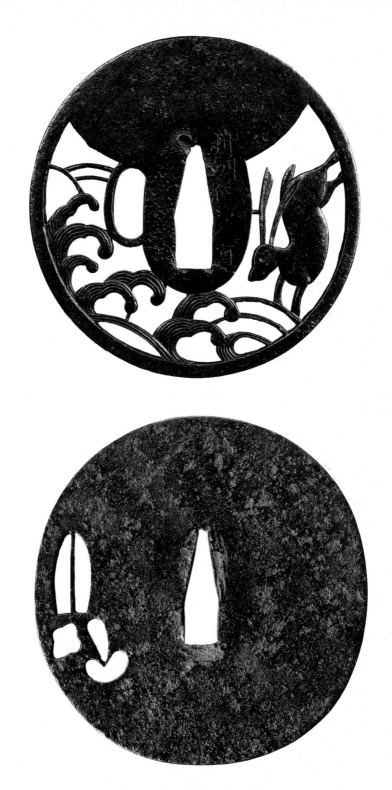

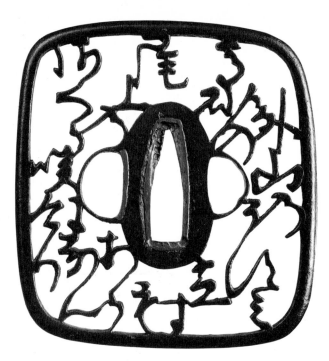

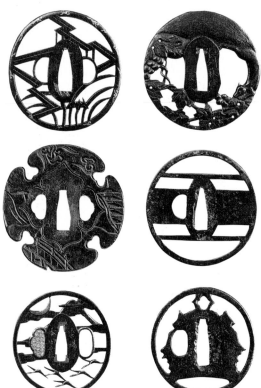

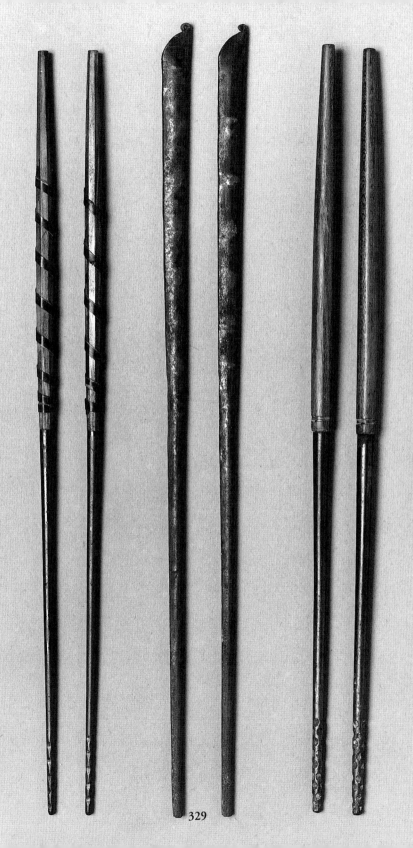

329

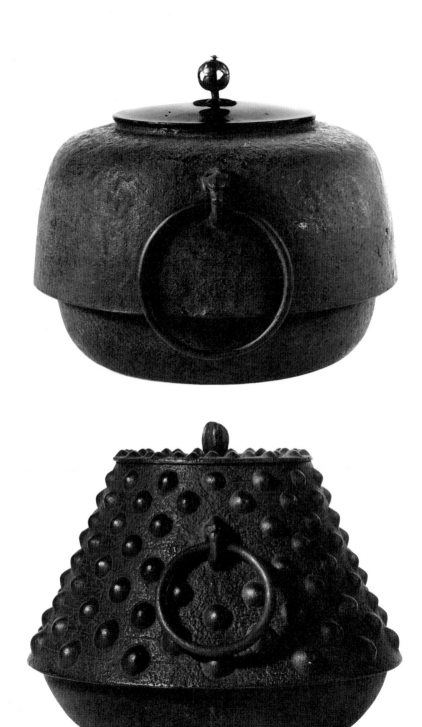

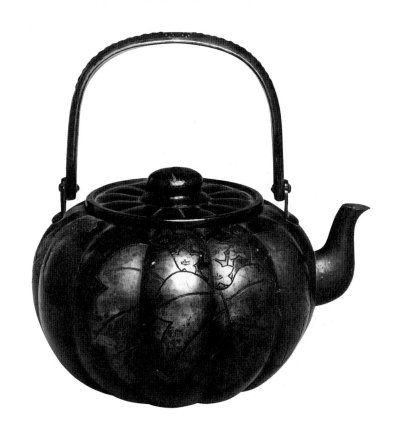

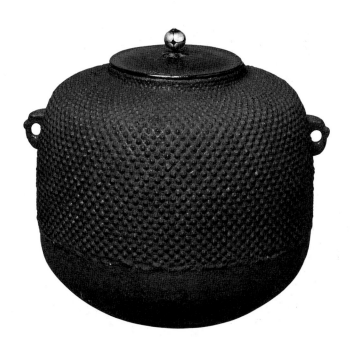

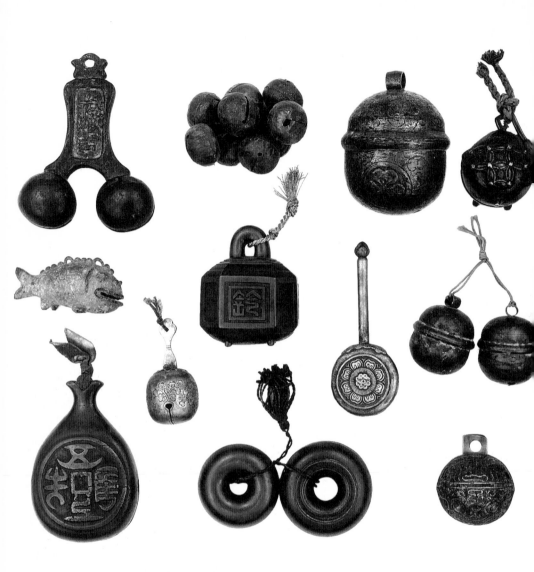

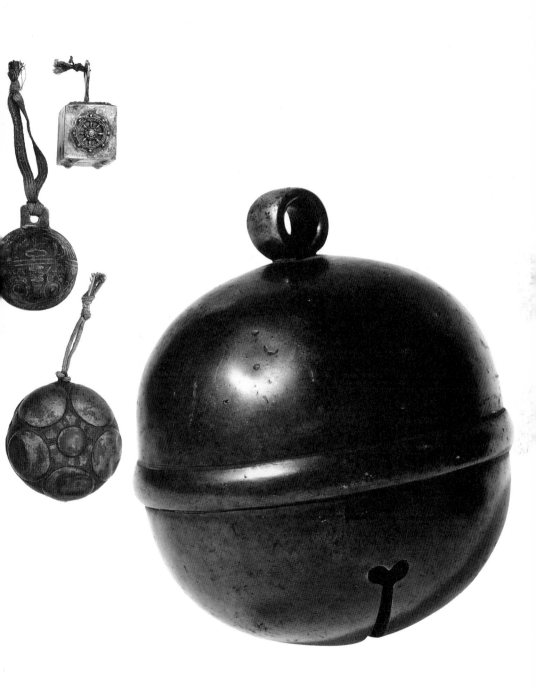

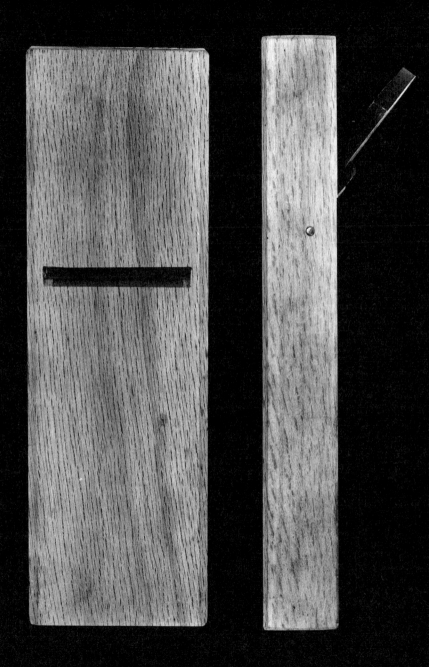

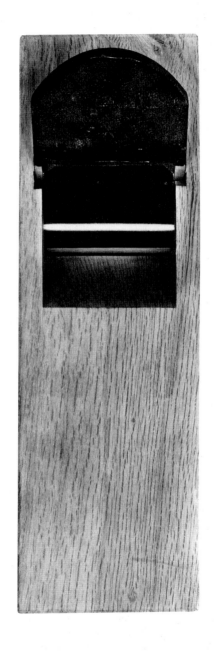

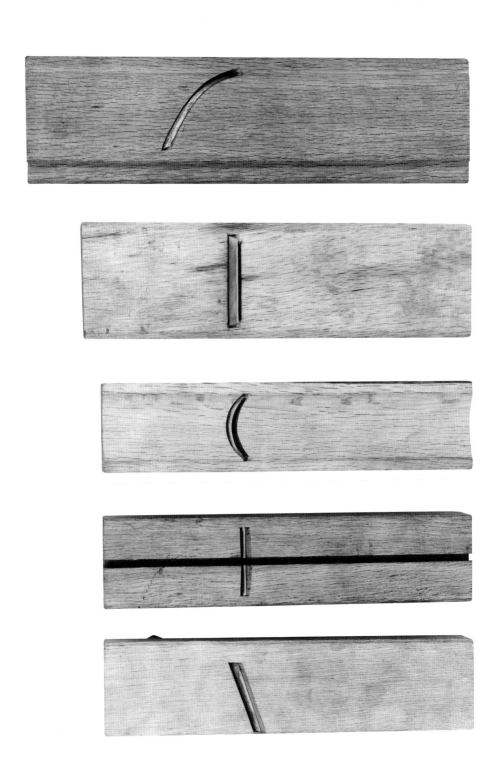

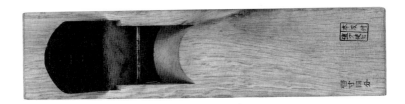

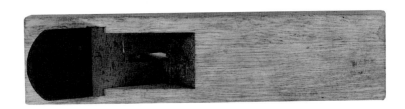

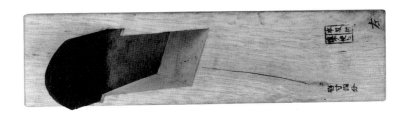

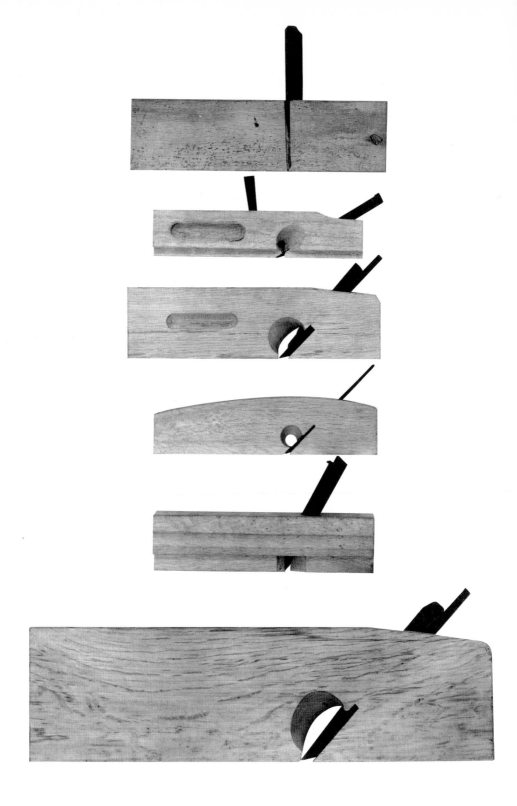

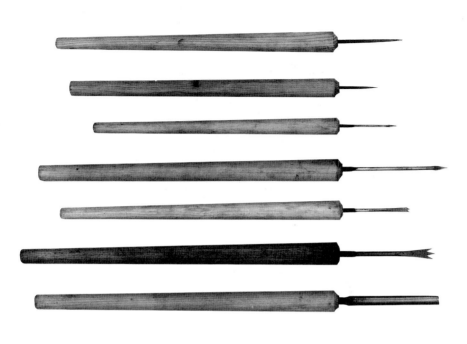

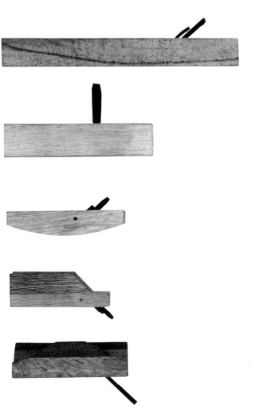

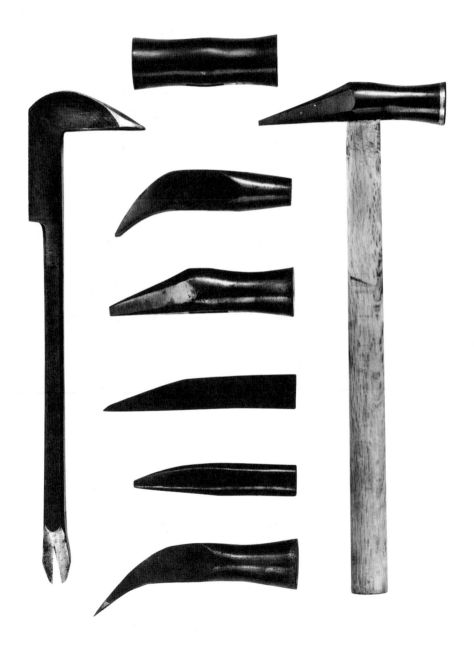

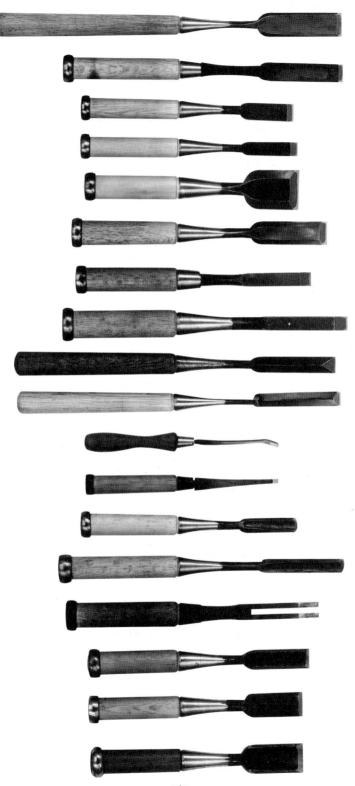

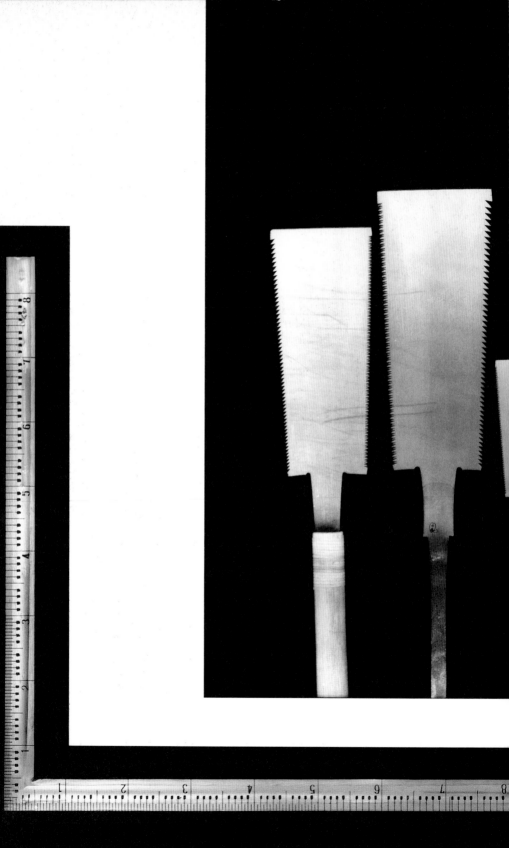

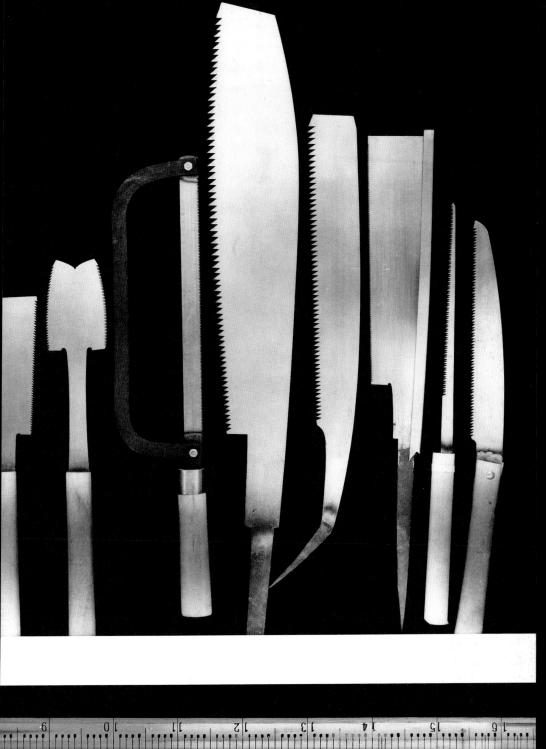

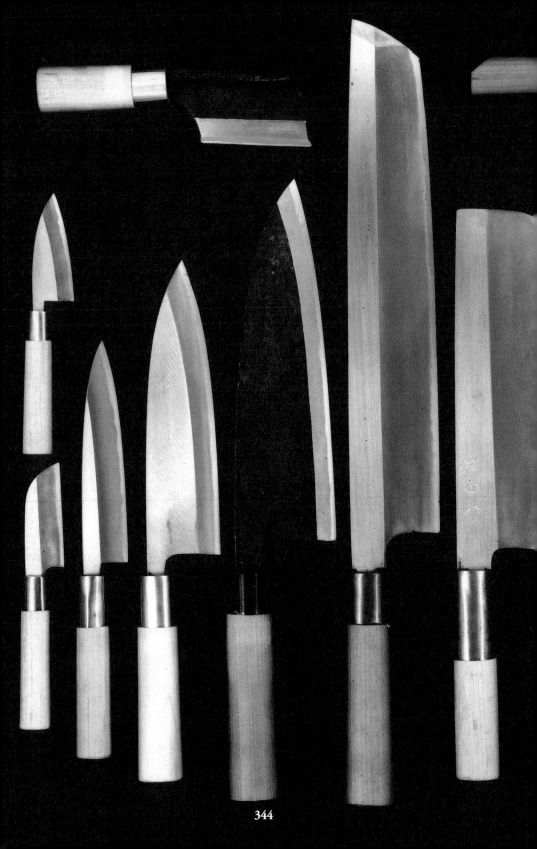

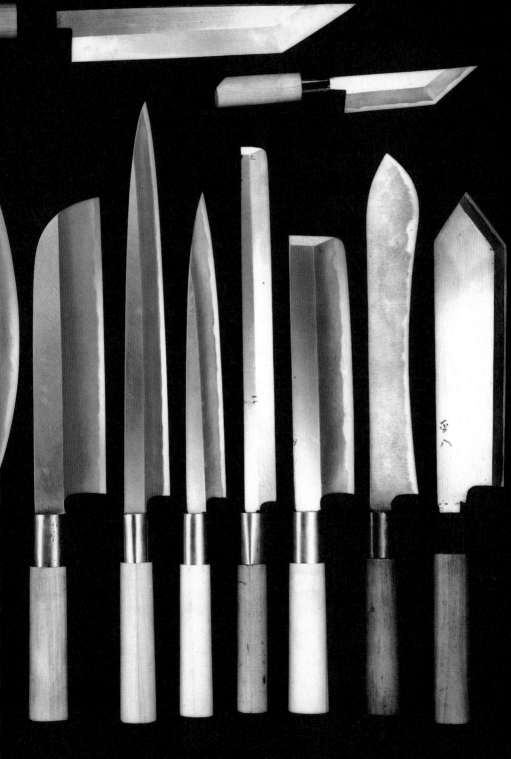

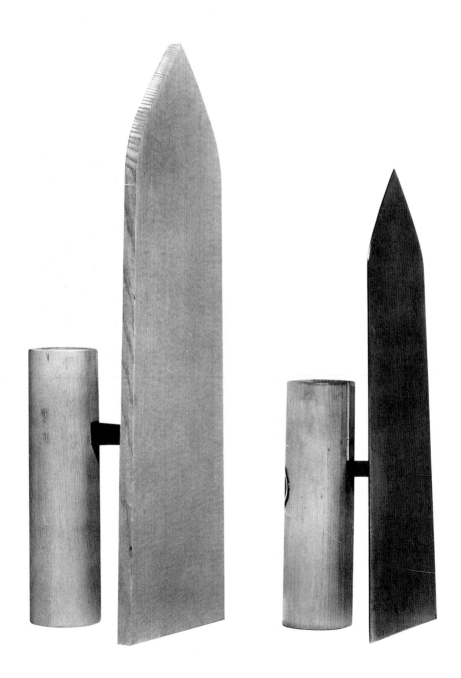

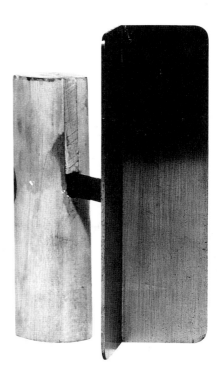
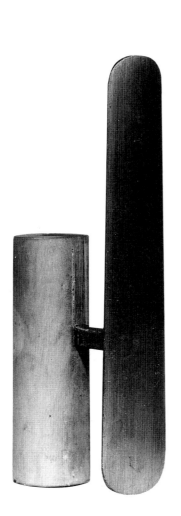

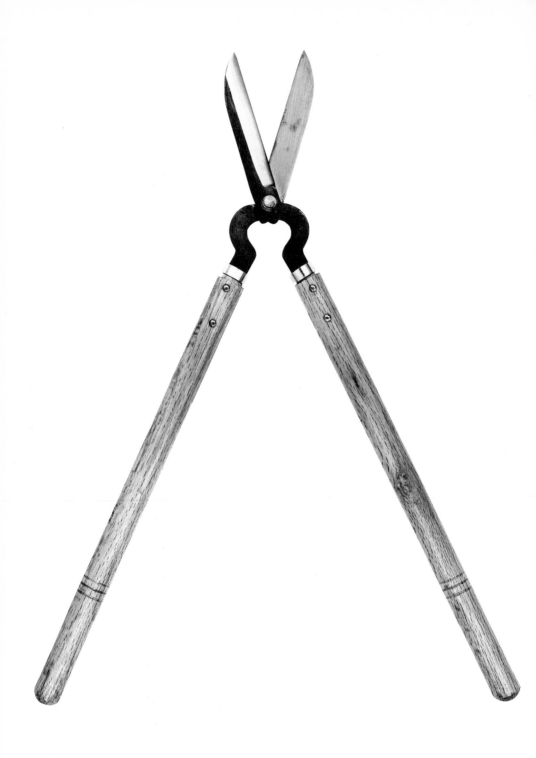

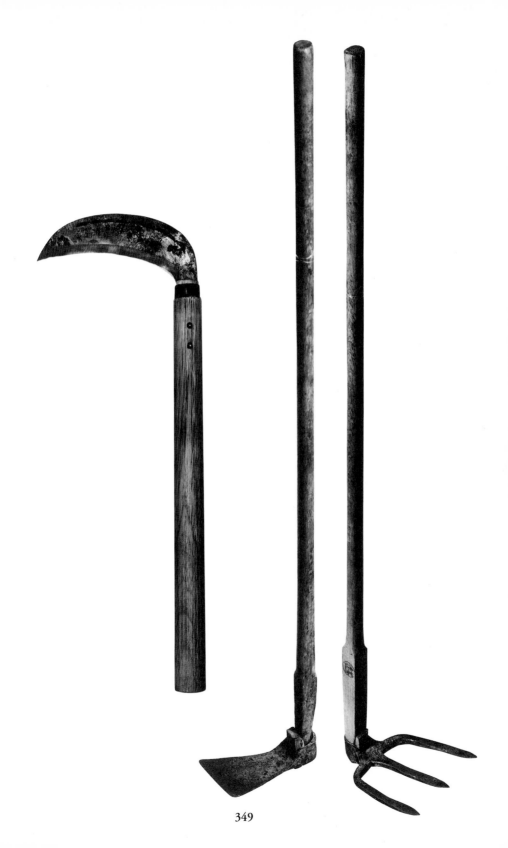

349

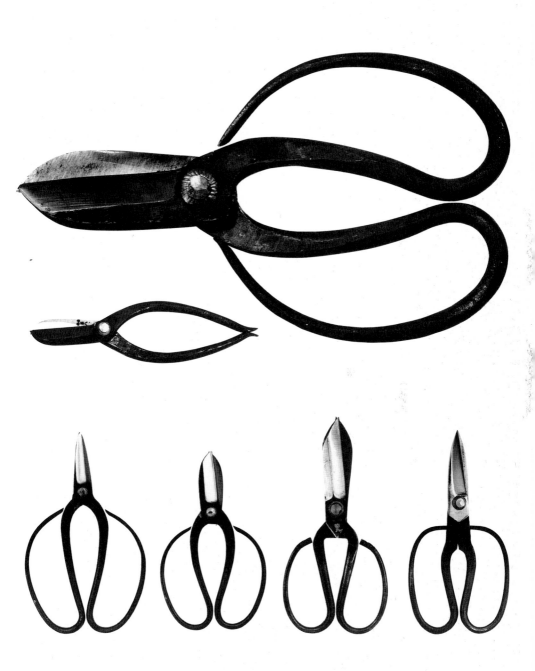

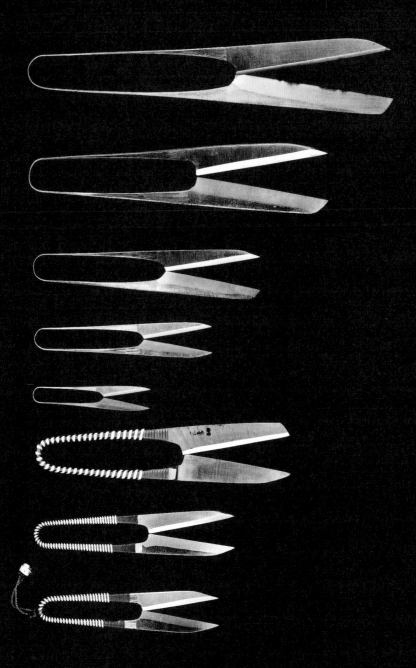

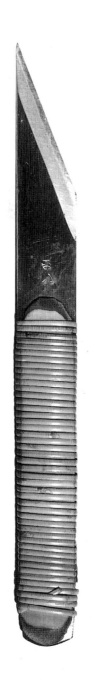
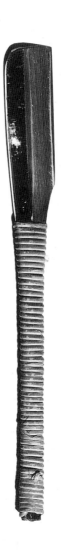

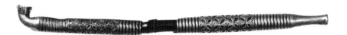

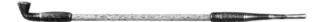

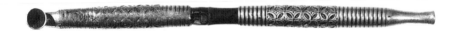

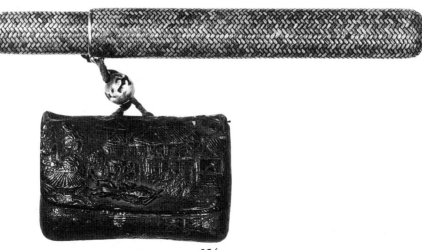

354

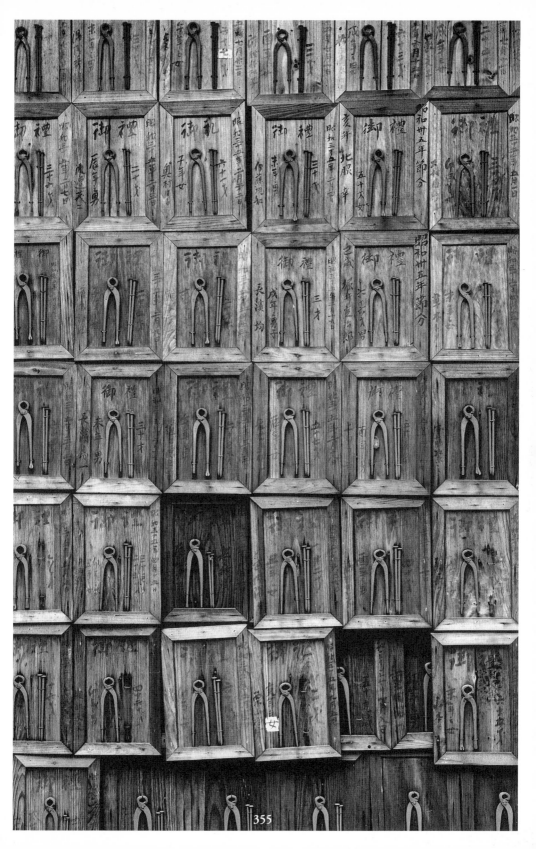

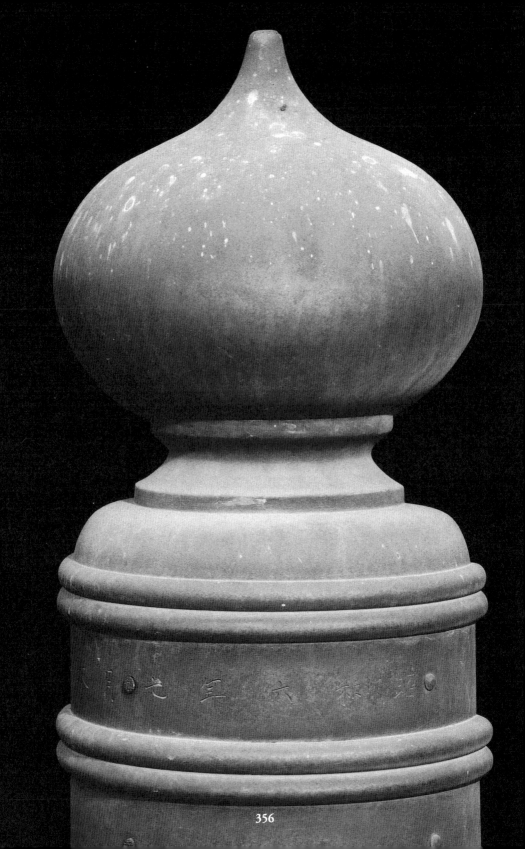

356

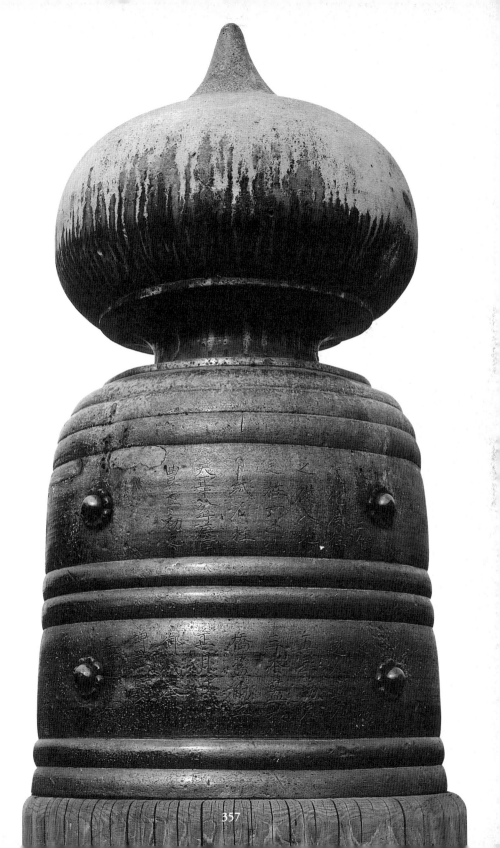

357

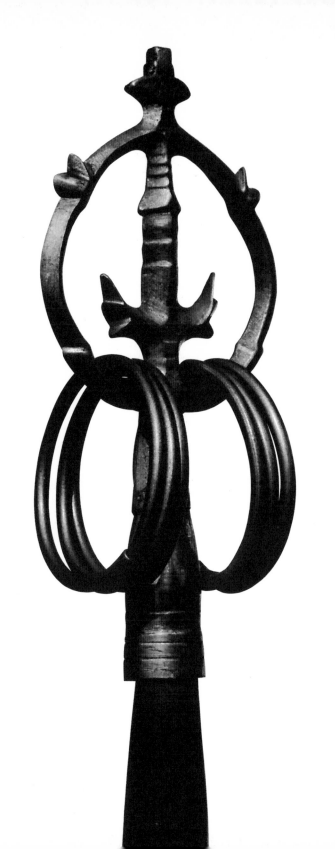

石　　Stone

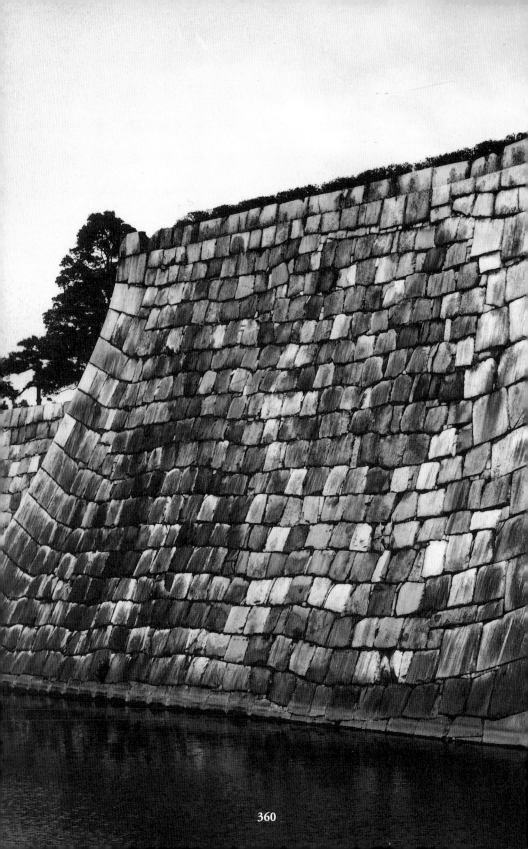

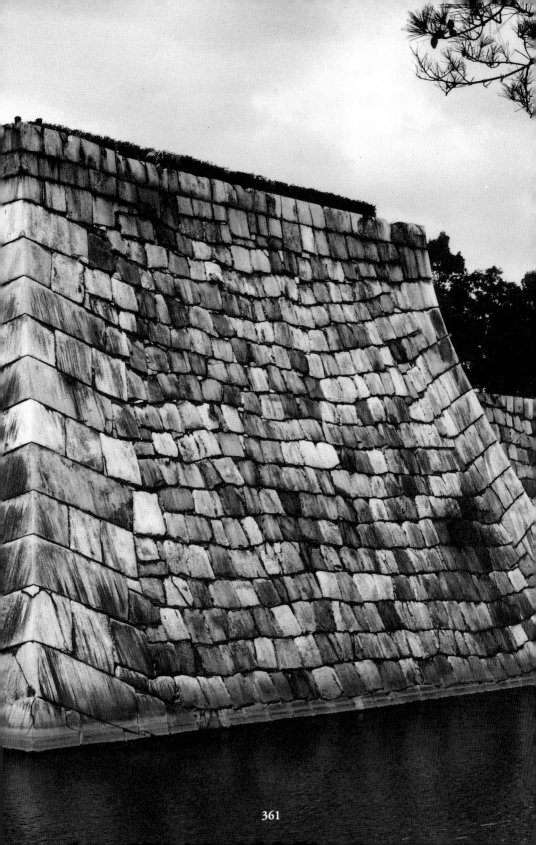

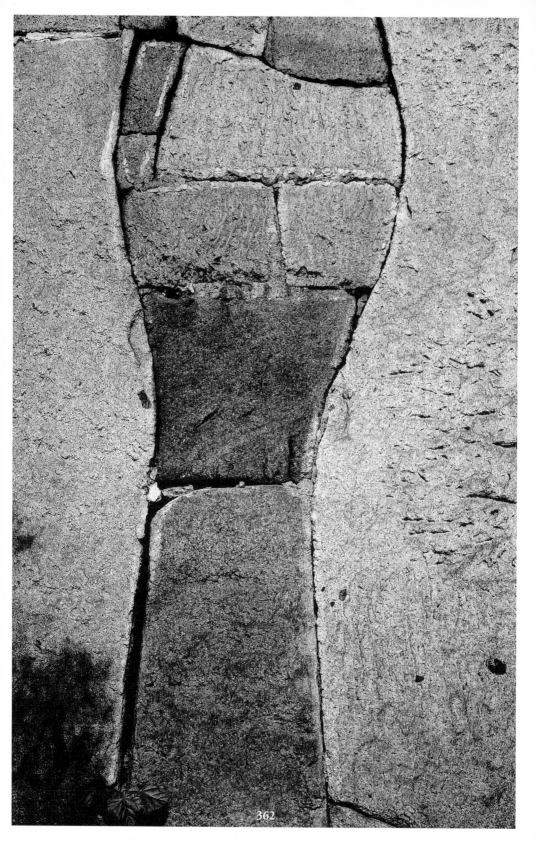

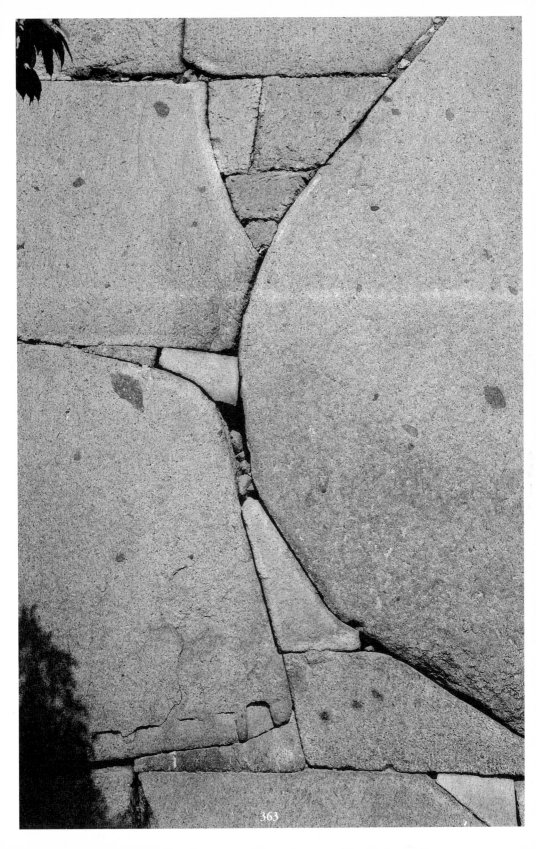

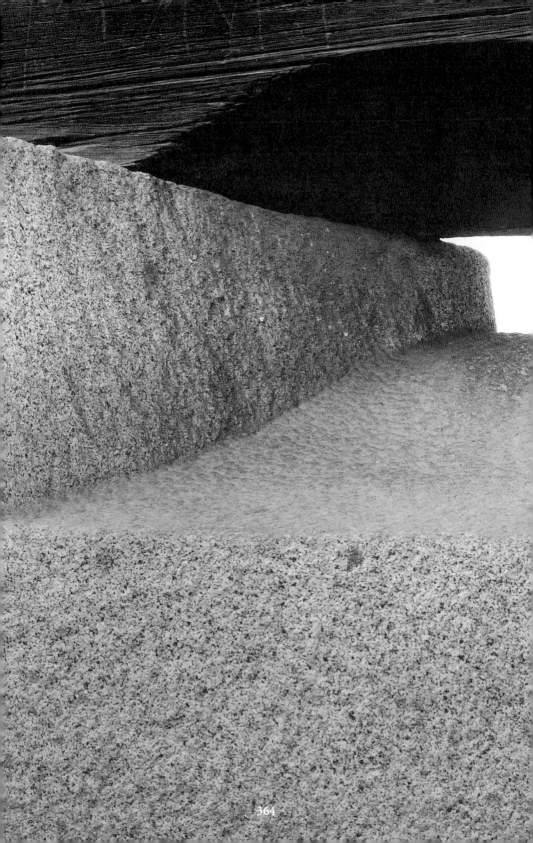

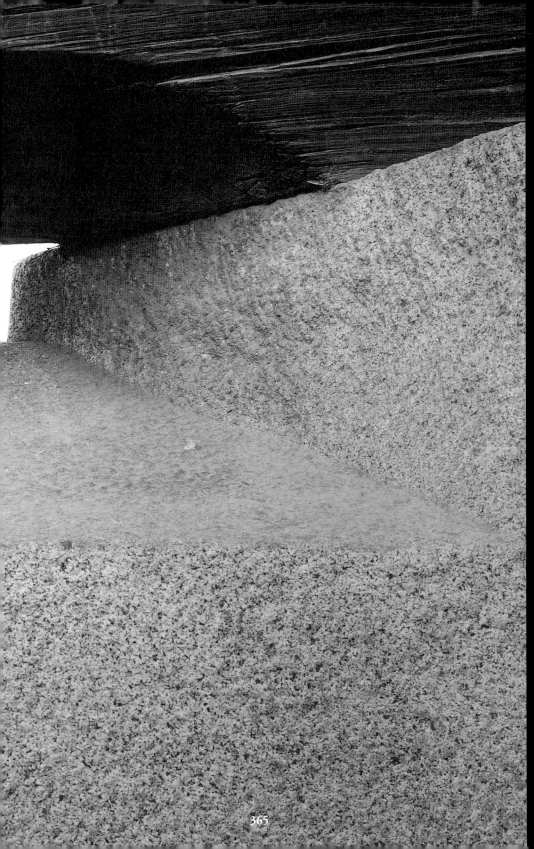

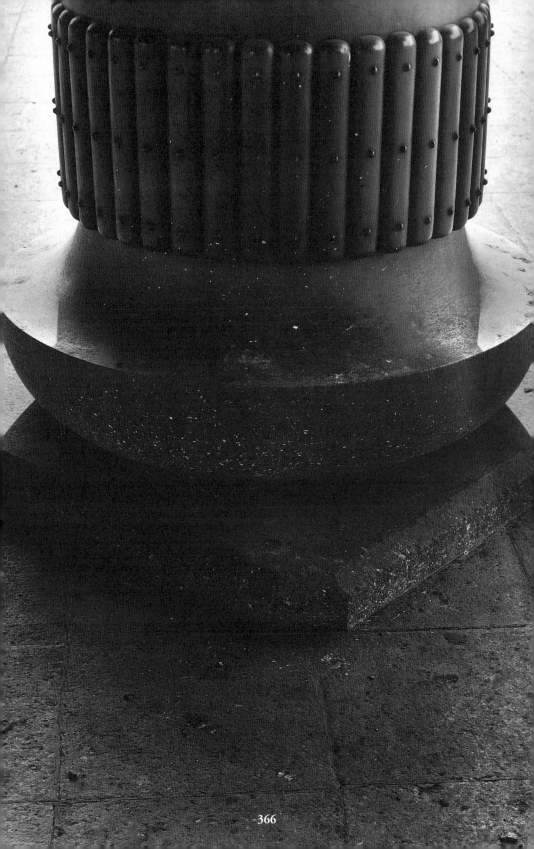

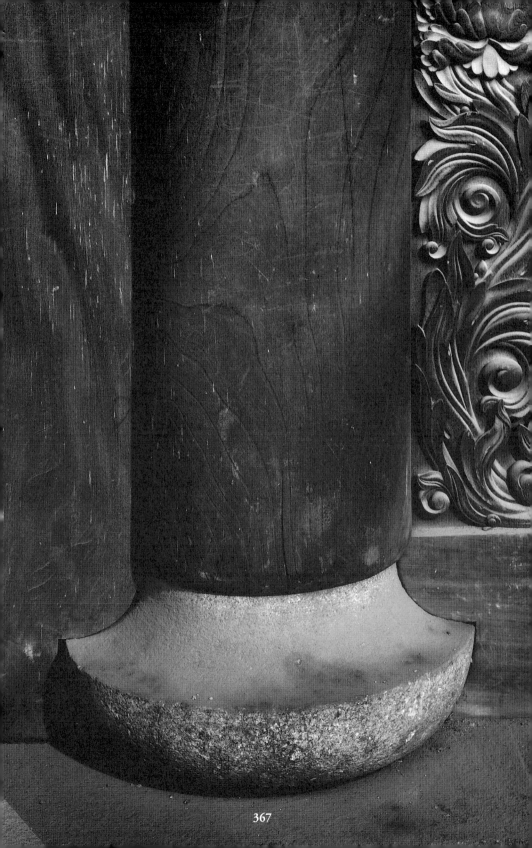

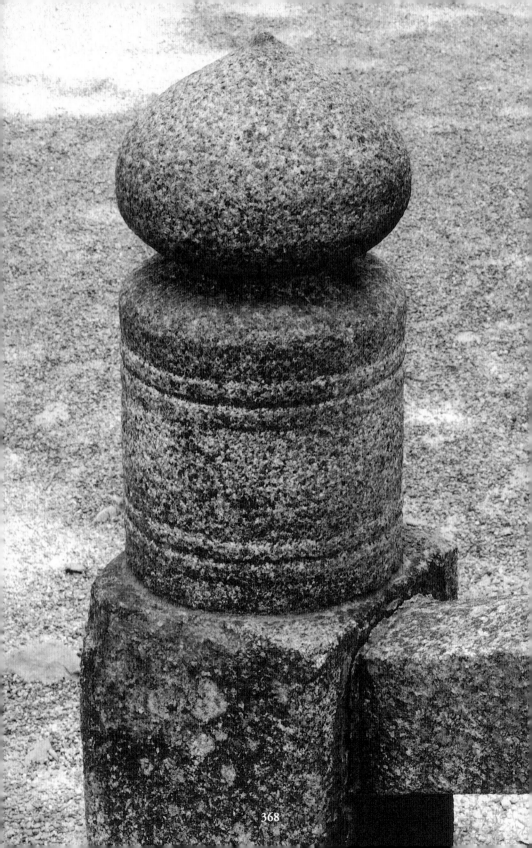

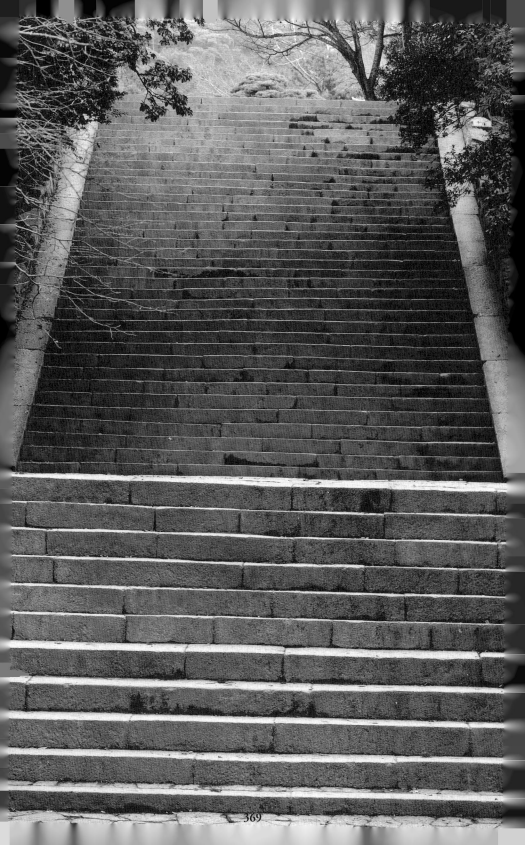

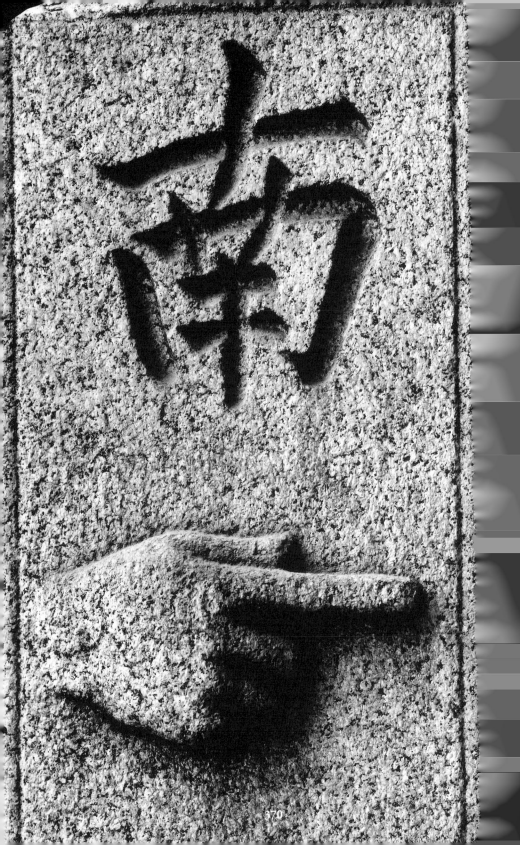

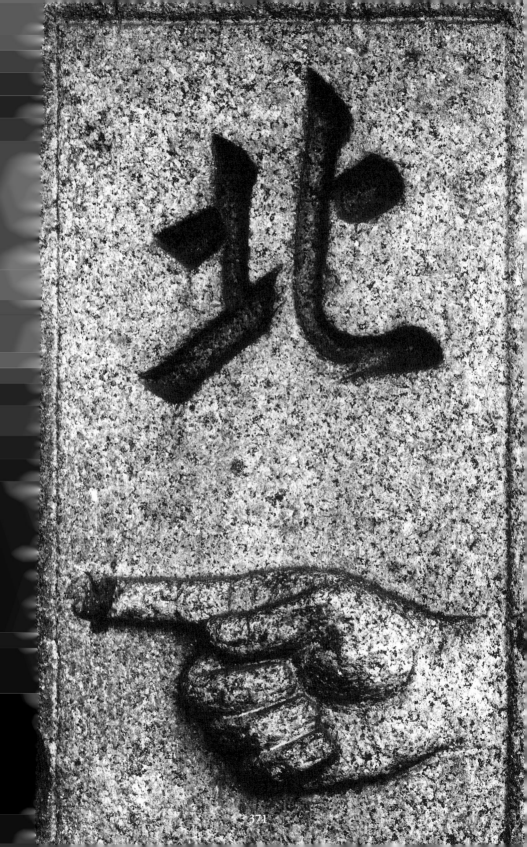

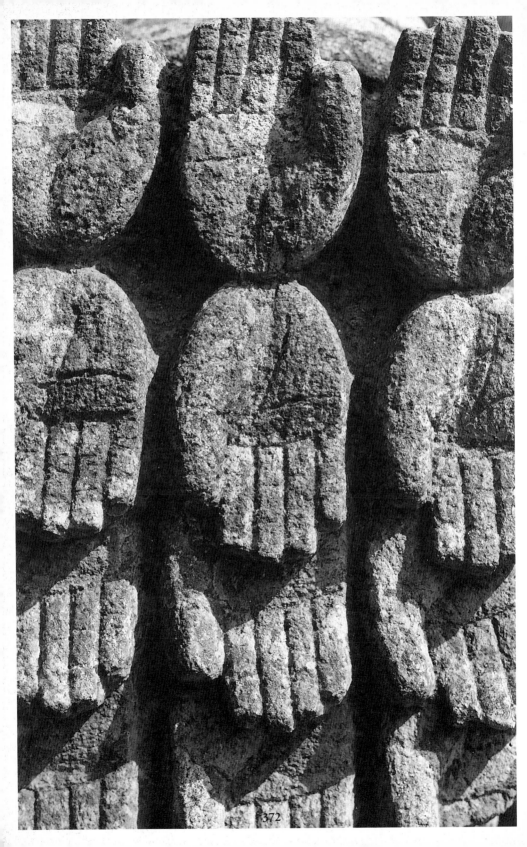

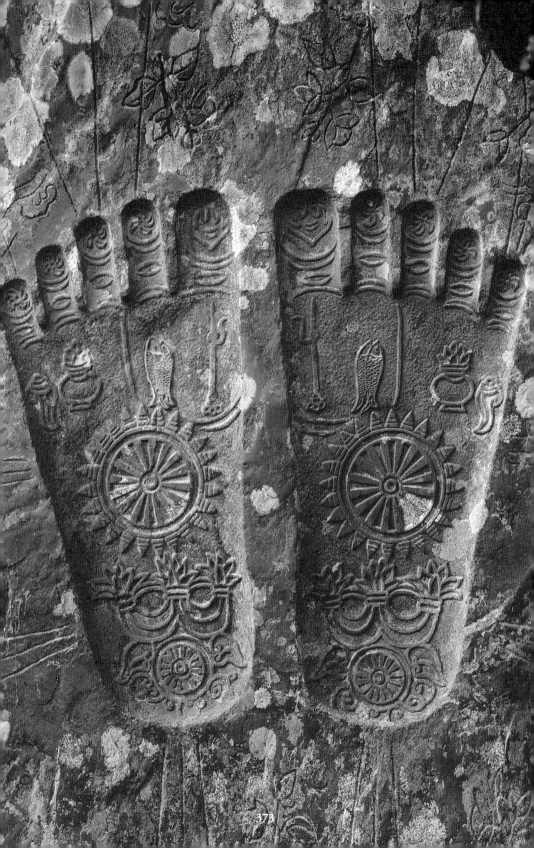

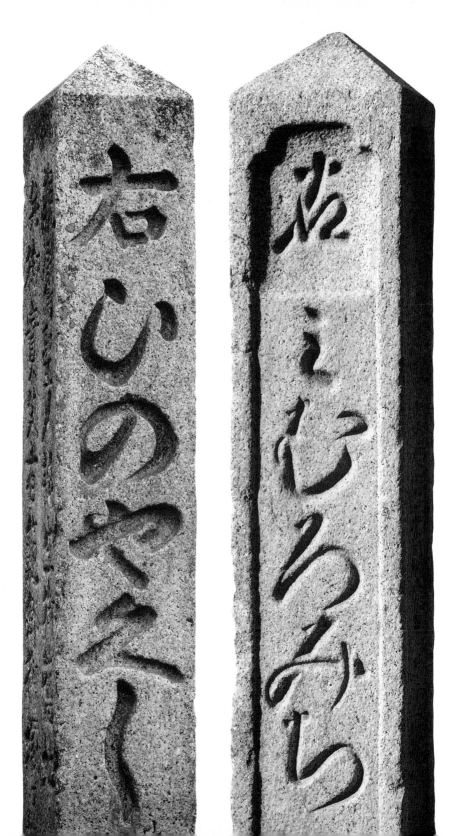

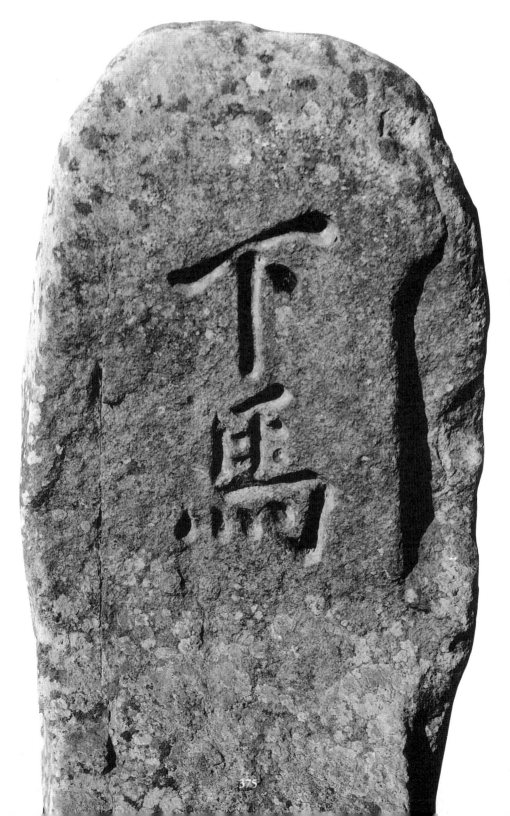

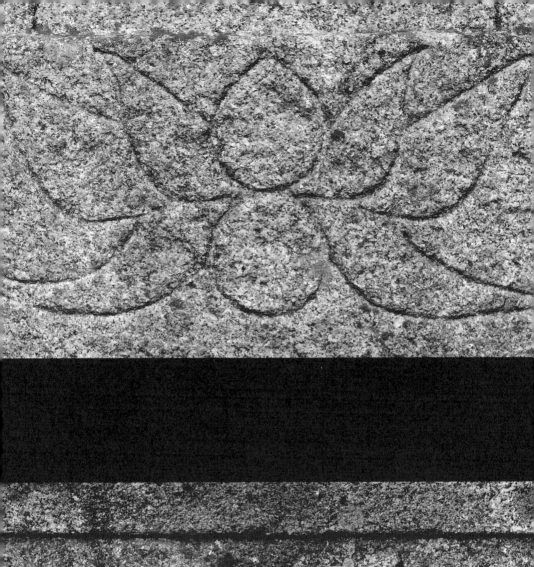
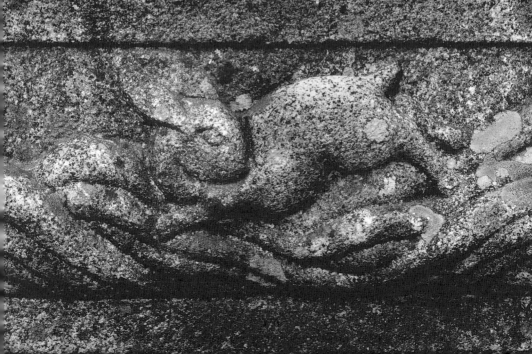

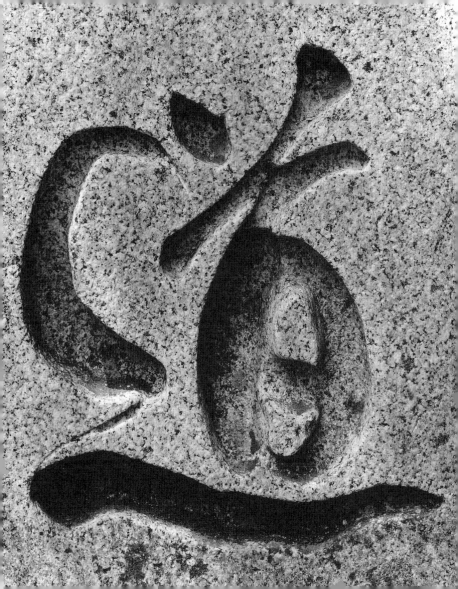

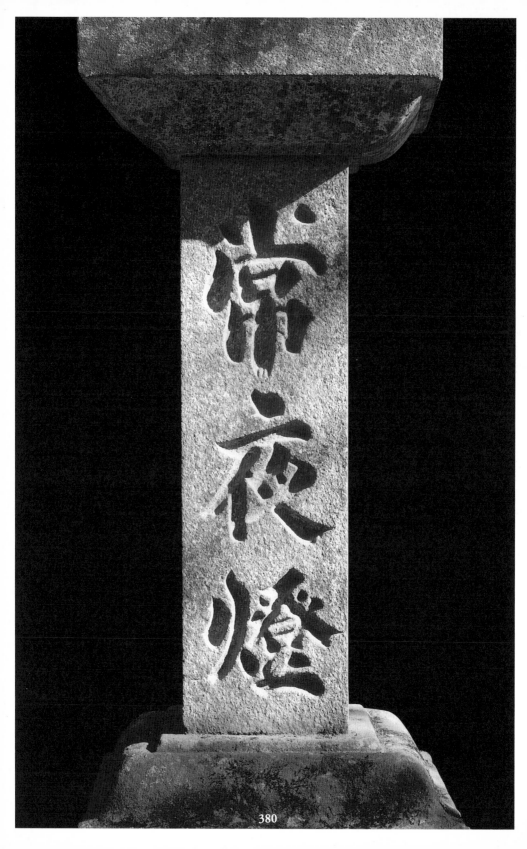

常夜燈

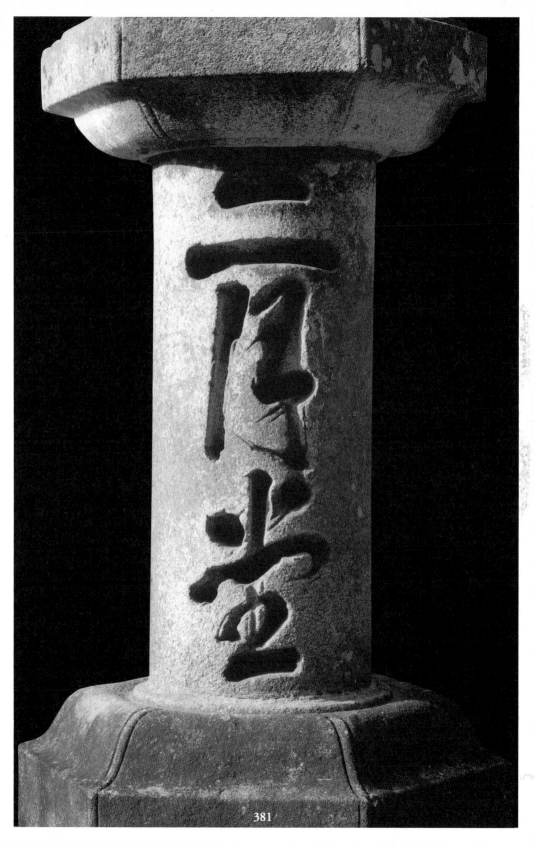

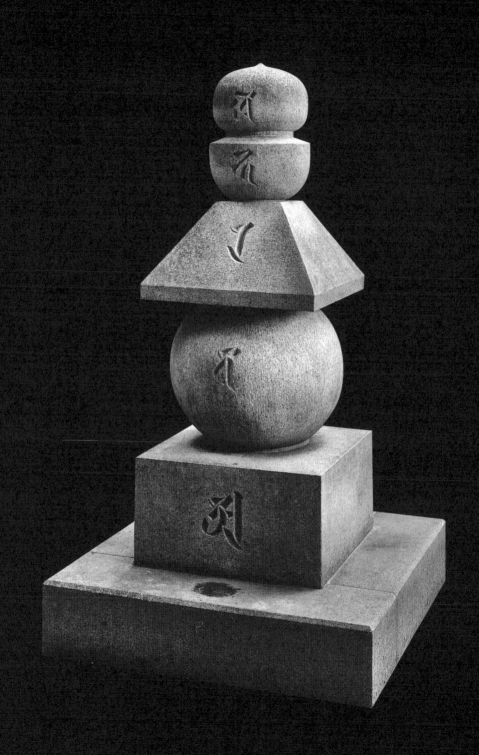

382

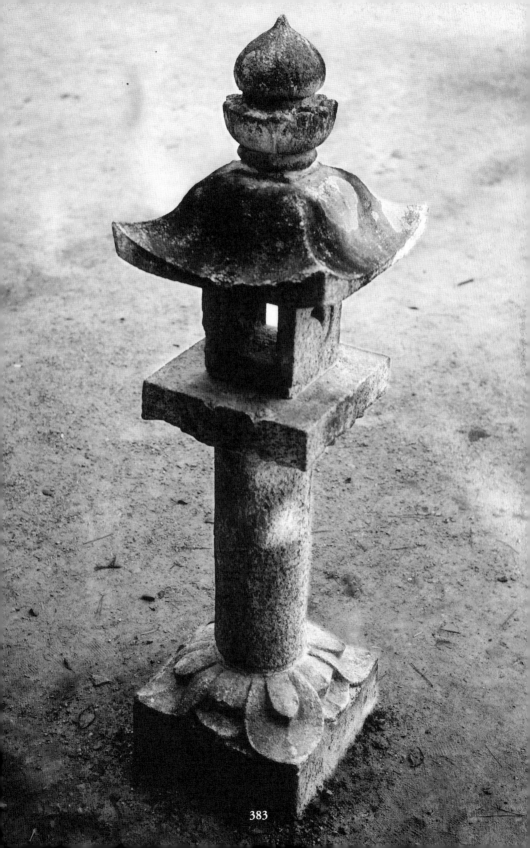

383

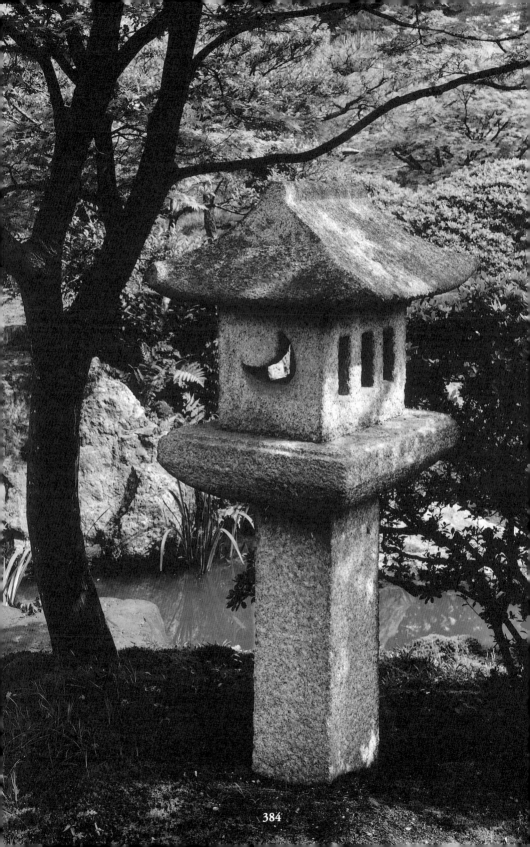

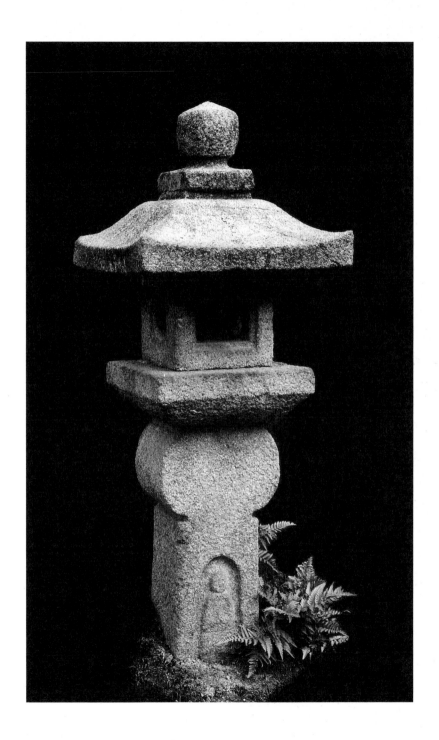

386

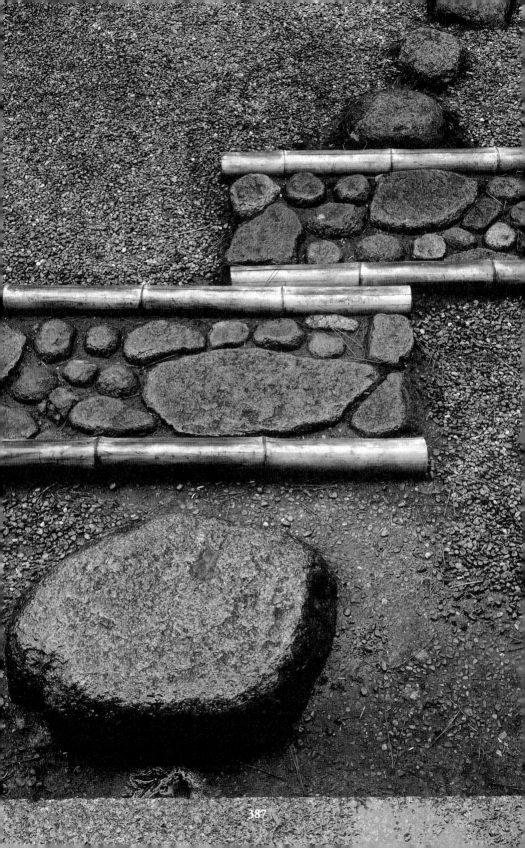

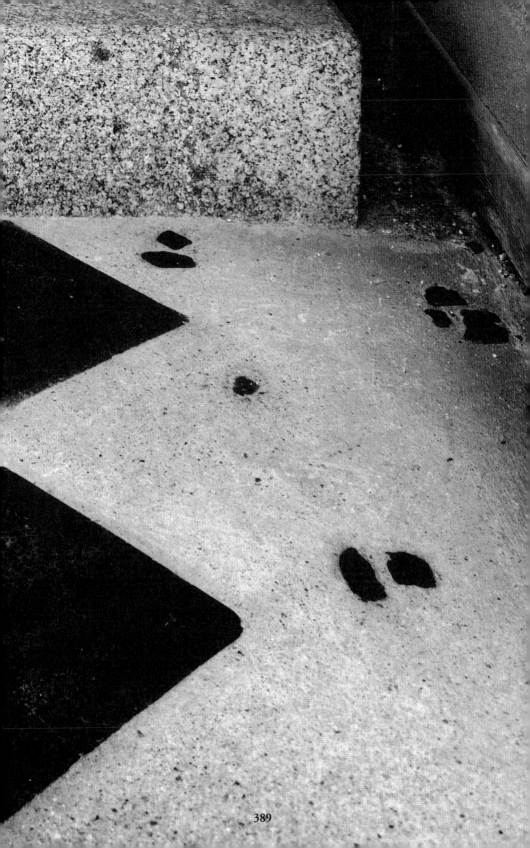

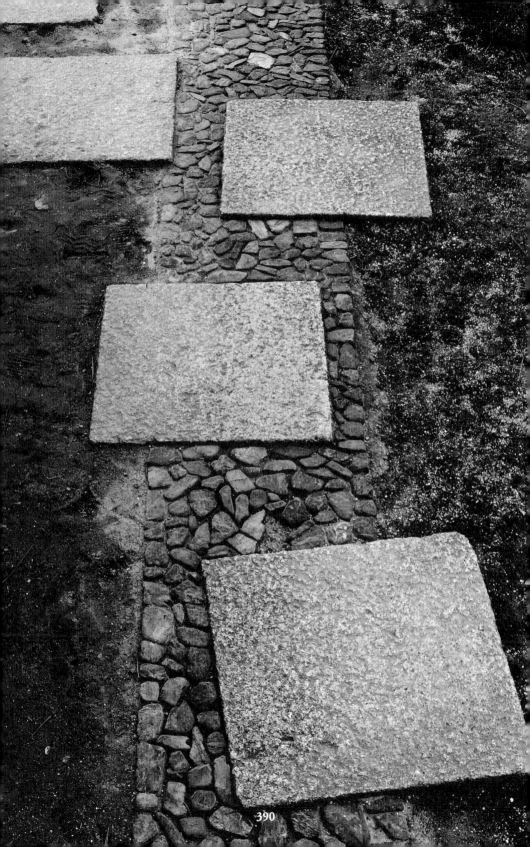

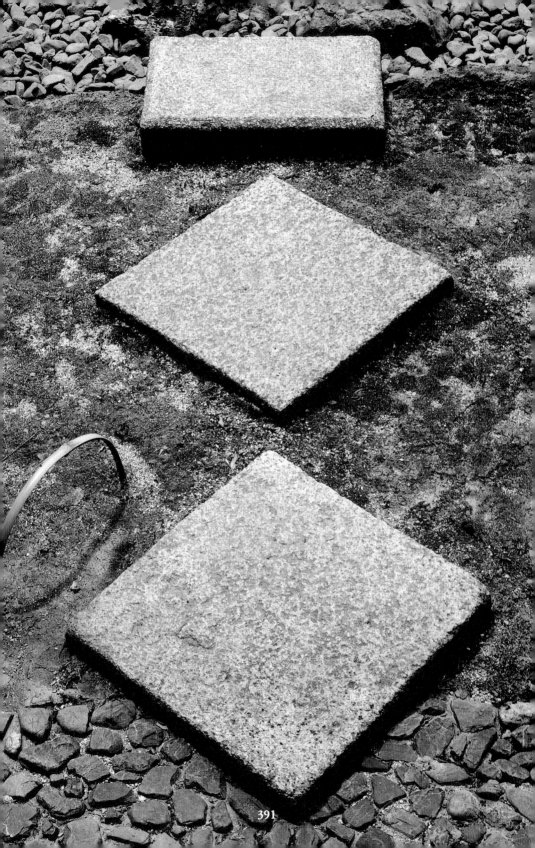

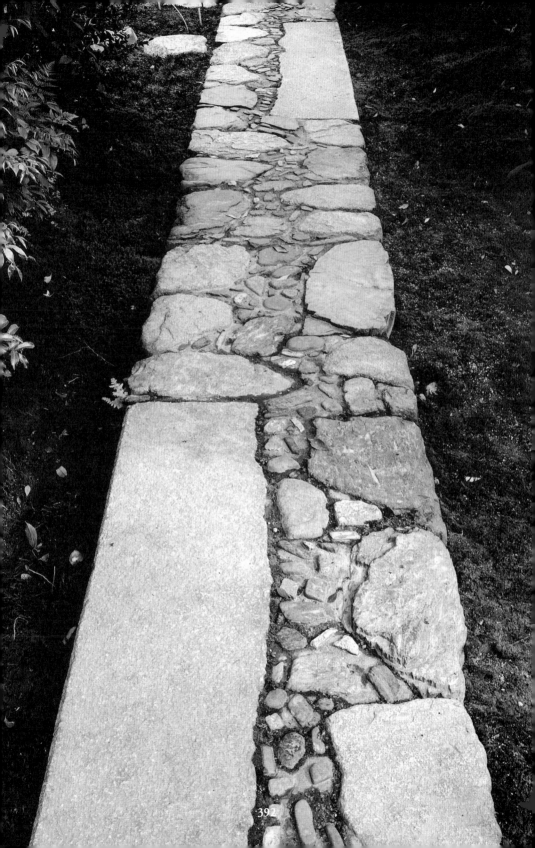

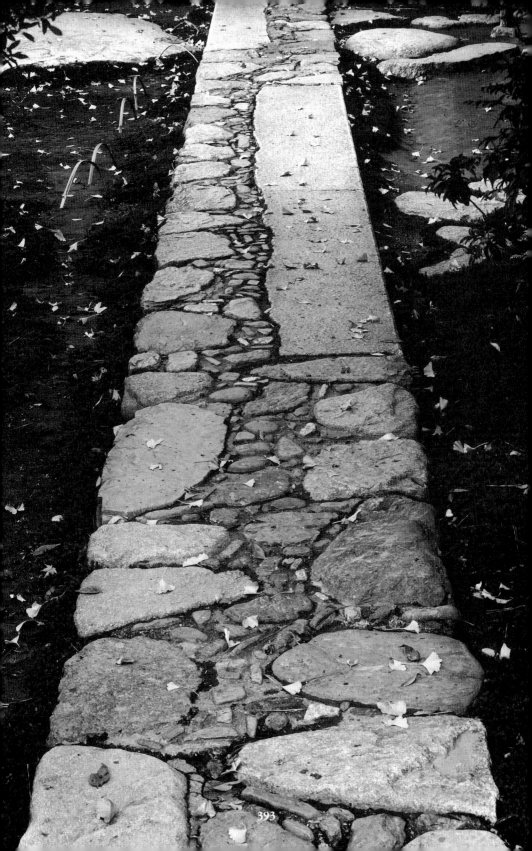

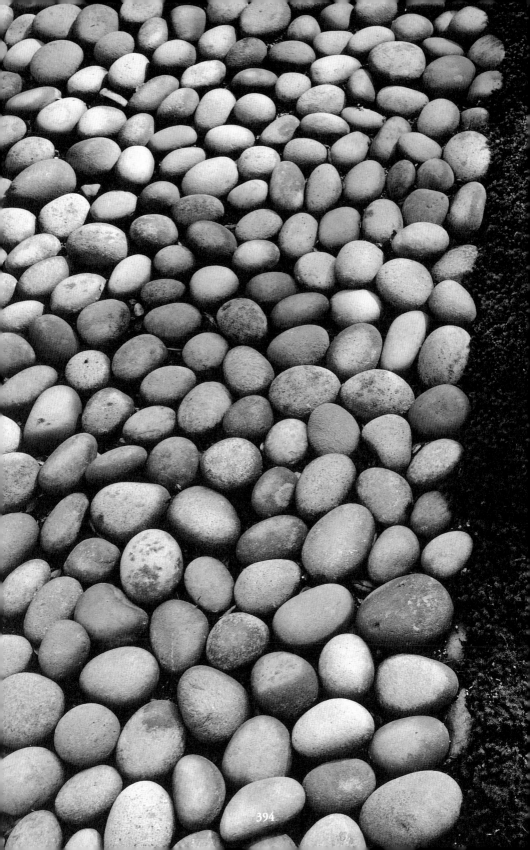

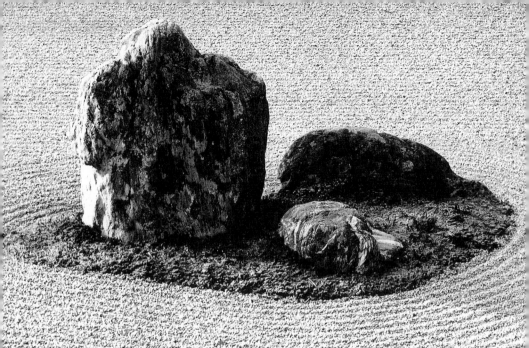

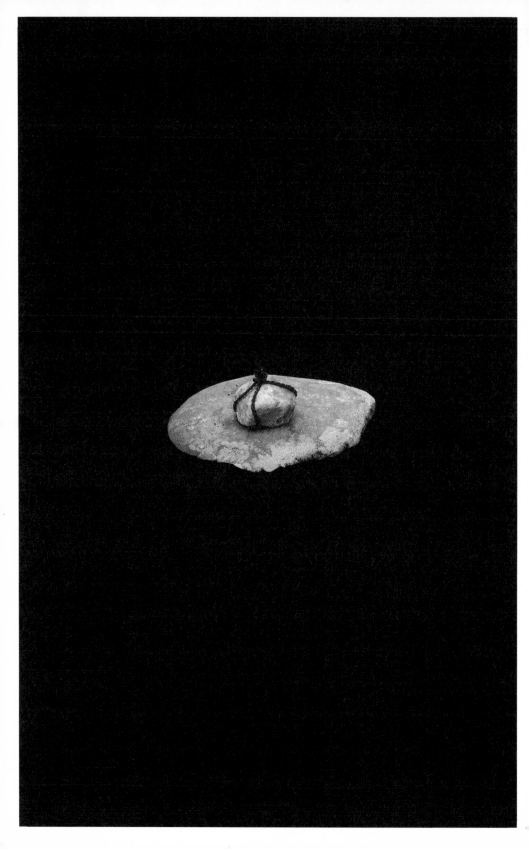

17

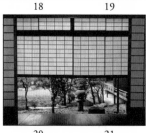

18 19

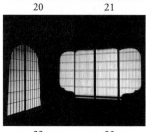

20 21

22 23

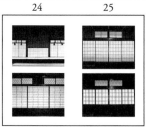

24 25

26 27

17.
Shōji, or sliding panels of paper on wooden frames, serving as doors or windows. The ones seen here are in a traditional *minka* (common house) in Kyoto.
18—19.
Shōji in the guest quarters of the Naka no chaya at Shūgakuin Detached Palace.
20—21.
Unique half-shōji on the entrance to the Bōsen tea room provides a carefully controlled view of the garden at the Daitokuji sub-temple Kohō-an, in Kyoto.
22—23.
Shōji on the decoratively curved windows of the Hiunkaku pavilion at the temple Nishi Honganji in Kyoto.
24—25. 26—27.
Shōji at the Sumiya, in Shimabara, an area once officially licensed as the pleasure quarters of Kyoto. The Sumiya is the only remaining two-story wooden *ageya* building, a place to which geisha were summoned to sing and dance or otherwise entertain, popular in the Edo period (1600–1868). The Sumiya was designated a national important cultural property in 1962. Originality and ingenuity distinguish the designs of its shōji, which are different in each room.

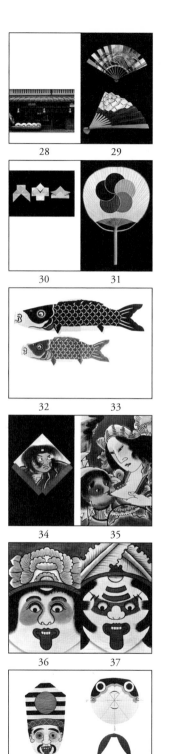

28

29

30

31

32

33

34

35

36

37

38

39

28.

Miyawaki Baisen-an, a 100-year old fan shop on Rokkaku Tominokōji, preserves the architecture and crafts of old Kyoto.

29.

Mai ōgi, or dance fans. The folding fan was invented in Japan in the early Heian period (794–1185). The richly decorated gold paper fans shown here are not used for relief from the heat but for countless subtle expressive functions in traditional dance.

30.

Origami creations. Shown here, from left to right, are a *hakama* (traditional skirtlike trouser garment), a feudal-period serving man, and a helmet.

31.

Uchiwa, or flat fans. The *uchiwa* was introduced to Japan from China during the Nara period (710–794). It is made by splitting bamboo into fine ribs, leaving a length of the stalk intact to form a handle, and then covering the framework with paper or silk. *Uchiwa* are used for ceremonial, utilitarian, and decorative purposes, and vary significantly in form and style.

32—33.

Koinobori, or carp banners. On May 5, Children's Day, families with young sons fly carp banners and streamers on a flagpole topped with a decorative windmill. When the custom originated in the mid-Edo period the banners were made of paper.

34—35. 36—37. 38—39. 40—41.

Tako, or kites. The kite, imported from China, originally had religious and military associations, but became a popular form of amusement among commoners during the Edo period. The brilliantly painted motifs often dictate the shape of the kite and vary regionally.

40 41

42 43

44 45

46 47

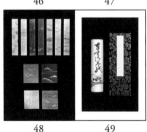

48 49

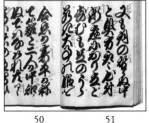

50 51

42—43. 44—45.

Hanafuda, literally, "flower cards." Western-style playing cards, introduced into Japan by the Dutch in the 1570s, became the basis on which the Japanese developed this distinctive card game. It is played with a 48-card deck divided into twelve four-card suits representing flowers and trees from each month of the year.

46—47.

Chōchin, or paper lanterns, came into use in the mid-Muromachi period, to light the streets at night time. They are still hung from the eaves of buildings today, particularly in front of restaurants and during festivals, or carried in festival processions.

48.

Shikishi and *tanzaku*. Papers used for writing poetry, such as waka and haiku, or for painting. *Shikishi* comes in two standard sizes, 21 by 18 centimeters (8.4 by 7 in.) and 27.3 by 24.2 centimeters (10.7 by 9.5 in.); *tanzaku* are a standard 36.4 by 6.1 centimeters (14.3 by 2.4 in.). Both *shikishi* and *tanzaku* are available in either solid white, or in a variety of colors, or color gradations with gold and silver patterns. The light-colored end is the top.

49.

Notebooks. Sheets of paper 18.2 to 19.7 centimeters (7.2 to 7.8 in.) are glued edge to edge and then rolled to create scroll-like notebooks.

50—51.

Jōruri script. A form of narrative chanting accompanied by the samisen. *Jōruri* emerged in the mid-Muromachi period (1333–1568). Today it is an integral part of *bunraku* puppet theatre.

52 53

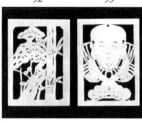

54 55

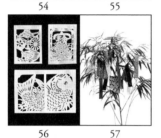

56 57

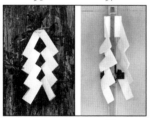

58 59

60 61

62 63

52.

Kiyomoto script. A form of narrative chanting accompanied by samisen and other instruments for kabuki. *Kiyomoto* was developed in the Edo period. The melody is bright and high-pitched.

53.

Tokiwazu script. Another form of narrative chanting accompanied by samisen and other instruments in kabuki. Like *kiyomoto*, it was also developed in the Edo period. The melody is less emotional and more dramatic than other forms of kabuki music, making it particularly suitable for dance dramas.

54—55. 56.

Kirigami, or paper cutouts, are pasted on Buddhist family alters or door lintels at New Year's, and on Shintō family alters and crossbeams during festival periods.

57.

Ornaments for Tanabata, or the Star Festival, celebrated on either July 7 or August 7, according to the use of either the modern or the lunar calendar. Fresh boughs of bamboo, decorated with strips of colored paper bearing poems or prayers for progress in calligraphy (the written sheets shown here), sewing (the miniature paper kimono), and other aspirations are displayed in front of homes and shops.

58.

Gohei, or ritual Shintō paper ornaments, on a bough of sacred *sakaki* tree attached to the south gate of the Yasaka Shrine in Kyoto.

59.

Gohei at the Kitano Shrine in Kyoto.

60—61. 62.

Mizuhiki and *noshi*. Both serve as ornaments for special occasions. *Mizuhiki*, made of twisted paper cords stiffened with a starch-and-water solution, decorate gifts and utensils. At festive times they are red and white, gold and silver, or gold and white. For sorrowful occasions they are black and white or blue and white. For weddings the paper cords are intricately worked. *Noshi* is a decoratively folded paper label, which is an element of formal gift wrapping, adhered to gifts for happy occasions.

63.

Folded red and white handmade paper decorated with the traditional felicitous emblems *shōchikubai*—pine, bamboo, and plum blossoms—and with a *mizuhiki*, or knotted paper cord, of gold and silver and placed on top of a lacquer pot for the spiced and sweetened sake (*toso*) drunk at New Year's to ward off evil.

64 65

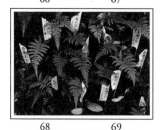

66 67

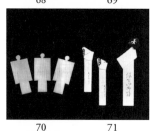

68 69

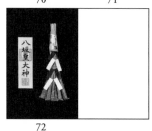

70 71

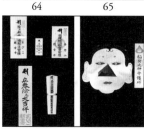

72

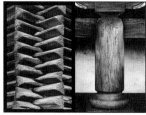

74 75

64—65.

Ema, or pictorial votive offerings, usually painted on wooden plaques. The *ema* shown here is sold at the *ema* market of Mt. Matsukura in the city of Takayama, Gifu Prefecture. *Ema* were first offered to insure the well-being of horses and cattle, but eventually evolved into prayers to provide family safety, financial success, and other benefits.

66.

Gofu, or protective amulets, like this one from the Abiko Kannon Temple in Osaka, are issued at Shintō shrines and Buddhist temples. Also known as *omamori* or *ofuda*, they are believed to provide protection from harm, bring good health, household safety, financial success, easy childbirth, and so forth.

67.

Protective talisman affixed to the entrance to the Sumiya —all of which are from the Sumiyoshi Shrine in Kyoto —to ensure domestic security and to ward off disease.

68—69.

Paper flags. Small paper flags, approximately 20 centimeters (8 in.) high, erected along the approach to the Fushimi Inari Shrine as votive offerings.

70.

Paper images in human form. They are used in ritual purification ceremonies.

71.

Talisman folded in traditional love-letter style. The one at the far right is decorated with a paper plum blossom.

72.

Protective talisman (*gofu*) from the Yasaka Shrine in Kyoto and ritual Shintō paper ornament (*gohei*) on a cluster of *chimaki*. These *chimaki*—a festive food made by steaming glutinous rice in bamboo leaves—are distributed as talisman during the famous Gion Festival in Kyoto, hence decorated with red and white paper ornaments as used in Shintō rituals.

74.

Corner of an *azekura*, or log storehouse, at Nigatsudō in Nara. *Azekura*-style storehouses—popular during the Nara period (710–794)—are constructed of horizontally stacked round, square, or triangular timbers, the latter of which (shown here) form a flat surface on the interior, and a corrugated-like exterior.

75.

Detail of a cloud-shaped bracket and bearing block on the main hall of Higashi Honganji Temple in Kyoto.

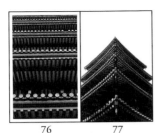

76 77

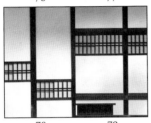

78 79

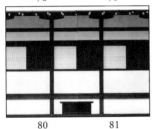

80 81

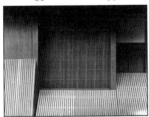

82 83

84 85

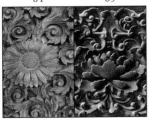

86 87

76.
Detail of the orderly system of rafters and eave end tiles on the five-story pagoda at the temple Daigoji in Kyoto.

77.
Five-story pagoda at the temple Hōryūji in Nara.

78—79.
Renji mado, or barred windows, in a temple gate at Shōren'in, Awataguchi (left); and to obstruct unwanted entries at Kyoto Imperial Palace (right).

80—81.
Contrasting fenestration seen on an exterior wall of the Kogosho building at Kyoto Imperial Palace.

82—83.
Delicate perpendicular lines of the bowed *inu-yarai* (literally, "dog palisade") and latticed bay window contrast the heavier pillar, crossbeam, and window frame timbers. Typical features of *minka* residences in old Kyoto, the detail shown is from the Ichirikitei in the Gion district.

84.
Round pillar of a covered corridor at the temple Tōdaiji in Nara.

85.
Shōji door pulls.

86.
Relief-carved chrysanthemum arabesque motif on the main gate of the temple Higashi Honganji in Kyoto.

87.
Relief-carved peony arabesque motif at the Tōshōgu Shrine in Nikkō.

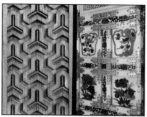

88

89

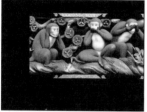

90 91

92 93

94 95

96 97

98 99

88.
Stylized tortoise-shell relief pattern on the side walls of the main gate at Higashi Honganji.

89.
Double doors of the Karamon gate at the Tōshōgu Shrine in Nikkō, decorated with inlaid bas-relief sculptures of exotic woods in their natural colors against carved whitewashed panels and frames.

90—91.
Relief-carving of the see-not, hear-not, and speak-not monkeys at the Tōshōgu Shrine. In Japanese, the word "monkey" (*saru*) is a homonym for "not," hence the pun.

92—93. 94—95. 96—97.
Geta, or wooden clogs composed of a thong attached to a wooden base. *Geta* have been traced back to the Yayoi period (ca. 300 BC to–ca. AD 300), when they were worn for working in the paddies, but came into wide use in the Edo period (1600–1868). The platform is usually made of paulownia wood, which is strong and light. Shown here are men's *geta*.

94—95.
Women's *geta*.

96.
Lacquered women's *geta*.

97.
Lacquered girl's *geta* (top), and curved women's *geta* (bottom).

98—99. 100—101. 102—103.
Boxwood combs for dressing and ornamenting the feminine coiffure have been popular since the Heian period (794–1185). Shown here (from left to right) are: the Genroku comb, the spatula comb, the halberd comb, and the Shinagawa comb.

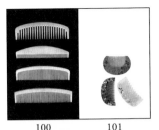
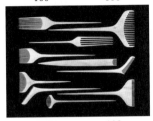

100 101

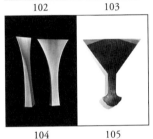

102 103

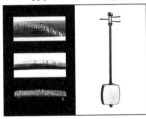

104 105

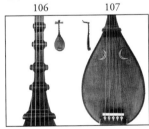

106 107

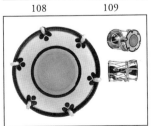

108 109

110 111

100.

Boxwood combs. Shown here (from top to bottom) are: the coarse comb, the flowing comb, the square-and-round comb, and the Rikyū comb.

101.

Ornamental combs.

102—103.

Boxwood combs. Shown here (from top to bottom) are: a comb for smoothing separations, the Shinagawa comb, the five-toothed comb, the Miyako comb, the spatula comb, the halberd comb, a smaller Shinagawa comb, the Genroku comb, the rat-tooth comb, and the clam comb.

104.

Samisen plectrums. Wooden plectrums are made from boxwood or oak; ivory plectrums are also common.

105.

Biwa plectrum. The base of the handle is shaped like a ginko leaf.

106.

Koto, or Japanese zither. The *koto* is about 2 meters (6 ft.) long, 15 centimeters (6 in.) wide at the upper edge and 24 centimeters (9.5 in.) wide at the lower edge. Thirteen strings run the length of the bowed top, made of paulownia wood, supported by moveable ivory bridges. It is plucked with small picks worn on the thumb and first two fingers of the right hand.

107.

Samisen, or three-stringed lute, consists of a wooden soundbox covered with cat or dog skin, a long unfretted neck, strings, bridge, and pegs. The wooden portions are made of sandalwood, mulberry, or quince; the strings of twisted silk or nylon; and the pegs of wood or ivory. It is plucked with a large wood-and-ivory plectrum and enjoys great popularity as accompaniment for traditional songs and kabuki and puppet dramas.

108—109.

Biwa, or short-necked lute. Four- and five-stringed lutes from India or regions west passed through China to reach Japan in the Nara period. *Biwa* of various styles and schools have developed over the centuries, differing in size, number of frets (four to six), positions held in, tunings, finger techniques, and notation systems.

110—111.

Tsuzumi, or hand drum. Originated in China but perfected in Japan, the *tsuzumi* is held on the left shoulder with the left hand, which also adjusts the cord for sound effects, and is struck with the right hand.

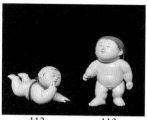

112 113

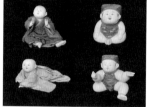

114 115

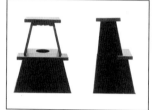

116 117

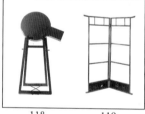

118 119

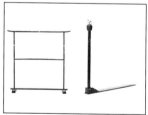

120 121

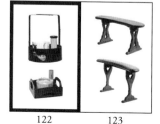

122 123

112—113. 114—115.

Gosho ningyō, or palace dolls. A new form of *kyō ningyō* that flourished in the Edo period. *Gosho ningyō* portray chubby, nude infants with characteristically large, round heads and smooth white skin, epitomizing the cherubic qualities of infanthood.

116—117.

Fumidai, or step stool. Commonly kept in the living room of homes for use as needed, the first step has a box-like structure, inside which string, tape, or other such dispensable items can be stored.

118.

Mirror and stand. Chinese-style handleless metal mirrors were made in various shapes through the ages, but it was not until the Edo period that handled mirrors and mirror stands were developed.

119.

Lacquered kimono rack composed of two sections hinged at the center.

120.

Lacquered kimono rack. A footed, single span rack. The *torii*-shaped top bar is a late characteristic.

121.

Post-mounted pincushion. The fabric being sewn is attached to the cord on the post to aid handling.

122.

Tabako-bon (literally, "tobacco tray"), or smoking set. The cylindrical container, generally made of bamboo, serves as the ashtray; the overturned pipe is tapped on the rim to remove the ashes.

123.

Arm, or elbow rest. Two early-style armrests, dating from the Nara period, are preserved in the Shōsō-in repository. The style used today, shown here, was developed in the Edo period.

124—125.

Nagahibachi, or long brazier. The name derives from the rectangular tabletop framing the brazier on four sides. Drawers for storing small items are set into the base. The pit for ashes and charcoal is lined with copper; a footed iron rest and pot for heating water is set on top. Metal chopsticks (center) are used for handling hot charcoal, and a metal scoop (right) for removing ashes.

126.

Go board and stones. The stones are stored in wooden bowls; the white stones made of polished clam or squilla shells, and the black stones of Nachi slate. Some historical accounts cite ancient China as the country of origin, while others trace it to India.

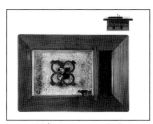

124 125

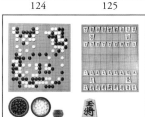

126 127

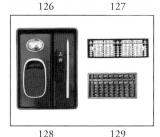

128 129

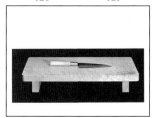

130 131

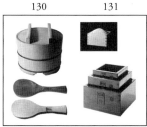

132 133

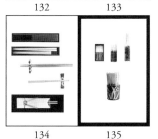

134 135

127.

Board and pieces for *shōgi*, referred to in the West as Japanese chess. The prototype for *shōgi*, as well as Western chess, is believed to have originated in India, but the Japanese have modified it beyond recognition. The major alteration is that an opponent's captured pieces may be used as one's own pieces.

128.

Suribako, or writing box, containing waterpot, inkstone, ink stick, and brush. *Suribako* are lidded and come in many sizes and shapes. They are frequently lacquered in any of several colors and decorated with *maki-e* sprinkled gold and silver dust, or inlaid mother-of-pearl.

129.

Soroban, or abacus. Invented in China, the abacus was introduced into Japan in the late sixteenth century. It has since been modified considerably and is used somewhat differently than its Chinese counterpart.

130—131.

Footed cutting board, or *mana-ita*, generally made of cypress, magnolia, or oak. The traditional wooden-handled steel knife shown here is designed exclusively for gutting and cutting fish.

132.

Top: *Meshibitsu*, or lidded vessel for cooked rice. Though sometimes lacquered, they are mostly of unfinished wood. Bottom: *Shamoji*, or paddlelike implement for serving rice, usually of unfinished wood, lacquered wood, or bamboo. *Shamoji* are believed to bring good fortune, and have been sold by Buddhist temples and Shintō shrines since the early Edo period.

133.

Masu, or boxes for measuring volume. The *masu* system of measure was standardized by Toyotomi Hideyoshi in 1586 as it is used to this day. Unfinished boxes (above) are used for dry measure, and lacquered boxes (below) for liquid.

134.

Hashi, or chopsticks. From top to bottom are: husband-and-wife chopsticks in a lacquer box; Rikyū *bashi*, named for the famous sixteenth-century tea master; square chopsticks, and willow chopsticks wrapped for auspicious occasions.

135.

Yōji, or toothpicks. Originally made primarily of willow (*yō*)—hence called *yōji*. Recently spicebush, peach, cedar, and bamboo are also used.

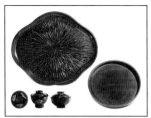

136 137

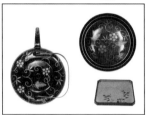

138 139

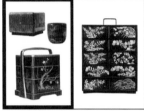

140 141

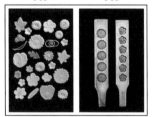

142 143

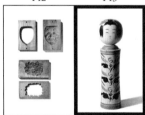

144 145

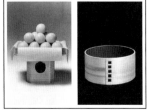

146 147

136—137.

Lacquer trays and soup bowls. Lacquer trays are used both to carry dishes to and from the table, and are placed on the table to contain the place setting. Soup bowls come lidded and unlidded; decorated soup bowls are used for special occasions.

138—139.

Lacquerware. Top view of a lacquered pot used for serving spiced sweetened sake (*toso*) at the New Year. Like the matching set of three sake cups, it is decorated with a pine, bamboo, and plum-blossom motif—symbols of grandeur, resilience, and courage, respectively, and favored for New Year decorations.

140.

Lacquer boxes and containers. Tiered food boxes (*jūbako*) came into general use during the late Muromachi period (1333-1568), and are still used today to hold delicacies for the New Year's holidays and the Girl's Festival on March 3. Handled tiered boxes are designed for carrying meals on outings to view the cherry blossoms or the autumn foliage. Both varieties are often richly decorated as shown. The *natsume* container for powdered tea shown here has a decorated lacquer finish, although they are frequently of unfinished wood.

141.

Lacquer portable cabinet for holding poetry anthologies, decorated with a *maki-e* (sprinkled gold and silver dust) motif of autumn grasses. Kōdaiji, Kyoto.

142.

Higashi, or dried confections, made of sugar and bean flour pressed in molds, appear in a variety of shapes —chrysanthemum, camellias, cherry, and plum blossoms, maple leaves, pine needles, flowing water, and countless others.

143. 144.

Higashi molds, usually made of cherry wood.

145.

Kokeshi doll. Wooden dolls with a round head attached to a cylindrical body with no limbs, typical of the Tōhoku region of northern Honshu. They are classified into ten types according to lathing techniques, form, and decoration. Most are painted with a girl's face, and a floral motif on the body.

146.

Footed ceremonial tray (*sanbō*). Although in ancient times, trays of this type were used for serving meals, today they are restricted to Shintō or Buddhist offerings. The *sanbō* is square in form and made of planed cypress, shown here with an offering of rice dumplings (*dango*).

147.

Kensui basin for rinse water, shown here of bentwood and lacquered red inside.

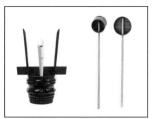

148 149

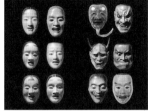

150 151

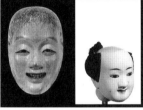

152 153

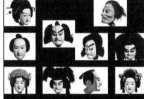

154 155

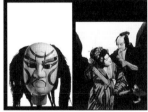

156 157

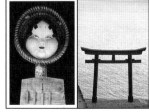

158 159

148.

Horned keg, or *tsunodaru*, for sake. The name derives from the elongated hornlike handles; the conical form at the center is the stopper. The body of the keg is lacquered red and tied with bamboo hoops. *Tsunodaru* are used at weddings, roof-raising ceremonies, and in Shintō offerings.

149.

Hishaku, or water ladles. Still in wide use today for ritual rinsing of the hands and mouth at shrines and in tea gardens.

150—151. 152.

Nō masks. The distinctive painted carved-wood masks employed in *Nō* theatre developed from earlier folk masks. There are five basic categories of characters and corresponding masks—gods, ghosts, beautiful women, madmen, and demons—with over 200 masks commonly used.

153. 154—155. 156.

Bunraku puppet heads. The puppet consists of a head, trunk, arms, and legs. The eyes (and sometimes even the eyebrows), the mouths, and the joints of the hands can be moved by the puppeteers to heighten dramatic effectiveness. The puppet heads are divided into categories based on age, sex, and temperament.

157.

Bunraku puppets—a young man and his courtesan sweetheart. Each of the major puppets in traditional *bunraku* puppet theatre is operated by three men, two of which are hooded and clothed in black. The hand of one of the puppeteers is partially visible behind the hand of the male puppet.

158.

Okame mask. Okame, also known as Otafuku, is a plump, rosy-cheeked smiling maiden's face, who symbolizes prosperity. The Okame mask shown here is displayed at the Bunnozuke-jaya, in Kyoto.

159.

Torii. A gatelike structure placed along the path to the shrine both marking the sacred precincts and symbolizing the shrine itself. There are four basic styles of *torii* gates. Shown here is the *myōjin*-style *torii* of the Tōshōgu Shrine on the shore of Lake Chūzenji in Nikkō, placed here in reverence of the sacred mountain standing behind.

160

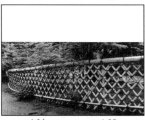

163

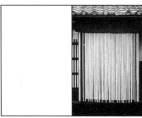

164 165

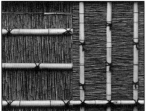

166 167

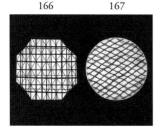

168 169

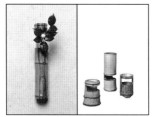

170 171

160.

Juzu, or Buddhist rosary, and *ihai*, or memorial plaques. *Juzu* are used in prayer to keep count in reciting the name of Buddha. They differ according to sect and are usually made of bo tree nuts, sandalwood, quartz, or coral. *Ihai*, bearing the name of the deceased, play a central role in Buddhist funerals and memorial services.

163.

Noren split curtains, usually cloth, are frequently hung in doorways of Kyoto townhouses. At this *minka* near Daitokuji, however, the *noren* is made of bamboo.

164—165.

Kōetsu-style fence at the temple Kōetsuji, Takamine, Kyoto. The style is named after the famous lacquer artist and calligrapher Hon'ami Kōetsu (1558–1637), for whom the temple is also named, and characterized by a rhombic lattice of heavy bamboo with a coping of split and bundled bamboo.

166—167.

Section of bamboo fence at Katsura Detached Palace, Kyoto. This fence, named after the imperial villa where it stands, is composed of vertically set split sections of bamboo with pointed tips and horizontally stacked bamboo twigs tied in place with hemp cords.

168—169.

Shitajimado, or exposed-lath windows, designed to suggest that the latticing is formed by the exposed laths of an unplastered opening in a mud wall. These windows were used widely for rooms in which the tea ceremony was performed. The octagonal window (left) is from the Sumiya in Kyoto, and the circular window (right) from the temple Hokkeji in Nara.

170.

Hanging bamboo vessel for tea-ceremony flower arrangements (*chabana*). These simple arrangements are composed of no more than two seasonal, indigenous varieties, of which the camellia is a favorite.

171.

Vessels for tea-ceremony flowers are frequently made of simple segments of bamboo, with openings cut in various positions.

172.

Bamboo *hishaku*, or water ladle. The delicate *hishaku* shown here is used for ladling water into and from the kettle in the tea ceremony.

173.

Chashaku, or bamboo tea scoop. A slender scoop used to dispense the powdered green tea from the tea caddy in the tea ceremony. The *chashaku* frequently bears a poetic name, and is one of the tea utensils that is displayed and examined by the guests—along with the teabowl and tea caddy—later in the ceremony.

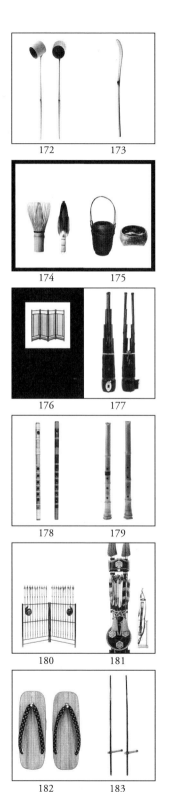

172 173

174 175

176 177

178 179

180 181

182 183

174.

Chasen, or tea whisk (left). Like many other tea-ceremony utensils, it is crafted from a single segment of bamboo; the upper portion is split into more than a hundred segments and the base left intact. The *chabōki,* or feather duster (right), is used to sweep ashes from the brazier.

175.

Woven bamboo baskets. The handled basket, shown on the left, is used as a vessel for flower arrangements. The basket on the right is used for carrying charcoal for the fire-building presentation (*sumi-demae*) in the tea ceremony.

176.

Tsuitate, or standing screen, movable partitions used in entry halls or reception rooms for blocking the wind and the view.

177.

Shō, a wind instrument introduced from China in the early seventh century used in Japanese court music (*gagaku*). The *shō* consists of seventeen bamboo pipes rising from a wooden cup-shaped body, two of which are mute. Tonal gradations are made by fingering the holes; continuous sound is produced by sucking and blowing alternately through the orifice at the base.

178.

Yokobue, or transverse flute. A fifelike instrument used to accompany a variety of traditional performing arts. It is held in the same style as the modern Western flute, and has seven finger holes.

179.

Shakuhachi, a vertical bamboo flute with a notched mouthpiece and five finger holes imported from China by way of Korea in the mid-seventh century. The name derives from the standard length of the instrument: 1 *shaku,* 8 (*hachi*) *sun,* or 54.5 centimeters (21.5 in.).

180—181.

Archery equipment, including bow, arrows, arrow holder, glove, arm pad, and bowstring. The bow is a standard 2 meters 21 centimeters (7 ft. 3 in.) in length, two-thirds of which is above the grip and one-third below. It is constructed of wood and bamboo, which is lacquered and wrapped. The arrows are 76 to 84 centimeters (30 to 33 in.) in length and made from a specific variety of small bamboo.

182.

Women's *geta,* or thonged clogs, made of paulownia wood with a bamboo-veneer surface.

183.

Bamboo stilts for recreation.

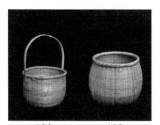

184 185

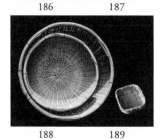

186 187

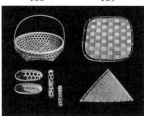

188 189

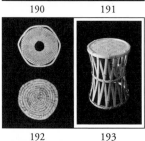

190 191

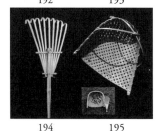

192 193

194 195

184—185.
Deep woven baskets used in the field for picking vegetables. Green bamboo is interspersed with aged bamboo as a decorative element.

186—187. 188—189.
Bamboo wares. Bamboo is woven to make a variety of objects for daily use. The forms and weaves vary according to their intended function—draining, holding, and drying.

190—191.
The open weave permits good circulation of air for drying fish. Woven bamboo wares are also used at the table as wet-towel holders, chopstick rests, and coasters, to keep dampness off of the table.

192.
Pot pads, to protect the table from scorching.

193.
Bamboo stool.

194—195.
Garden rakes, or *kumade* (literally, "bear's paw"), and dust pan for gathering fallen leaves.

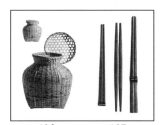

196 197

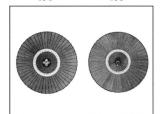

198 199

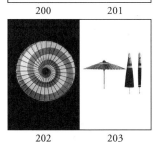

200 201

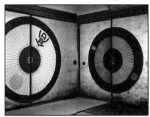

202 203

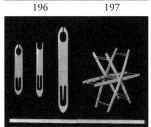

204 205

206

196.

Basket used to carry fish.

197.

Green-bamboo chopsticks for use in the *kaiseki* meal that sometimes accompanies the tea ceremony. The chopsticks are classified by shape and the location of the natural joint. Shown here, from left to right, are: end joint, tapered at both ends, and middle joint.

198—199.

Weaving implements. From left to right: *hi*, or shuttles; *osa*, or yarn guide; *itomaki*, or reel for winding thread; and below, *monosashi*, or ruler.

200—201. 202—203.

Janome, or snake-eye, paper rain umbrellas, so named because they resemble the eye of a snake when open. Popularly used since the late seventeenth century, they are either black and white, persimmon and white, or indigo and white.

204—205.

Umbrella papers of various sizes affixed to silver-leaf *fusuma* doors form an innovative motif in the Umbrella Room on the second floor of the Wachigaiya, in the Shimabara district of Kyoto.

206.

Bamboo birdcage (*torikago*).

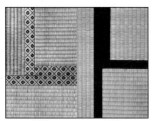

208 209

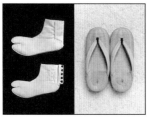

210 211

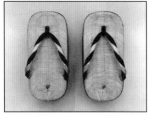

212 213

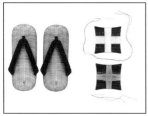

214 215

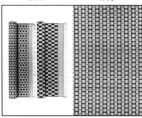

216 217

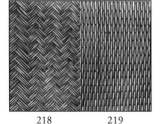

218 219

208—209.

Tatami mats; (left) at Hokkeji, Nara, and (right) Sumiya in Kyoto. Early *tatami* is believed to have been thin. Heian-period (794–1185) mats varied in thicknesses and were used as isolated pieces. Since the Muromachi period (1333–1568) *tatami* has been made of a thick straw base covered in woven rush (*igusa*) and covers the floor of a room completely. The mats are a standard 1.76 by .88 meters (5.8 by 2.9 ft.) in Tokyo, and 1.91 by .95 meters (6.3 by 3.1 ft.) in Kyoto; both are approximately 6 centimeters (2.4 in.) thick.

210.

Tabi, or socks worn with kimono. Originally made of animal skin, *tabi* later changed to silk or cotton, and buttons or clasps were added to the backs. White *tabi* are worn for formal occasions; indigo for traveling, and light persimmon, light yellow, or gray for daily use.

211. 212—213. 214.

Zōri, or thonged sandals, covered with woven rush. Early *zōri* developed from *geta* in the Kamakura period (1185–1333), attaining their present form in the Edo period (1600–1868).

215.

Thread wound on wooden bobbins.

216—217.

Hanamushiro, or patterned rush matting. Different patterns are achieved by weaving rush dyed in various colors.

218—219.

Wicker hamper weavings; (left) of bamboo, (right) of willow boughs.

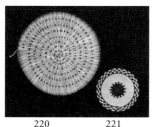

220 221

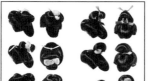

222 223

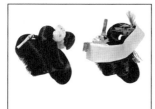

224 225

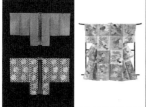

226 227

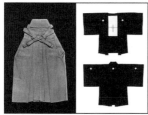

228 229

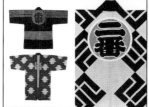

230 231

220—221.
Round cushions of woven rice straw.
222—223. 224—225.
Kamigata, or hairstyles. Side and rear views of Edo-period hairstyles worn by (from top to bottom): (left page) house maids, working-class maidens, geisha; (right page) brides, married women, upper-class maidens.
224.
Edo-period working-class maiden's hairstyle.
225.
Edo-period brides's hairstyle and ornamentation.
226—227.
Nō costumes. Worn in multilayers, the outermost layer is usually a richly patterned brocade or damask. Outer costumes fall into two basic types: *ōsode*, or wide-sleeved (left), and *kosode*, or narrow-sleeved (right). During the eighteenth and nineteenth centuries the patterns, colors, and fabrics worn by the different characters were systematized.
228—229.
Hakama, or loose trousers, and *mon-tsuki haori*, or jacket with family crests, worn as formal dress over kimono. Different versions of *hakama* and *mon-tsuki haori* were worn by upper-class men and women over the ages. Today they are worn mostly by men on very formal occasions, or by those practicing the traditional Japanese arts. The degree of formality depends on the number of crests.
230—231.
Hanten, or *happi*. A straight-sleeved coat bearing a house or shop name (*yago*) or symbol. *Hanten* were worn mainly by artisans and members of the fire brigade during the Edo period. Today they are worn at festivals.

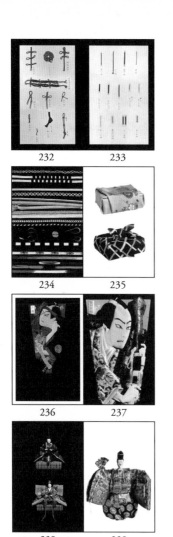

232 233

234 235

236 237

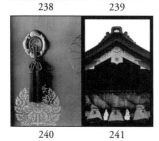

238 239

240 241

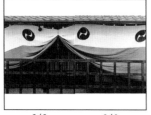

242 243

232—233.

Kumihimo, or braiding. Silk cords or bands braided using weighted bobbins. Shown are samples displaying some of the many styles of braiding and knotting.

234.

Obijime, the cord that secures the *obi* (sash) worn with a women's kimono; and *haori* ties. Both are crafted with *kumihimo* braiding.

235.

Furoshiki, or carrying cloths. A square cloth used for wrapping, carrying and storing objects. *Furoshiki* come in a variety of sizes, fabrics, colors, and patterns, and can be tied in a number of ways depending on the size and shape of the object.

236—237.

Hagoita. A decorated battledore, used for the game *hanesuki* played at the New Year's holidays. Ornamental *hagoita*, elaborately decorated portraits of beautiful women and kabuki actors in padded applique silk, developed during the Edo period.

238.

Hina ningyō, or palace dolls, representing the emperor and empress, are displayed on a tiered stand with their attendants and household goods for the Doll Festival on March 3. The practice of displaying dolls dates back to the Edo period, and bears wishes for family prosperity and progeny.

239.

Nō doll. A doll representing the venerable old man character of Nō theatre. During the Heian period dolls were used as effigies to displace defilement, malevolent spirits, and disease. Dollmaking flourished during the Edo period when dolls that were appreciated purely for their aesthetic beauty, and as playthings, became popular.

240.

Hikite, or finger-grip door pulls, on the *fusuma* sliding doors at the temple Hokkeji in Nara. The ornamental vermilion tassels and the floral motif on the metalwork are befitting of a temple for Buddhist nuns.

241.

Shimenawa, or sacred rope, on the front of the worship hall at Izumo Shrine, Shimane Prefecture. A large rope made of twisted rice straw used to demarcate a sacred area from the profane.

242—243.

Manmaku. A horizontal curtain of cotton, linen, twill damask, or brocade with family crests hung on the exterior of a home for auspicious occasions, shown here from the Gion district of Kyoto.

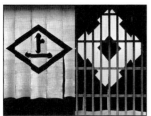

244 245

246 247

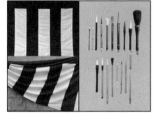

248 249

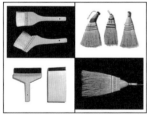

250 251

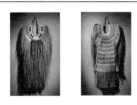

252 253

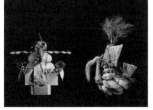

254 255

244—245. 246—247.

Noren, or split curtains, originally hung in doorways to block sunlight and views from passersby. Today they have become symbols of the establishments they grace, signaling that the shop is open for business.

248.

Kujiramaku. A bunting with black-and-white vertical stripes and black border on the upper edge, hung on mournful occasions.

249.

Fude, or calligraphy brushes for use with *sumi* ink. They are in the traditional style of those imported from China when writing was introduced to Japan.

250.

Hake, or flat paint brushes. Those shown below are designed for applying lacquer.

251.

Hōki, or brooms, traditionally of wild grasses with bamboo handles, have been made and used for sweeping clothes, floors, and gardens since the Muromachi period in the same form in which they are seen today.

252—253.

Mino, or rice-straw rain cape, traditionally used by farmers, fishermen, and in the mountains. Shown here are a *mino* used on outings from the Tōno region of Iwate Prefecture (left); and a *mino* used in the fields from the Onikōbe region of Miyagi Prefecture (right).

254.

Kagamimochi. A traditional offering of round rice cakes, in two or three tiers, to the deities and Buddhas in celebration of the New Year.

255.

New Year's ornament in the shape of a *takarabune*, or treasure ship, made of rice straw and decorated with pine, bamboo, and plum blossoms, the auspicious symbols for the New Year.

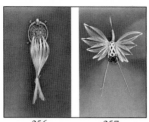

256 257

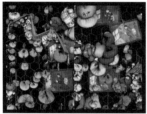

258 259

260

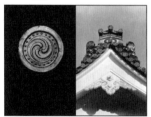

262 263

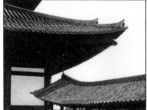

264 265

266 267

256—257.

Mizuhiki twisted paper cords intricately worked into images of the bushy-tailed tortoise (left) and the crane (right), both of which symbolize good luck.

258—259.

Kugurizaru. Folded cloth stuffed with cotton batting offered at the Yasaka Kōshindō in Kyoto in exchange for answers to prayers.

260.

Fude, or calligraphy brush, dipped in *sumi* ink.

262.

Round eaves tile decorated with beading and the ancient triple-comma pattern.

263.

Temple architecture gable decorations. Here the round tiles are ornamented with stylized chrysanthemums. The massive ridge-end decoration in roof-tile clay at the top is called a *shishiguchi,* or lion's mouth, and the fancy white decoration under the gable is known as a *gegyo,* or pendant fish.

264—265.

Yanegawara, or roof tiles. Ceramic roof tiles were introduced into Japan from Korea and China during the Asuka period (552–646).

266—267.

Mushikomado (literally, "insect cage window"). A style of barred windows seen on second-story front wall windows in Kyoto townhouses, in which the vertical timbers are wrapped with rope and then plastered.

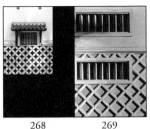

268 269

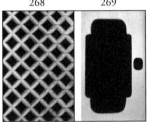

270 271

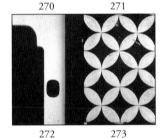

272 273

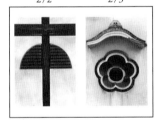

274 275

276 277

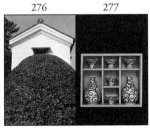

278 279

268—269. 270. 273.

Namako-, or sea cucumber-, style wall. This decorative effect is produced by affixing square tiles to a wet clay wall and then plastering the joints in a semicircular relief. The style originated in the Edo period (1600–1868) and reached its height of popularity during the Meiji period (1868–1912).

271. 272.

Entrance to an earthern-wall storehouse whitewashed with plaster at the Ikoma Seiten in Nara.

274.

Comb-shaped window. Seen only in residences of court nobles or feudal lords, this aperture in the wall of the Seiryōden main building of Kyoto Imperial Palace was created for the emperor to view the courtiers.

275.

The plum blossom-shaped window of a whitewashed earthern-wall storehouse near Shūgaku-in Detached Palace in Kyoto.

276—277.

Chidori, or flying plover, motif in the earthern outer wall of a residence in the Ponto chō area of Kyoto.

278.

Kura, or storehouse, in the Hōkō-in of the Nara temple Yakushiji. Most traditional *kura* in Japan have a wood-frame structure to which bamboo lathing and palm fiber is affixed as a wall base, covered with a thick layer (20 centimeters, or 8 inches) of mud, and finished with a layer of plaster.

279. 280—281. 282.

Saké bottle (*tokkuri*) and cup. These highly popular ceramic items are made in many sizes, shapes, colors, and patterns.

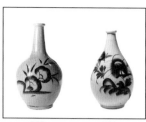

280 281

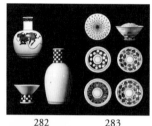

282 283

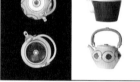

284 285

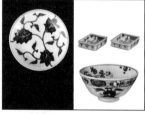

286 287

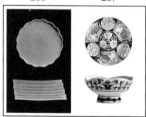

288 289

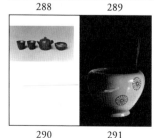

290 291

283.

Rice bowls. A variety of forms and patterns typical of rice bowls for everyday use.

284—285.

Ceramic teapot (*dobin*) with a blue fishnet pattern. The teapot, indispensable to daily life in Japan, is thought to have evolved from medicine containers and iron kettles. Pots like these are found in an immense variety of shapes, with many different kinds of handles and decorative motifs.

286.

Plates.

287.

Dishes used in a *kaiseki* meal, sometimes served in conjunction with the tea ceremony. Top: *Mukōzuke*, or "over there" dishes, because they are placed on the far side of the tray as it stands before the diner. They are found in a variety of forms. Those shown here have a blue underglaze motif. Bottom: *Akae* (literally, "red picture") candy dish, so named because of its decoration.

288—289 (top).

Plates.

289 (bottom).

Footed bowl.

290.

Teapot, small tea cups, and lipped bowl for cooling hot water to the proper temperature for tea of the finest flavor. Red clay ceramics of this kind, especially Banko and Tokoname wares, are popular for *sencha* tea-ceremony utensils.

291.

White porcelain hibachi (brazier) for live charcoal to warm the hands or to heat water for tea, from Hokkeji Temple in Nara. Hibachi come in many sizes, shapes, and types and may be made of wood, metal, or pottery.

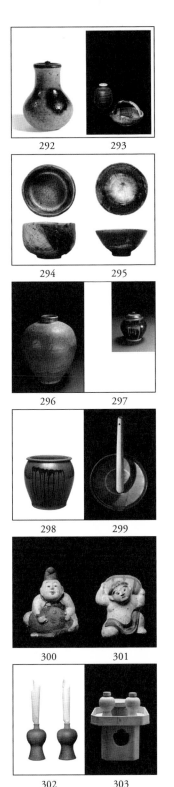

292 293

294 295

296 297

298 299

300 301

302 303

292—293.

Tea-ceremony utensils.

294—295.

Teabowls. Tea ritual, as practiced in Song (960–1279) China, was introduced into Japan during the Kamakura period (1185–1333). Sen no Rikyū, who transformed tea ceremony into *chanoyu*, or "the way of tea," preferred teabowls imperfect in form and coloration to highly refined wares.

296.

Shigaraki jar. The town of Shigaraki, in Shiga Prefecture, gives its name to the ceramic ware that has made it famous. Shigaraki kilns are considered to be among the oldest in Japan.

297.

Salt jar. Jars of this kind, always glazed and lidded, are found in kitchens throughout the country. Most are similar in shape and size.

298.

Water jar. An implement for everyday living.

299.

Ceramic mortar (*suribachi*) and wooden pestle (*surikogi*) for kitchen use. Bowls of this sort date back as far as the Heian period (794–1185). Linear grooves are cut into the clay in several directions before firing. The pestle, for which willow, mulberry, and mountain ash are considered the best materials, is scraped over the grooves to grind grain, yams, sesame seeds, and other foodstuffs.

300—301.

Fushimi figurines made and sold as souvenirs at the Fushimi Inari Shrine, in Kyoto. These unglazed and painted ceramic figurines come in hundreds of forms, including those of the gods of wealth and good fortune, Ebisu (left) and Daikoku (right).

302.

Ornamental saké bottles used for saké offerings to the Shintō deity at the Kitano Shrine, in Kyoto.

303. 305.

Vessels for rice offerings, along with the saké, to the Shintō deity at the Kitano Shrine.

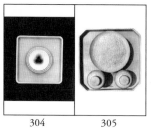

304 305

306

309

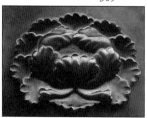

310 311

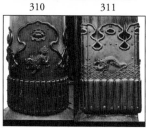

312 313

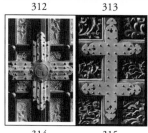

314 315

304.
Unglazed triple cups with central cloud pattern. These cups, shown resting on a tray of unfinished wood, are used for the presentation of saké to Shintō deities, or for drinking saké on ceremonial occasions.

306.
Small shrine representing the fox deity, Inari, at the Akinoshina Temple in Nara.

309.
Iron gate. Higashi Ōtemon, Nijō Castle, Kyoto.

310—311.
Peony applied as a decorative element to a round pillar at Higashi Honganji Temple, Kyoto.

312.
Cast Chinese-lion-motif fitting for a round wooden pillar at Higashi Honganji Temple.

313.
Cast dragon-and-wave-motif fitting for a square pillar at Higashi Honganji Temple.

314.
Gilt decorative metal fittings on the doors of the Karamon gate at the Taiyū-in, a mausoleum built to enshrine the third Tokugawa shōgun, Iemitsu, in Nikkō.

315.
Gilt decorative metal fittings on the double doors of the Yashamon gate at the Taiyū-in. The door panels display a colored bas-relief peony motif.

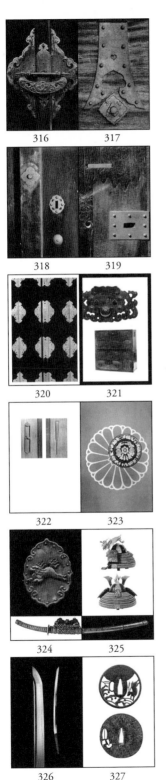

316
317

318
319

320
321

322
323

324
325

326
327

316.

Padlock. Padlocks were introduced to Japan from the continent during the Nara period (710–794). It was not until the Edo period (1600–1868), however, that they became craft objects, like this one on the gate at the Futarasan Shrine in Nikkō.

317.

Metal door fittings, Nishi Honganji Temple, Kyoto.

318.

Keyhole, Futaiji Temple, Nara.

319.

Keyhole on the five-story pagoda at Kōfukuji Temple in Nara.

320.

Decorative fittings on the doors of a *zushi*, or miniature shrine.

321.

Iron fittings from, and on, a *tansu*, or chest of drawers. *Tansu* from northern and northeastern Honshū are elaborately decorated with iron plates, locks, and pulls.

322.

Metal door pulls on wooden doors from Manshu-in Temple, Kyoto.

323.

Detail of *fusuma* (sliding partition) with a stylized sixteen-petaled chrysanthemum motif. The elaborately worked circular door pulls are also decorated with chrysanthemums. Hokkeji Temple, Nara.

324.

(Top) Cast metal decorative hardware, Higashi Honganji Temple, Kyoto. (Bottom) *Tachi*, a sword with a single-edge blade 60 centimeters (23.6 in.) or more in length. It is comprised of a blade, scabbard, sword guard, and hilt.

325.

Kabuto, or medieval helmet (side and rear views), composed of metalwork and lacing. The pronglike projections, known as *kuwagata* (literally, "hoe shape"), and the rampant dragon attest to the warrior's proud lineage.

326.

Sword blades. The Japanese sword, made of painstakingly tempered and polished steel, reached an unsurpassed level of technical, and aesthetic, perfection.

327. 328.

Tsuba, or sword guards; the metal plate that separates the blade from the handle of the sword for protection and balance. Since the sword was the samurai's most valued possession, *tsuba* and other sword fittings became objects of creativity and refined craftsmanship. *Tsuba* are usually made of iron, decorated with openwork, carving, inlay, and gilding.

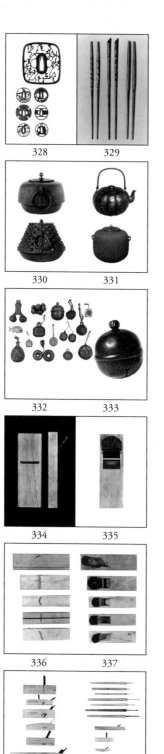

328 329

330 331

332 333

334 335

336 337

338 339

329.
Metal chopsticks for handling charcoal in hearths and braziers. They are generally iron or bronze and may be plain or ornamented. Some have wooden tops.

330.
Cast-iron kettle with bronze lid for tea ceremony. These kettles are designed to rest directly on top of a special metal brazier containing charcoal.

331.
(Top) Spouted cast-iron kettle with bail handle. These kettles are believed to have evolved from the tea-ceremony kettle shown below. Spouted kettles are cast in Kyoto, Osaka, and Morioka. (Bottom) Cast-iron *araregama* (literally, "hailstone kettle") for tea ceremony. The name is derived from the tiny knobs that decorate the surface. *Araregama* may be large or small; the pattern may cover all or only part of the surface.

332—333.
Bells. The refreshing sound of tingling of bells has been a favorite throughout Japanese history. Small bells developed along with religious services. They are generally iron or bronze and are found in a large variety of sizes, shapes, and ornamental motifs.

334—335.
Kanna, or plane. Bottom, side, and top views of a typical wood plane, comprised simply of a hardwood block and blade. *Kanna* vary in size and shape according to the task they are designed to perform.

336—337.
Bottom and top views of various wood planes (from top to bottom): corner-rounding plane (used by door makers), small flat plane, molding plane, lattice-bar plane (for making shōji doors), and edge plane.

338.
Side views of various wood planes for paring and smoothing the base and walls of channels for sliding doors.

339.
(Top) A variety of awls and drills. (Bottom) Side views of various wood planes (from top to bottom): small flat plane, plane for adjusting plane blocks, round-block plane (for smoothing curved surfaces), and edge planes (for rounding and bevelling door edges).

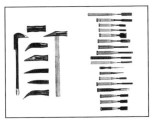
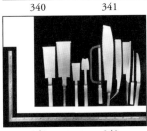

340 341

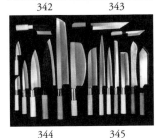

342 343

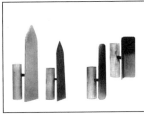

344 345

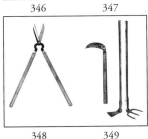

346 347

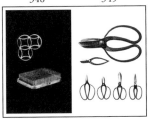

348 349

350 351·

340.
Kanazuchi, or hammer, with hammerheads and nail pull.
341.
Nomi, or chisels, like their Western counterparts, vary in size and shape according to intended use.
342—343.
Nokogiri, or saws. Japanese saws cut on the pull; variety in teeth and forms reflect different uses. (Bottom) Angle rule, in the traditional unit of measure 10 bu to 1 sun, (3.03 centimeters or 1.193 inches).
344—345.
Hōchō, or kitchen knives. The steel blades vary in size and shape according to foodstuff—fish, meat, vegetables —and type of cut.
346—347.
Kote, or trowels, used for applying and smoothing mud, plaster, or cement on wall surfaces and corners.
348.
Pruning shears.
349.
Kama, or sickle; and *suki*, or hoes. In Japan the sickle is the traditional implement for harvesting grain or cutting tall grass, as opposed to the scythe.
350.
Shizumi and *kenzan*, two kinds of supports used in flower arrangement.
351.
Flower shears.

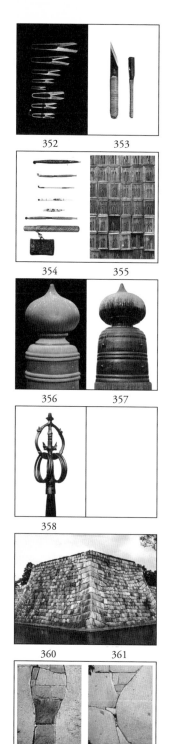

352
353

354
355

356
357

358

360
361

362
363

352.
Sewing scissors.

353.
Cutter (left) for leather or paper, and razor (right) for shaving.

354.
Kiseru, or pipes, were traditionally smoked by men and women alike. They are most commonly composed of a bamboo shaft with decorated metal bowl and mouthpiece fittings, and vary in length.

355.
Offerings at Shakuzōji, known in the vernacular as the Nail-pulling Jizō Temple, in Kyoto. Offerings comprising a large nail and a pair of pincers are made as prayers to relieve life's sufferings.

356—357.
Metal *giboshi*, or leek-flower form, railing post knobs used as decorative elements on the balustrades at Nijō Castle (left) and Sanjō bridge in Kyoto.

358.
Buddhist priest's staff, of which only the top is seen here. The shape of the metal top is based on that of a stupa reliquary, and the loose rings produce a jingling sound when the staff is shaken. This ritual implement is sometimes used to beat time during the chanting of sutras.

360—361.
Stone ramparts of the moat at Nijō Castle in Kyoto. These unmortared walls are the remains of what once surrounded the 400-by-500-meter (1312-by-1640-foot) Kyoto residence of Ieyasu, the first Tokugawa shōgun.

362—363.
Stone ramparts of the moat at Osaka Castle.

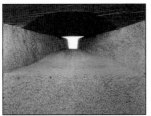

364 365

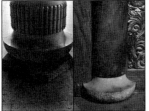

366 367

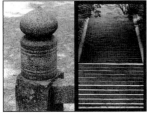

368 369

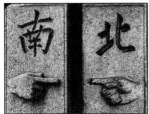

370 371

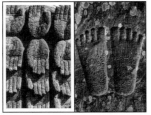

372 373

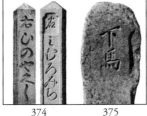

374 375

364—365.
Loophole in the wall of Osaka Castle. Square, round, and triangular apertures were created in the fortress walls through which the enemy could be fired down upon.

366—367.
Soseki, or foundation stones, set under pillars of the main gate at the temple Higashi Honganji in Kyoto.

368.
Granite railing post knob on a bridge at Miidera Temple in Ōtsu, Shiga Prefecture. The leek-flower form, believed to have made its way east from Turkey via Persia and India, is frequently used as a decorative element on the posts of veranda railings or bridges. It is usually made of metal or stone.

369.
Upward-surging flight of stone steps—a literal stairway to heaven—just beyond the main gate at the head Jōdo-sect temple, Chion'in, in Kyoto.

370—371.
Signposts pointing "north" and "south" on Higashiyama Street in Kyoto.

372.
Stone Buddha hands. This crude but arresting arrangement of hands found near the Ōzawa Pond in Kyoto is highly unusual.

373.
Footprints of the Buddha in stone, Kiyoshikōjin, Takarazuka, Hyōgo Prefecture. It is said that before his death and entry into nirvana, the Buddha Sakyamuni (Shaka, in Japanese,) stood on a stone and left his footprints. For centuries thereafter, prior to sculptures of the Buddha, footprints like this were carved and revered. The tradition passed from India to China and thence Japan, where copies were carved throughout the various regions.

374.
Signposts identifying street names, Kyoto.

375.
"Dismount" post, Yakushiji Temple, Nara. Signs ordering persons to dismount from their horses, as a gesture of respect, were posted in front of temples, shrines, and some upper-class residences.

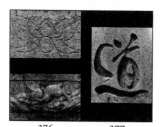

376

377

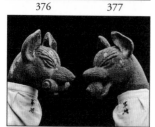

378

379

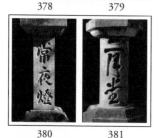

380

381

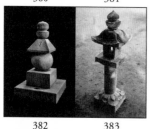

382

383

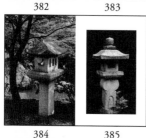

384

385

386

387

376.
Line carving of a lotus flower in stone at the Byōdō-in Temple in Uji (top). Stone relief (bottom).

377.
Carved character on a stone monument.

378—379.
Stone foxes at the Fushimi Inari Shrine, Kyoto. There are many interpretations of the mythical relationship between the fox and the deity of grains, Inari. One says that a magician, under the influence of esoteric Buddhism and Taoism, became possessed by fox spirits, developed the ability to make oracular pronouncements, and gradually evolved into Inari. The Fushimi Inari Shrine is a popular shrine to pray for worldly wealth. The bibs are "dedications" given in exchange for answers to prayers.

380—381. 383. 384—385.
Stone lanterns. Stone lanterns originated in India, where they were used by monks for lighting and for offerings at Buddhist alters, and were later introduced into Japan via China. They spread to the secular world during the Kamakura period (1185–1333). Shown here are carved characters on a stone lantern base at Nigatsudō in Nara (381) and stone lanterns from Yakushiji Temple, Nara (383); from the garden of Sentō Gosho, Kyoto (384); and from the garden of Katsura Detached Palace, Kyoto (385).

382.
Five-level stupa, Kōzanji, Kyoto. The five levels, each labeled in Sanskrit, symbolize (from top to bottom): sky (a jewel shape), wind (a bowl shape), fire (a truncated pyramid), water (a sphere), and earth (a square block). Stupas such as these have been made as votive offerings, memorials, or reliquaries at Buddhist temples since the Heian period (794–1185).

386.
Steppingstones in the garden of Katsura Detached Palace. Segments of the garden path are carefully spaced to control movement through, and heighten awareness of, the garden step by step.

387.
Steppingstones in front of the Kōgestsu-tei teahouse at the Arisawa residence, Matsue, Shimane Prefecture. Sections of fresh bamboo are placed among the stones to greet guests invited to the tea ceremony.

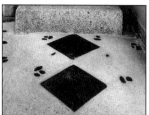

388 389

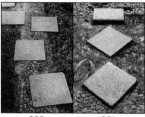

390 391

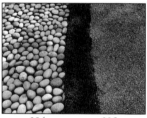

392 393

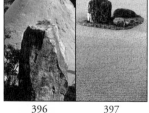

394 395

396 397

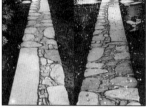

398

388—389.
Steppingstones set in *miwado* cement in front of a teahouse at Shūgaku-in Detached Palace.
390.
Square-cut steppingstones traverse the stone-paved path outside the Enrindō memorial hall at Katsura Detached Palace.
391.
Arrangement of square-cut steppingstones leading to a round washbasin at Katsura Detached Palace.
392—393.
View looking south (left) and north (right) of the stone-paved path leading to the waiting bench in the garden of Katsura Detached Palace.
394—395.
Cobblestone and coarse sand used to represent the natural coastline in the garden at Sentō Gosho, Kyoto.
396.
Moon dais and white sand cone in the garden of the Silver Pavilion (Ginkakuji), Kyoto.
397.
Stone arrangement in the dry landscape garden at the temple Ryōanji, Kyoto.
398.
Sekimori ishi, or barrier stone. A stone tied with palm-hemp cord placed on a steppingstone in a tea garden indicates the path beyond is off-limits.

Portions adapted from *Forms, Textures, Images,* Weatherhill, Inc., of New York and Tokyo, 1979.

Classic Japanese Design
Katachi

Photographer : Takeji Iwamiya
Art Director : Kazuya Takaoka

Designers : Takeshi Hamada, Nobukazu Ito
Supervising Editor : Kazuya Takaoka
Editors : Kyoko Otani, Kuniko Ishizuka
Translators : Pamela Virgilio, Douglas Allsopp
Producer : Ryoji Nagai (Unlimited Music Inc.)

Printing : Nissha Printing Co., Ltd.

Takeji Iwamiya was one of Japan's foremost
photographers and a professor at the Osaka University of Art.
In his many published books and exhibitions
he explored subjects including gardens,
images of the Buddha, and traditional Japanese motifs,
and was the recipient of the Education Minister's
Art Encouragement Prize.

Kazuya Takaoka has won numerous awards for
his book and poster art direction and design.
He is the author and producer of two previous books
and related events entitled
"AIDS & HIV" and "QOL" (Quality of Life).
He is active in the production
of imagery that is non-damaging to the body, mind and spirit.